Sketch · Plan · Build

World Class Architects Show How It's Done

Sketch • Plan • Build

World Class Architects Show How It's Done

COLLINS|DESIGN

An Imprint of HarperCollinsPublishers

First published in 2005 by:
Collins Design,
An Imprint of HarperCollins*Publishers*
10 East 53rd Street
New York, NY 10022
Tel: (212) 207-7000
Fax: (212) 207-7654
collinsdesign@harpercollins.com
www.harpercollins.com

Distributed throughout the world by:
HarperCollins*Publishers*
10 East 53rd Street
New York, NY 10022
Fax: (212) 207-7654

Executive Editor:
Paco Asensio

Editorial coordination & text:
Alejandro Bahamón

Translation:
Wendy Griswold

Art Director:
Mireia Casanovas Soley

Graphic Design and layout:
Emma Termes Parera

ISBN: 978-0-06-074971-2

Library of Congress Cataloging-in-Publication Data

Bahamón, Alejandro.
 Sketch, plan, build : world class architects show how it's done / by Alejandro Bahamón.
 p. cm.
 ISBN 0-06-074971-7 (hardcover)
 1. Architectural drawing--20th century. 2. Architectural drawing--21st century. I. Title.
 NA2700.B25 2005
 720'.28'4--dc22
 2005000330

Printed in China

Third Printing, 2007

The drawing has always played a central role in architecture. It is the graphic language that architects use to express an idea and, consequently, it is intimately linked to the history of architecture, having been its principal mode of translating ideas into reality. The drawing is the architect's essential means of expression and communication, the tool most often used to convey his or her intentions to clients, builders, and the general public. While, like any other means of representation, it has a limited ability to reflect the real world, it is the mechanism that allows for the best reading of the relationships between a project's formal, functional, and technical aspects.

Depending on the standpoint from which it is analyzed, the architectural drawing has great importance as a document. It is considered a work of art in and of itself and, in this respect, each document can be analyzed in terms of composition, color, or intent. With regard to its creator, the drawing has enormous biographical interest, reflecting his or her ideas and architectural reasoning, and even his or her moods. Finally, the drawing is also of documentary interest vis-à-vis the architecture.

The architectural drawing can be classified according to the requirements, the audience with which information about the project is to be shared, or the stage of development. Each type has its own graphic quality and represents different aspects of the project.

The sketch consists of the first outlines a designer puts forward in his or her attempt to resolve and express a specific aspect of the project. Since it is a freehand drawing, developed quickly in response to the architect's first impulse, it may be the most personal graphic document, the one that best expresses the creator's personality.

The architectural plan, setting forth the three views that are indispensable in describing a work—the layout, the elevation, and the section—dates back to the Renaissance. Depending on the audience, architectural plans can contain more or less information, such as measurements, text with technical specifications, section marks, or textures, and can be supplemented with other views, such as perspectives, axonometries, or detailed plans.

The technical plan is the starting point for the actual construction of a project. It is based on the architectural drawing, which is a key construction tool in and of itself, but is supplemented with a series of plans on a larger scale and with greater technical specificity. The technical plans show and dissect the inner workings of a project, from the overall structure to the smallest details and finishes.

This book focuses on the graphic representations used by some of our most noteworthy contemporary architects to convey the essence of their work. Thus, it becomes a primary tool for understanding many of the traits that characterize their architectural reasoning. Just as the work of Alvar Aalto, a man of few words, has been analyzed mainly through the many drawings he left as a legacy, this compilation reveals the different nuances each of the contemporary architects featured use to express their own ideas through the drawing. A very diverse graphic tour, it starts with the sketch and then extends to the other drawings, running the gamut from popularly known architects such as Tadao Ando, Mario Botta, Alvaro Siza, Dominique Perrault, and Renzo Piano, to those who have just recently gained international recognition such as Klein Dytham, Vincent Van Duysen, Future Systems, and RCR Arquitectes. This variety gives us a very broad overview of the primary means of architectural expression and its variables, according to the architect's own reasoning, the technical resources he or she uses, and cultural influences.

Alberto Campo Baeza

Alberto Campo Baeza, a Spanish architect based in
Madrid, has always combined academics with the
practice of architecture. His teaching has taken him to
universities in Pennsylvania, Weimar, Colombia,
Vicenza, and Chicago, among other places. His work in
the construction of buildings as well known as the
Headquarters of the Caja de Granada, the offices of
Editorial SM, and the De Blas and Gaspar houses, have
earned him national and international recognition,
such as the Eduardo Torroja award (2003), the COAAO
award (2003), and the Bienal de Miami award (2000).
He is currently working on his first house in the United
States: the Olnick Spanu house in Garrison, New York.

Baeza

De Blas House Sevilla la Nueva, Madrid, Spain, 2000

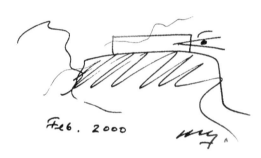

Feb. 2000

On the crest of a north-facing hill, this house is a response to its location. Because of the irregularity of the terrain, the house sits on a platform. A transparent glass box roofed with a structure of white-painted steel rests atop a concrete box which, embedded in the earth like a cave, is the refuge that includes the living area. The glass box, like a cabin, provides a vantage point from which to view the mountains near Madrid.

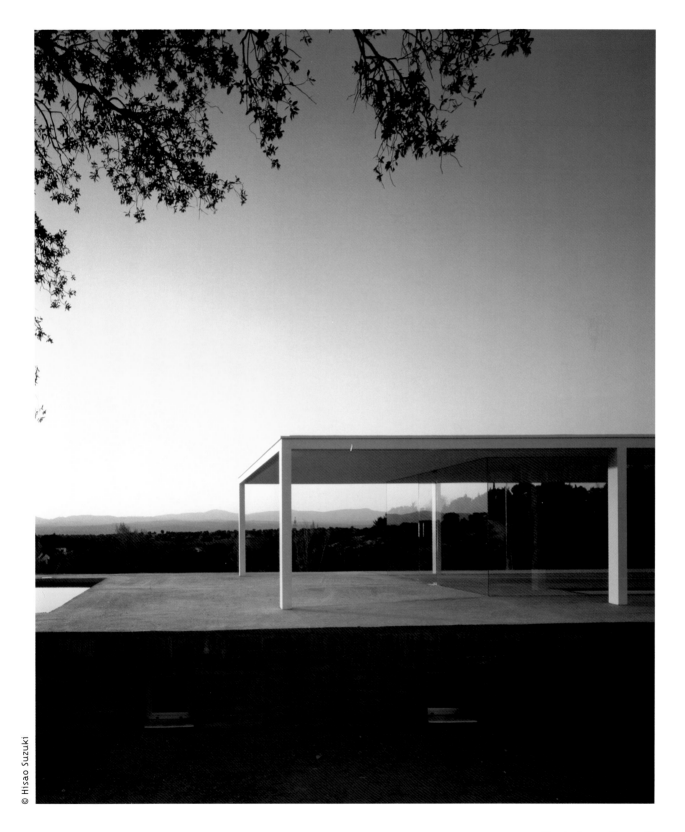

1
mountain + tree

2
to stablish a
platform

3
to carve to house. hot
cold

← STEREOTOMIC

4
to cover it is raing

to plan it is windy
← TECTONIC.

stereotomic + tectonic =
= ARCHITECTURE.

DE BLAS HOUSE
with A. del V.

January 18 1999.

Schematic design sketches

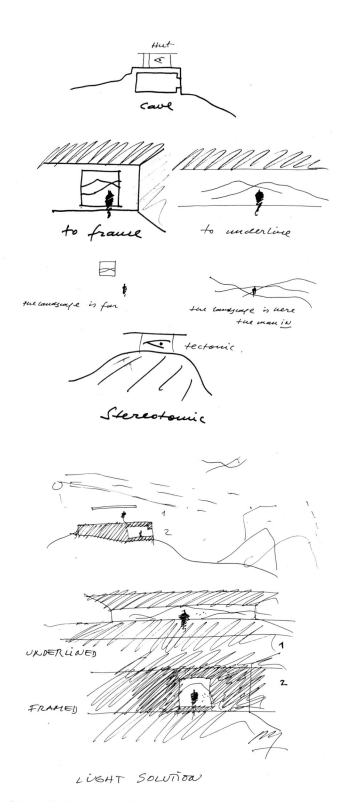

Schematic design sketches

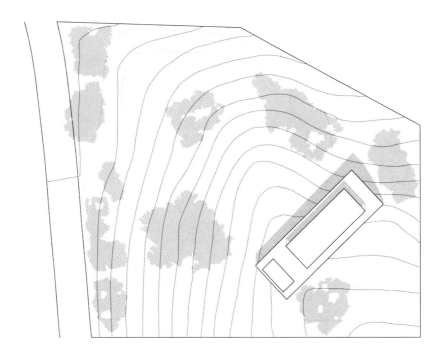

Site plan

Ground floor plan

Second floor plan

0 1 2

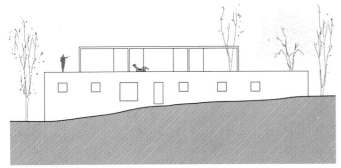
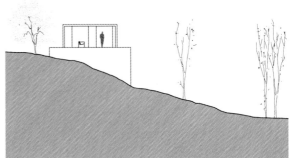

Elevations

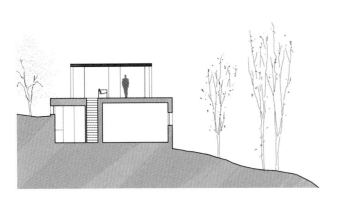

Sections

Caja de Granada Granada, Spain, 2001

This building, housing the city's most important bank, is a new reference point for the area. Since the land slopes, it was built on a giant plinth, which accommodates parking, archives, and the data processing center. The theme of this glass and concrete structure is the capture of light. Thus, the two south-facing facades function like a sunshade, subtly changing the illumination in those offices, and the two north-facing facades receive the light through a composition of stone and glass that illuminates the individual offices.

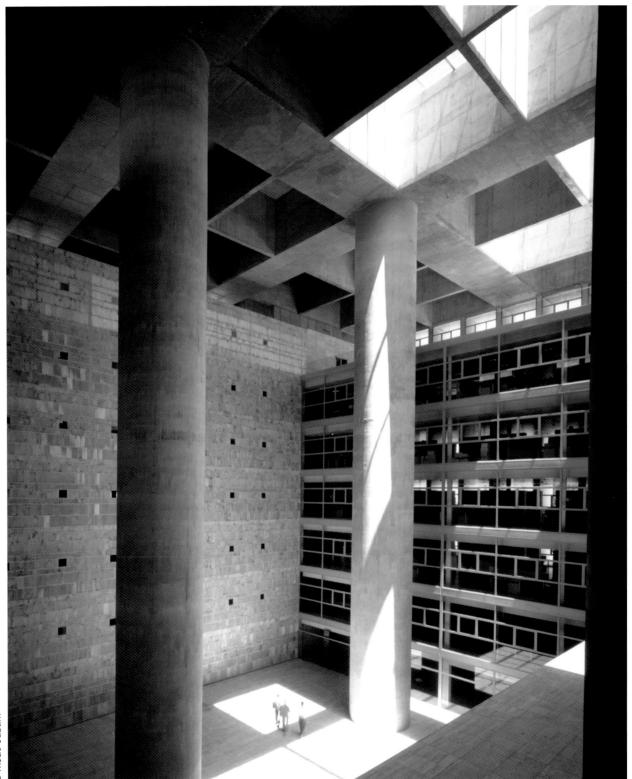

STEREOTOMIC

TECTONIC

G

CAJA GENERAL de GRANADA
HEADQUARTERS
BANK
IN
GRANADA – SPAIN
1992
Competition august 92
winner
1st PRIZE

HORMIGON

may 31 · 91

GASTDOZENT
· A. CAMPO BAEZA ·

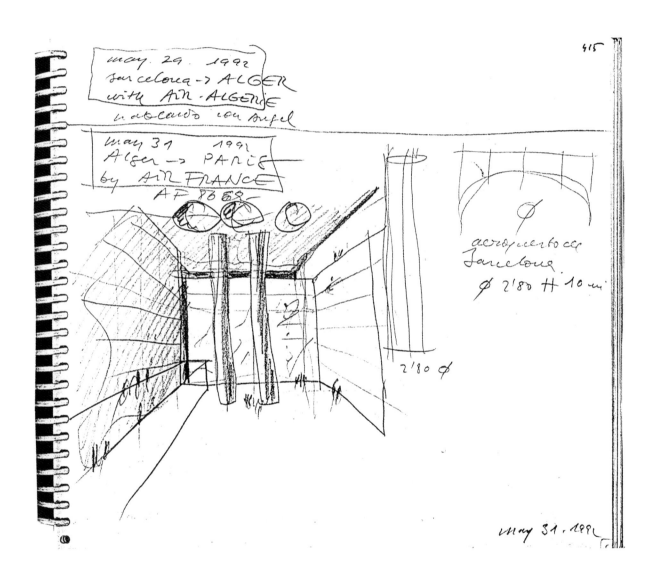

may. 29. 1992
Barcelona → ALGER
with AIR·ALGERIE
hablando con Rafael

may 31 1992
Alger → PARIS
by AIR FRANCE
AF 8868

415

acropuerto de
Barcelona.
φ 2'80 H 10 m

2'80 φ

may 31. 1992

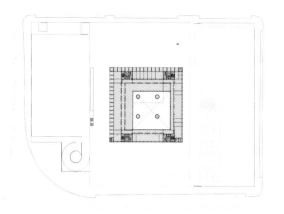

Site plan

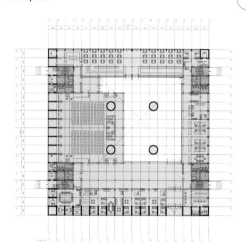

Ground floor plan

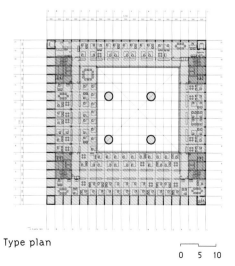

Type plan

```
0   5   10
```

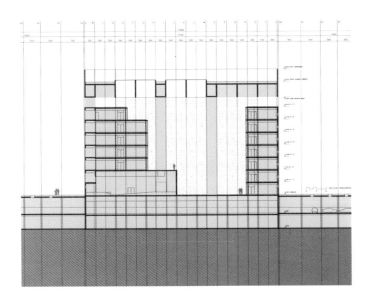

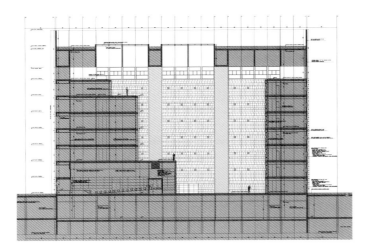

Sections

Editorial SM New Headquarters Madrid, Spain, 2002

This building's proximity to a highway defined its "fallen steel giant" aesthetic, to use the architect's words. Its facades were designed to trap the light needed in the interior through different types of openings, such as the large eye on the west that frames the landscape. The building, which consists of a metallic structure of stainless steel panels atop a vast concrete platform, highlights the contrast between these two materials with such different properties.

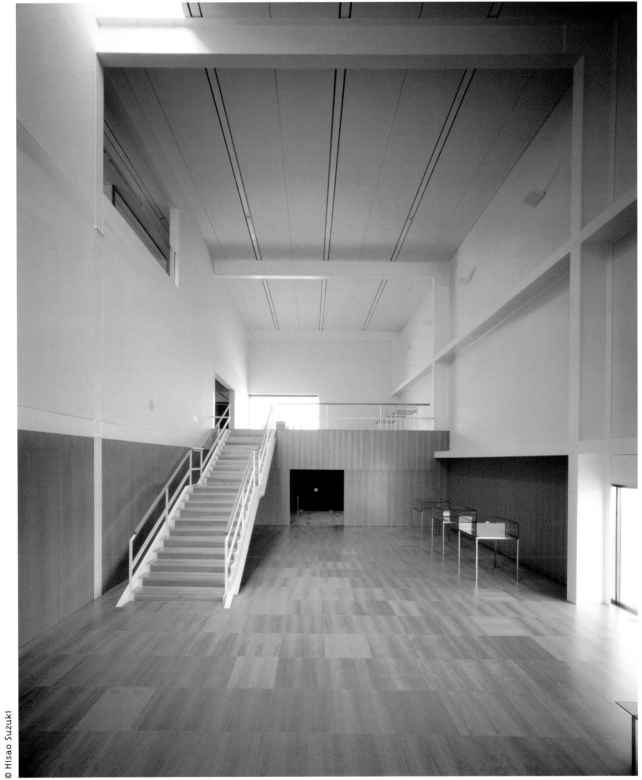

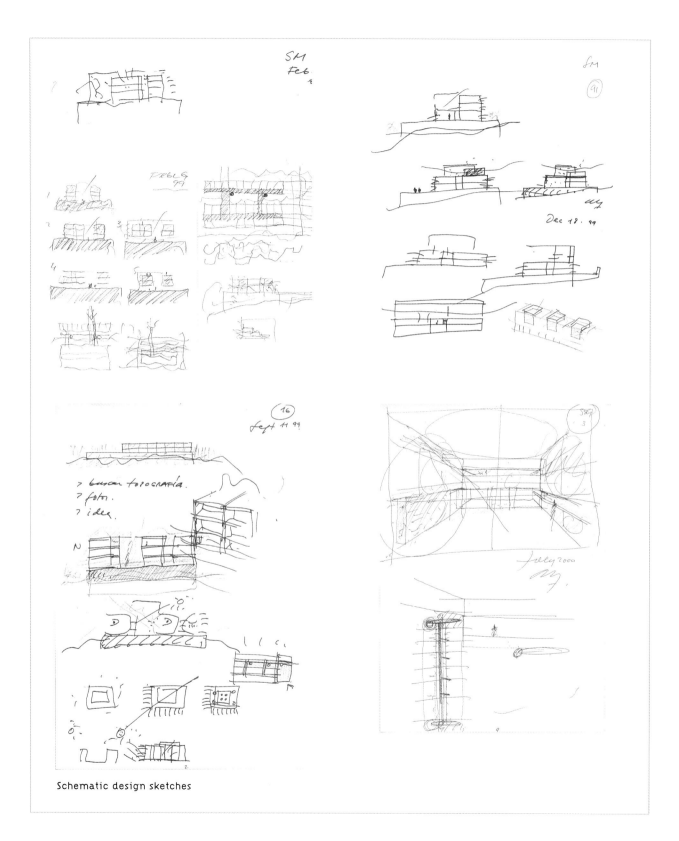

Schematic design sketches

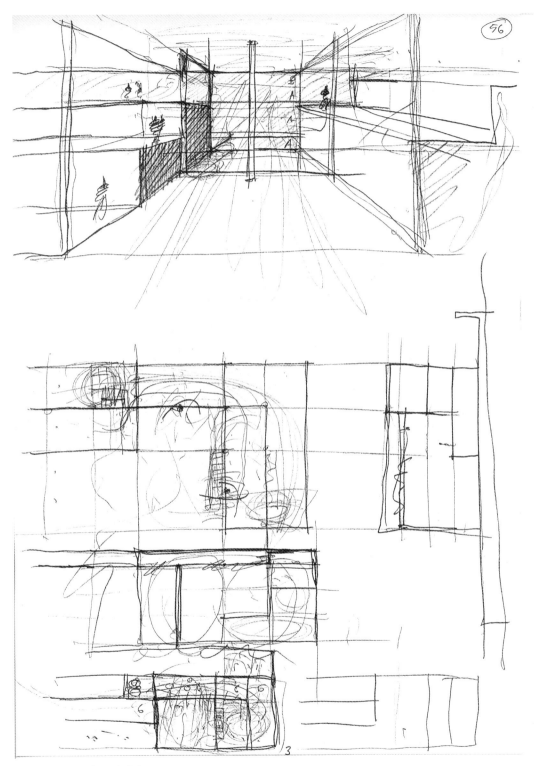

Schematic design sketches

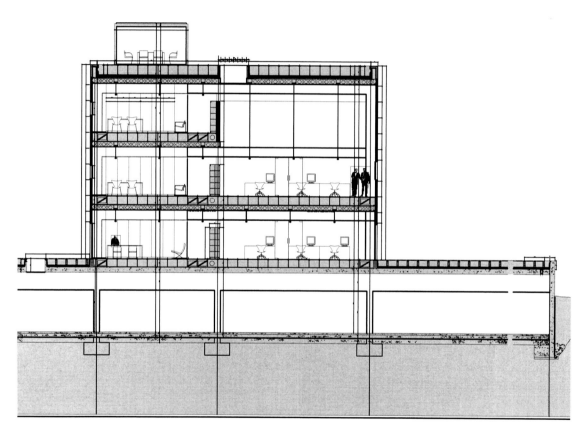

Section

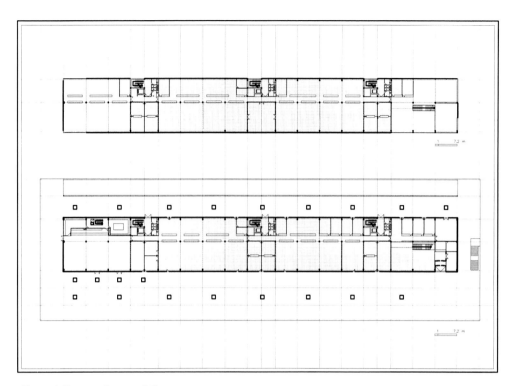

Ground floor and second floor

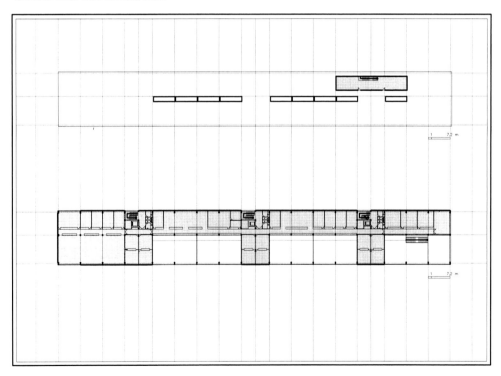

Roof floor and third floor

0 5 10

Archi-Tectonics

Winka Dubbeldam is an architect and principal of
Archi-Tectonics, a firm established in New York in 1994.
The studio operates like a laboratory, placing special
emphasis on the importance of research and development
as essential to the design process, and using computer
technology as an active ingredient. In this respect, the
computer becomes a tool that generates designs rather
than merely a means of representing them. The dynamic
structures that result are not just three-dimensional
objects, but components for measuring strength,
creating intelligent systems, and organizing the
functional plan. Dubbeldam's work includes residential
and commercial projects as well as real and virtual
designs for urban projects, architecture, installations,
and publications.

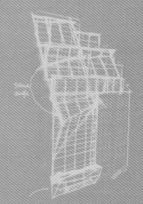

☐ SoundScape

☐ Greenwich Street Project

Tectonics

SoundScape Washington DC, USA, 2003

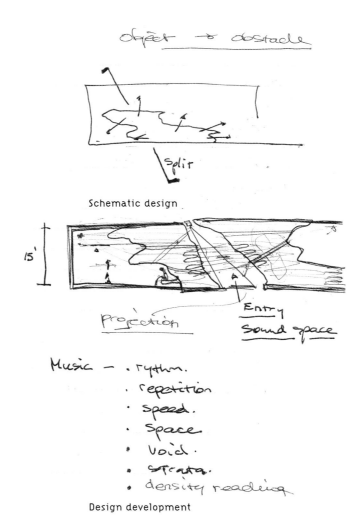

object → obstacle

Split

Schematic design

15'

Projection

Entry
Sound space

Music — · rythm.
· repetition
· speed.
· Space.
· Void.
· Strata.
· density reading

Design development

This project is the result of an invitation to a collective exhibition, "Masonry Variations," arranged by the National Building Museum in Washington, D.C., that explored new applications, techniques, and expressions of the use of masonry in architecture. The project took an historical look at light architecture, especially membranes, and came up with a composition that used sound and abstraction of shape as a point of departure. It includes a series of solid, soft volumes developed in Maya—an animation program that converts sound frequencies into forces that distort the surfaces of solids, generating spaces such as the soundscapes.

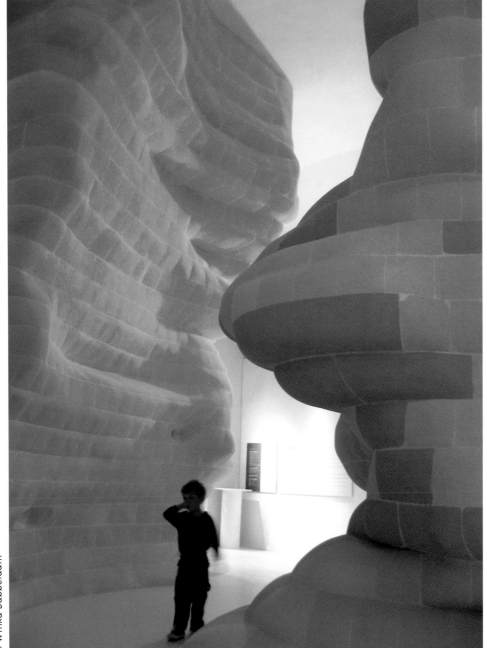

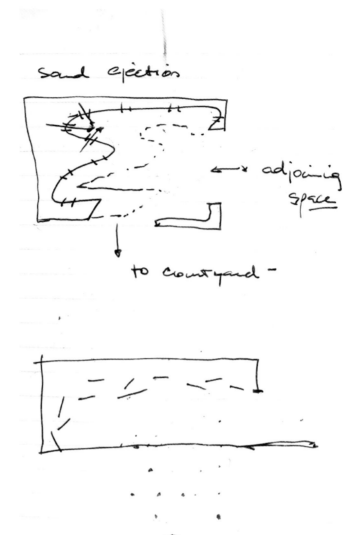

sound ejection

←→ adjoining space

to courtyard —

Schematic design

Sound frequency study

Construction documentation

Deformation process

Interior models

Exterior models

■ Archi-Tectonics

Greenwich Street Project New York, NY, USA, 2004

The characteristic trait of this project, located in New York's SoHo district, is an innovative made-to-measure glass skin covering an old brick building that has been converted into residential lofts. The transparent structure was achieved with curved panels of one-of-a-kind insulating glass, creating a transitional zone between the glass and the existing building, which was used to install a series of balconies and create an interesting dialogue between the old and the new.

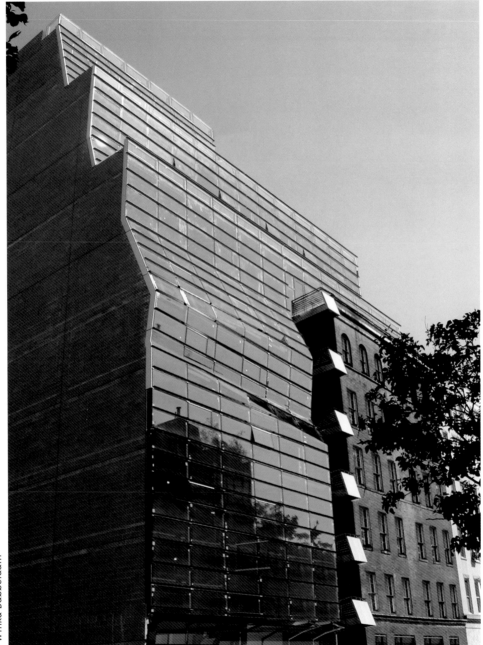

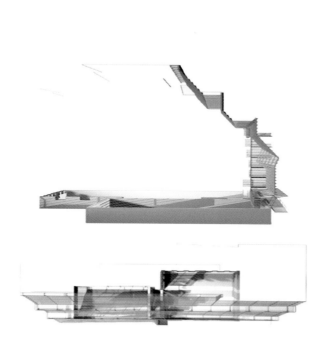

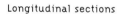

Longitudinal sections

Axonometric perspective

Axonometric study

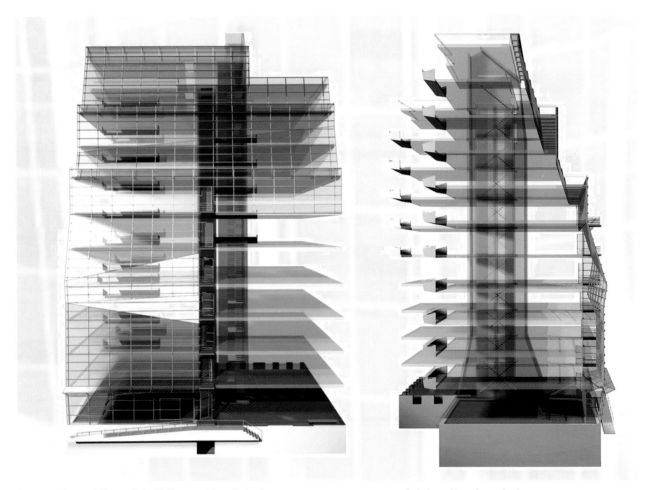

Perspective cut through building sectional shadow Point sectional rendering

AMP Arquitectos

AMP Arquitectos is a team established in 1981 by Felipe Artengo Rufino, Fernando M. Menis, and José María Rodríguez-Pastrana Malgón. Their work has focused on the Canary Islands area and includes public buildings and private residences as well as landscaping. One of their most important buildings is the Seat of the Government of the Canary Islands. Their concern that the building fit in with the physical location and its history gives the structure its definitive aesthetic. The daring combination of materials and careful research into their use, along with clear geometric play, are characteristic of these architects' work.

AMP

Arquitectos

Seat of the Government of the Canary Islands Santa Cruz de Tenerife, Spain, 1999

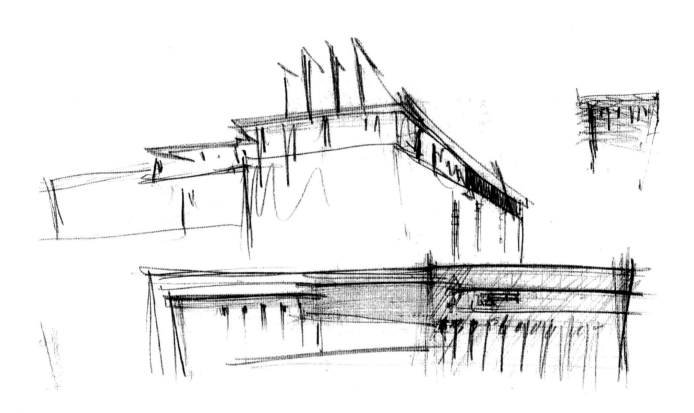

The Seat of the Government of the Canary Islands, located in a district that dates back to the city's founding, has become a new urban reference in Santa Cruz de Tenerife. Two axes intersect and create spaces: a central crater and a horizontal passageway. Basaltic rock and concrete are the building's most distinctive features, while its geometric shape contrasts with the irregularities of the rough terrain.

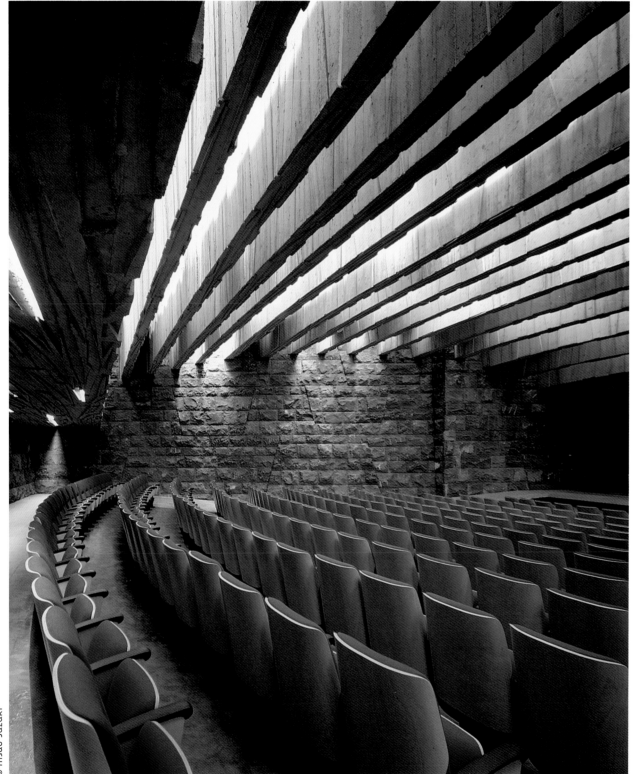

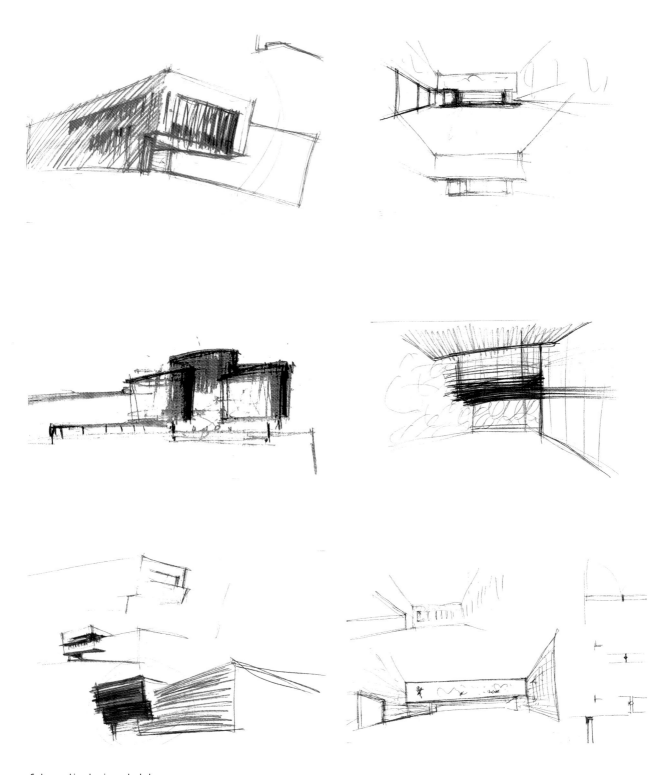

Schematic design sketches

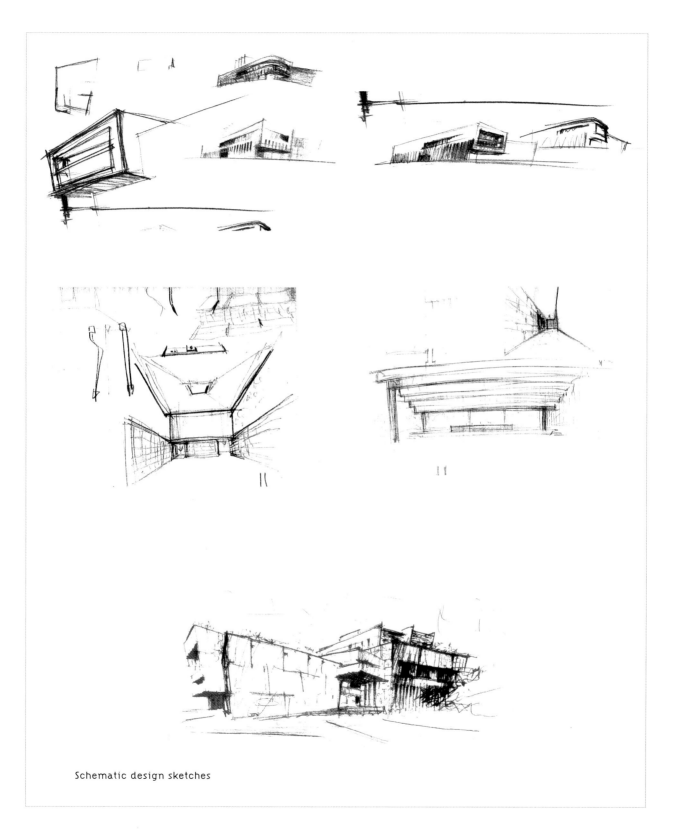

Schematic design sketches

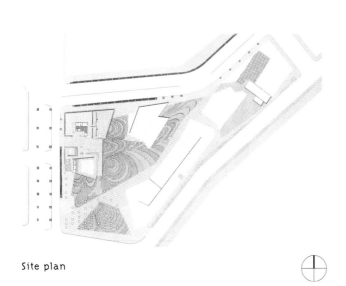

Site plan

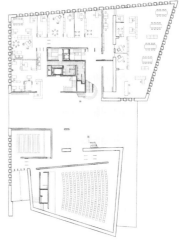

Floor plan

0　5　10

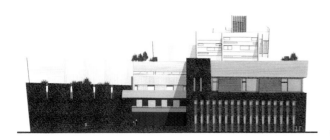

East elevation

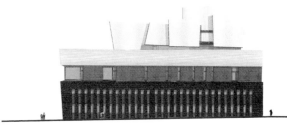

North elevation

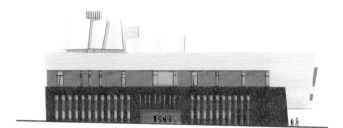

West elevation

South elevation

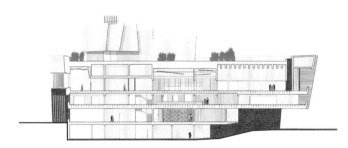

N to S transverse building section

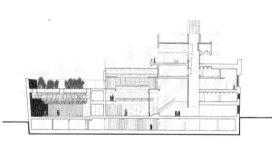

S to N transverse building section

Extension of the La Orotava Acclimatization Garden La Orotava, Tenerife, Spain, 1999

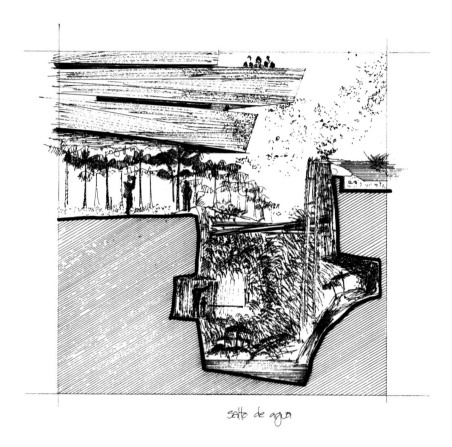

salto de agua

This garden's objective is to educate the public about the tropical ecosystems most representative of the Americas. The project involves a tour of these ecosystems and extends from urban to rural settings, beginning and ending in the historic garden. Expansion of the garden provided an additional 375,000 sq. ft. to supplement its exhibitional, educational, socio-cultural, and scientific functions. Gently sloping ramps placed among the flowerbeds of the old nursery join the pre-existing garden with the new one.

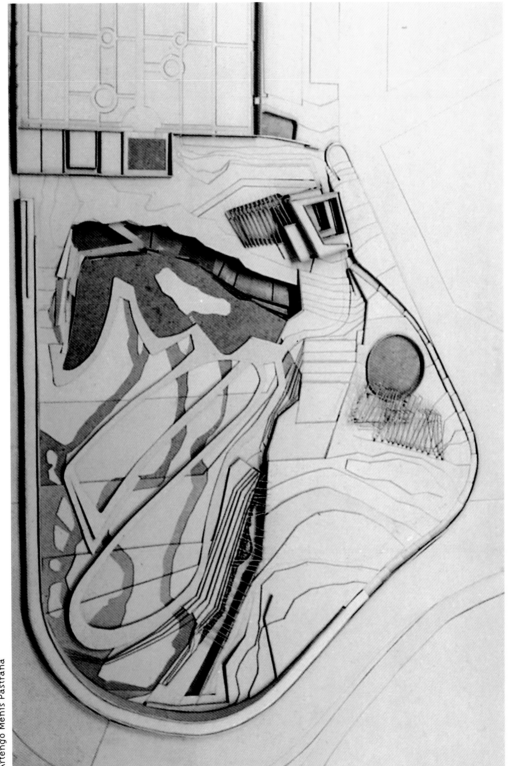

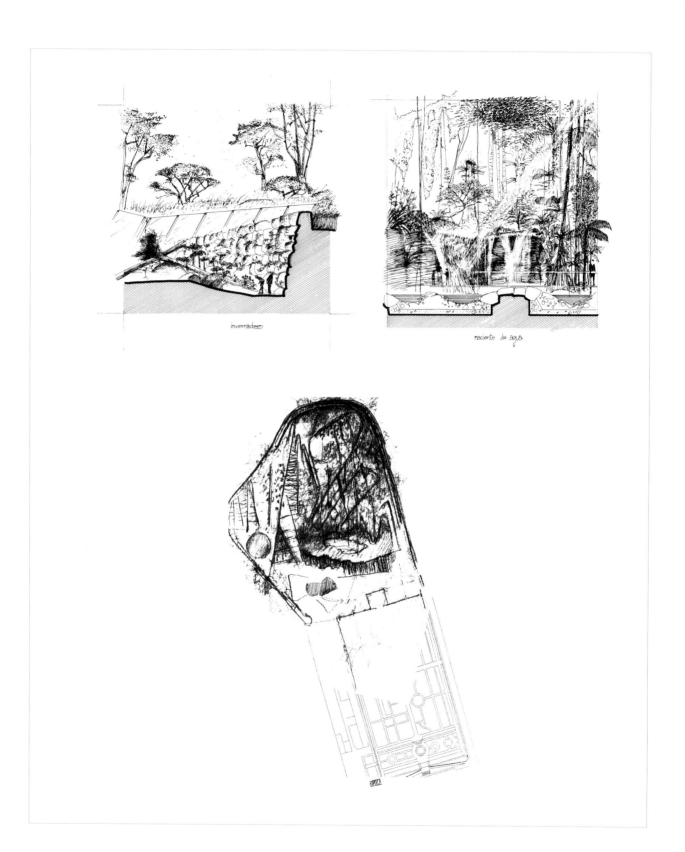

invernadero

naciente de agua

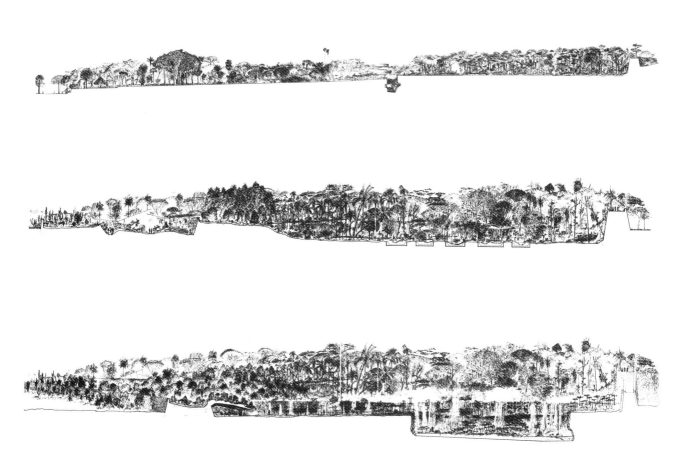

Sections

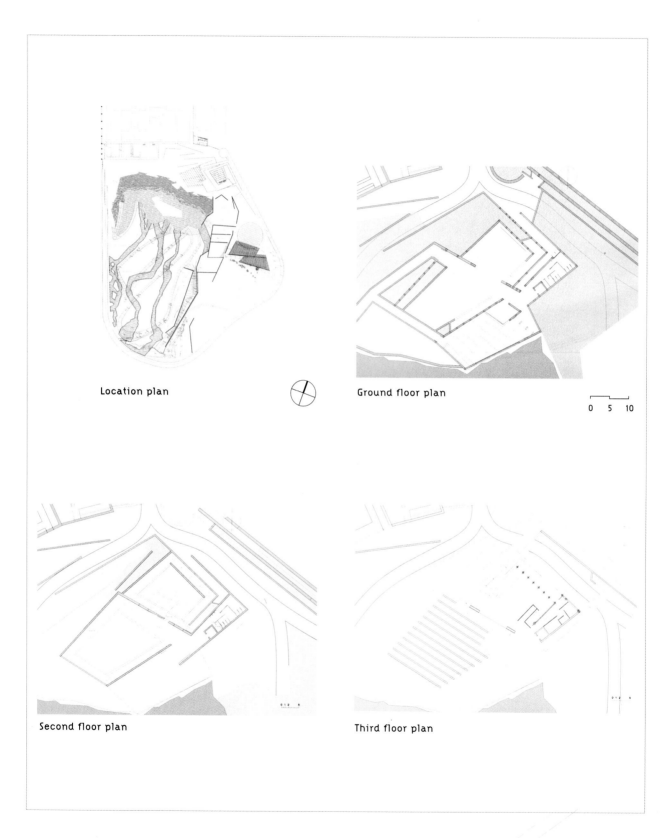

Location plan

Ground floor plan

0 5 10

Second floor plan

Third floor plan

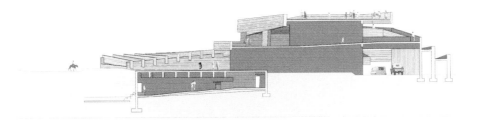

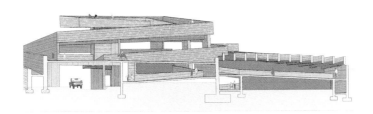

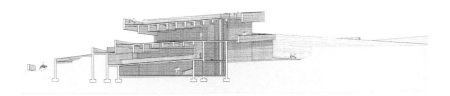

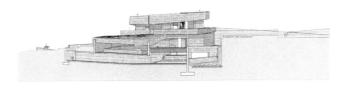

Sections

Tenerife Sur Convention Center Costa Adeje, Tenerife, Spain, 1998

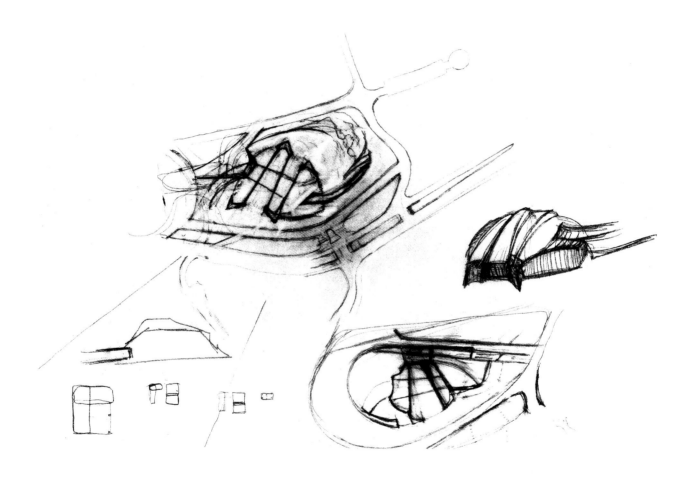

The Tenerife Sur Convention Center is located near the sea in a vast semi-desert area filled with a local type of volcanic rock known as "chasnera." This terrain inspired the architects to create the geometric shapes, integrated into the landscape, that comprise this building. The roof of plant fiber panels is like flowing liquid, thanks to the placement of the gaps between them, which divide and multiply, producing cracks for light and ventilation and intensifying the sensation of weightlessness on the surface.

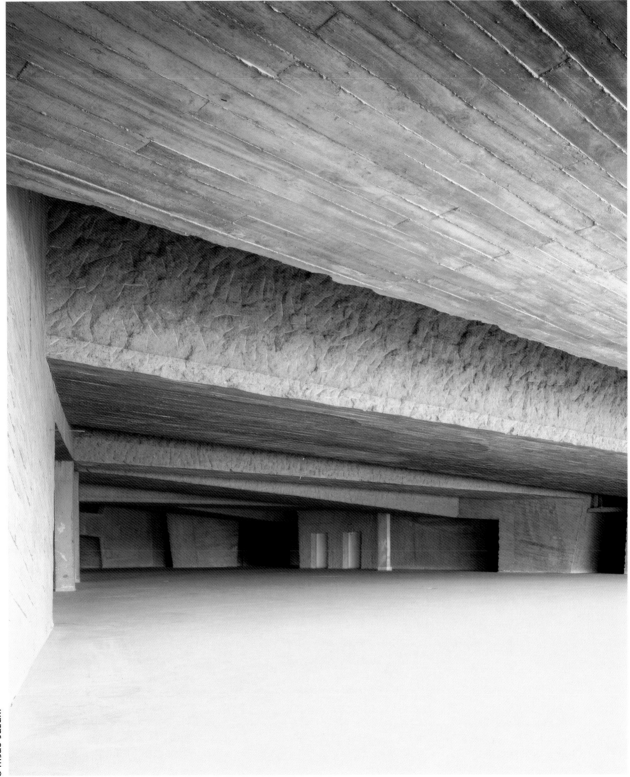

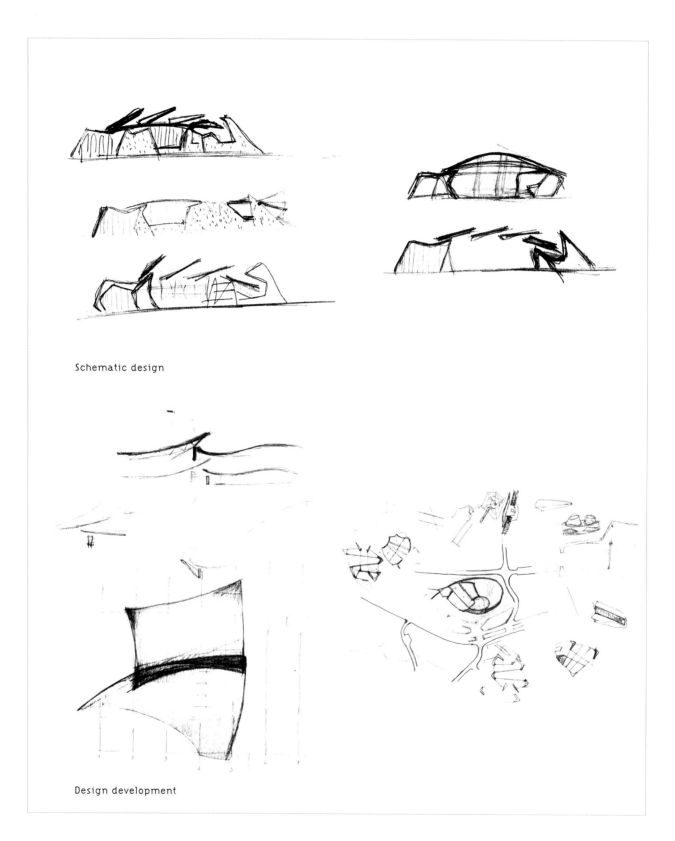

Schematic design

Design development

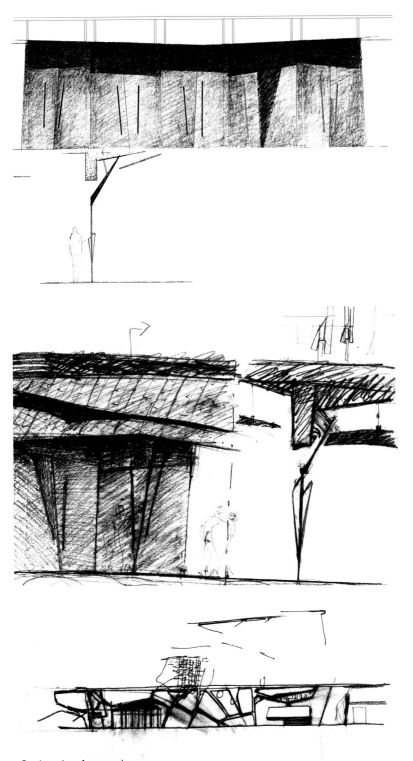

Design development

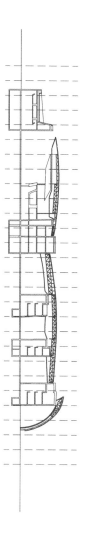

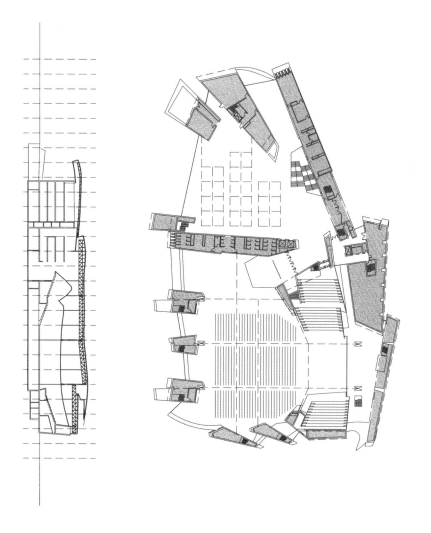

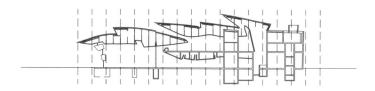

Plan and sections

0 5 10

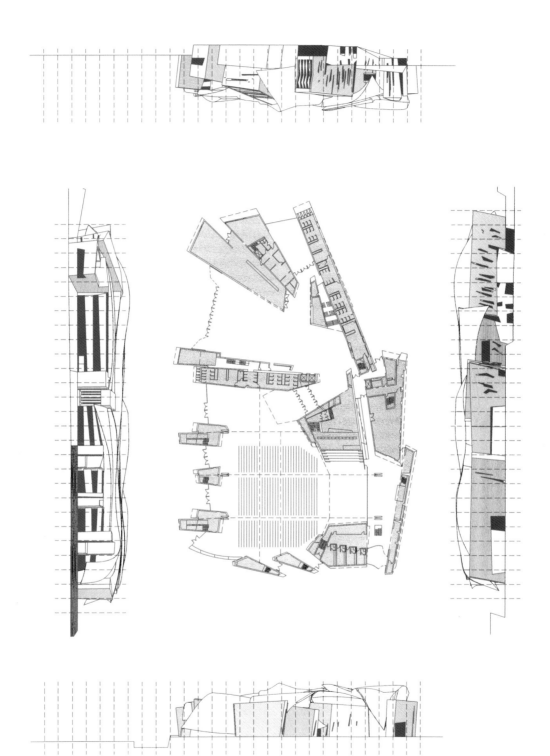

Plan and elevations

Asymptote

Asymptote is an architectural and interior design firm established in New York in 1988 by Hani Rashid and Lise Anne Couture. Its recent work has earned national and international recognition in several fields: furnishings, interior design, architecture, and urban design. This work extends to and is exemplified in physical and virtual projects as well as temporary installations. Their recent works can be found all over the world: the Univers Theater in Denmark, the Library of Alexandria in Egypt, the State Theater in Russia, and the Tohoku Historical Museum in Japan.

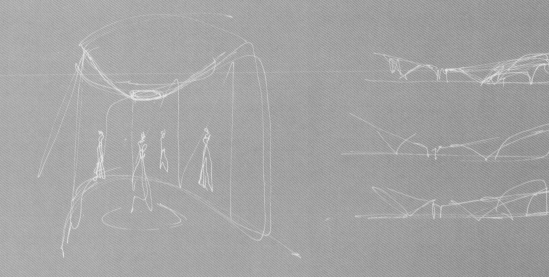

☐ Carlos Miele Flagship Store

☐ Hydra Pier

tote

Carlos Miele Flagship Store New York, NY, USA, 2003

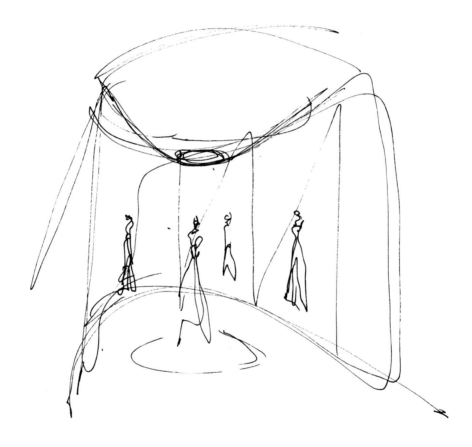

The architecture and interior design of this New York store generates a dual image in which contemporary concepts mix with more traditional aspects of Brazilian culture. This arrangement is based on the ideas of the fashion designer who owns the store, and combines the objectives of the locale, as both a point of sale and a sophisticated space for showing off the label's latest collections. The interior configuration is achieved through a series of curved lines that define the different display areas and other spaces. Computer-generated drawings were fundamental to both design and construction.

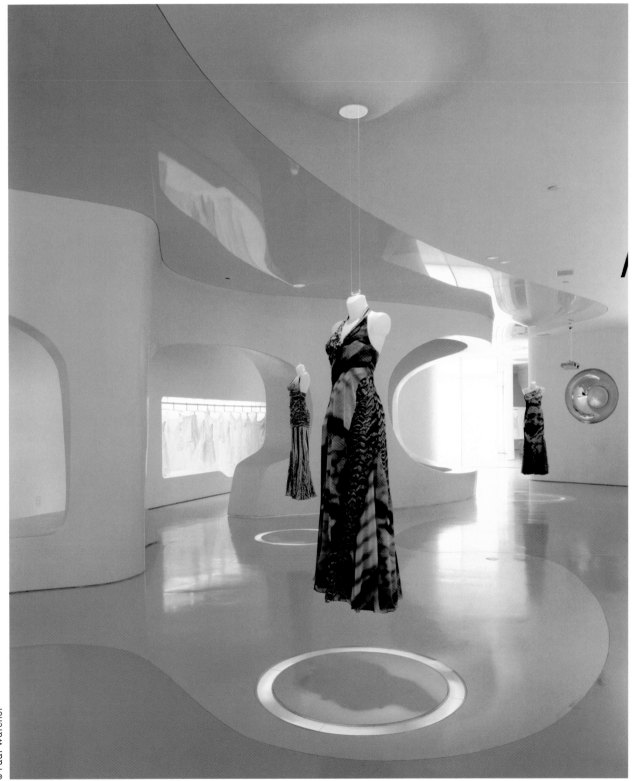

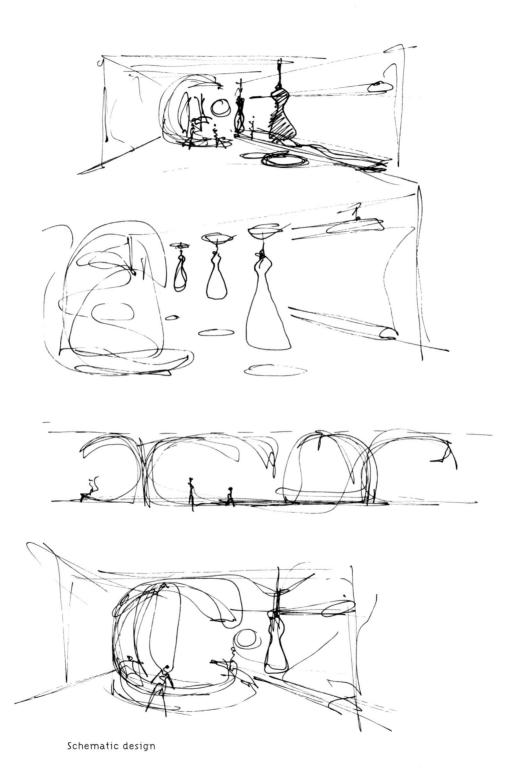

Schematic design

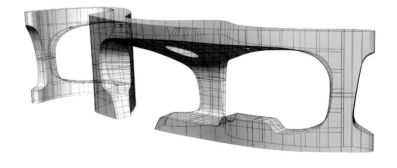

Three-dimensional models

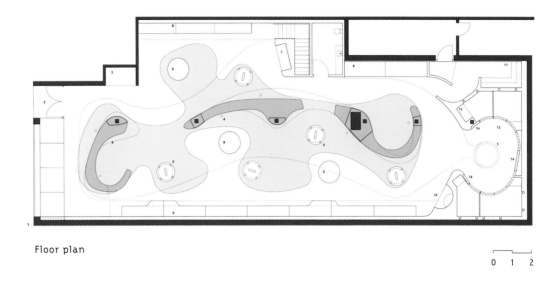

Floor plan

0 1 2

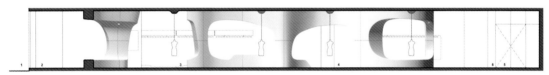

Longitudinal section

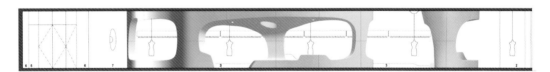

Longitudinal section

Transverse section

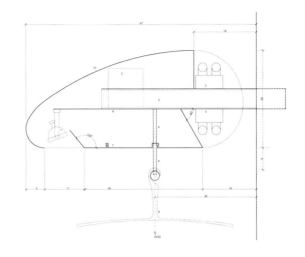

ARCHITECTURAL METAL CASEWORK, SHOP
PAINTED W/ LAQUER FINISH

STAINLESS STEEL CUSTOM HANGER

WOMEN'S CLOTHING

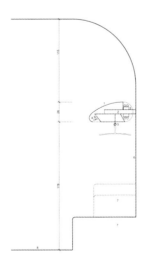

Construction details

■ Asymptote

Hydra Pier Haarlemmermeer, The Netherlands, 2002

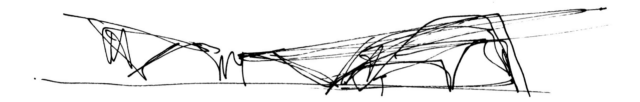

Haarlemmermeer, adjacent to the Amsterdam Schipol Airport in the Netherlands, is the site of the 2002 Floriade horticultural exposition. Asymptote was the team competitively selected to design and build the main municipal pavilion, the purpose of which was to promote the city of Haarlemmermeer as a vital, fast-growing urban setting. The pavilion housed several exhibits, mainly multimedia, during the expo, and was designed to subsequently accommodate various public and private events. The design uses the constant air traffic over the site and the endless vehicular traffic on the nearby highway as formal referents.

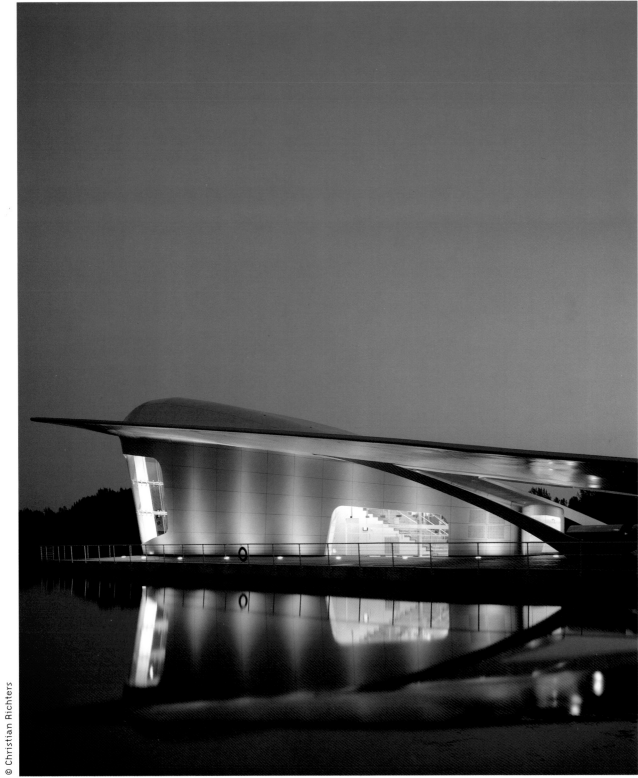

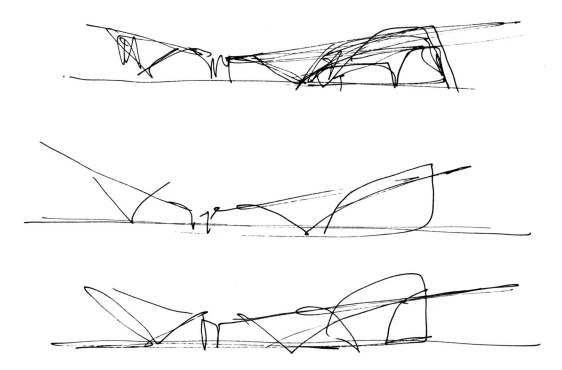

Schematic design

Sections study

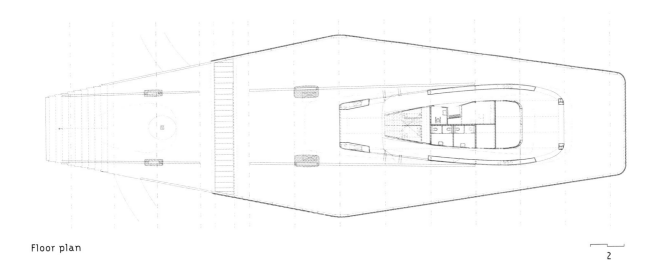

Floor plan

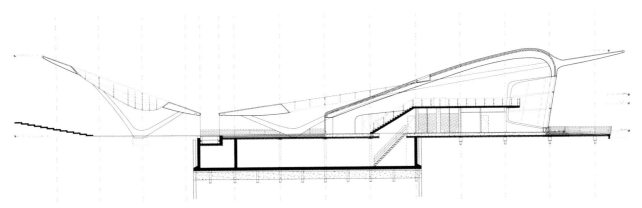

Longitudinal section

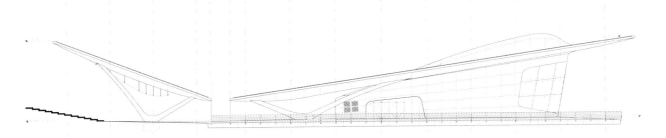

Longitudinal section

Bolles + Wilson

Julia B. Bolles-Wilson was born in Münster, Germany, where she studied architecture at the Technische Hochschule Karlsruhe. She later studied at the Architectural Association of London. Peter L. Wilson was born in Melbourne, Australia and studied architecture at the University of Melbourne and the Architectural Association of London. He worked as an assistant in the offices of Elia Zenghelis and Rem Colas and went on to found, with Julia B. Bolles, the Wilson Partnership in London (1980). In 1989 the firm relocated to Münster, East Germany, and their work has since gained international renown. The two combine their work as architects with teaching, having been guest professors at Europe's most famous schools of design.

☐ New Luxor Theater

☐ LB Dom North Neighborhood

☐ RS + Yellow Furniture

Wilson

Bolles + Wilson

New Luxor Theater Rotterdam, the Netherlands, 2001

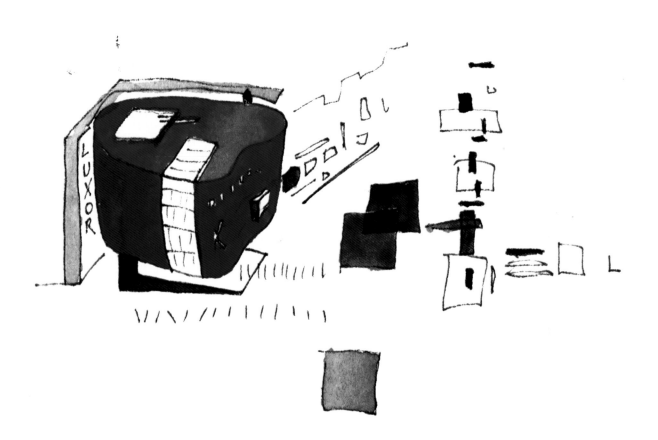

The New Luxor Theater is located in Kop van Zuid, a new urban development on Rotterdam Bay, overlooking the Maas River and Rijn Harbor. The building has multiple orientations and a single exterior wrapping facade that integrates the view from any angle. The building's size— it accommodates 1500—and varied composition based on transparent acoustic elements make it resemble a large musical instrument. The wood panels lining the interior of the main auditorium create a warm, intimate atmosphere.

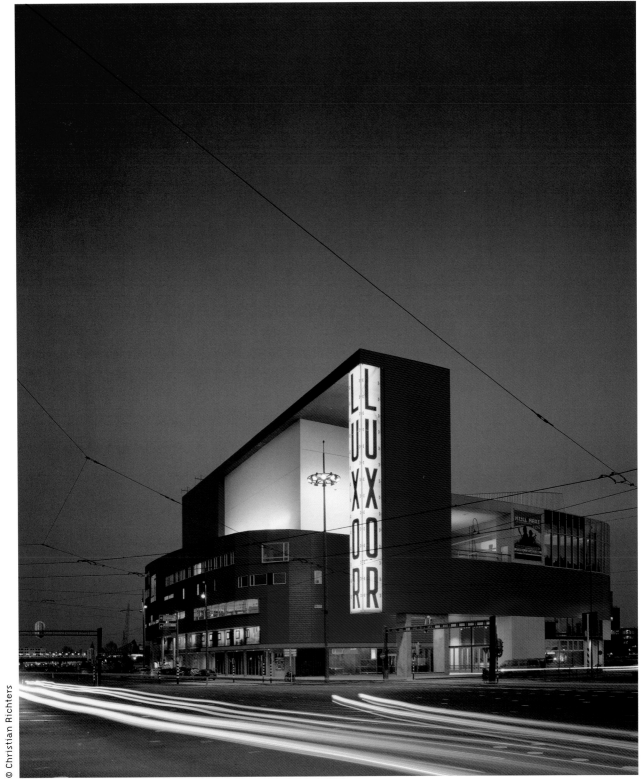

LIJKEN OP EEN GROTE ROEIBOOT

Schematic design renderings

Schematic design renderings

Schematic design renderings

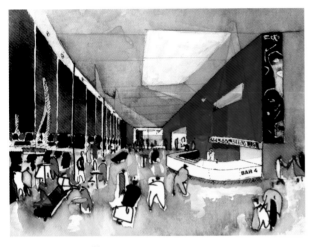

Interior perspectives

Interior perspectives

Interior perspectives

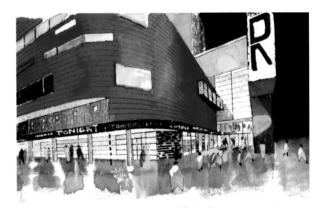

Exterior perspectives

Interior perspectives

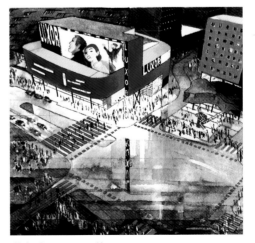

Exterior perspectives

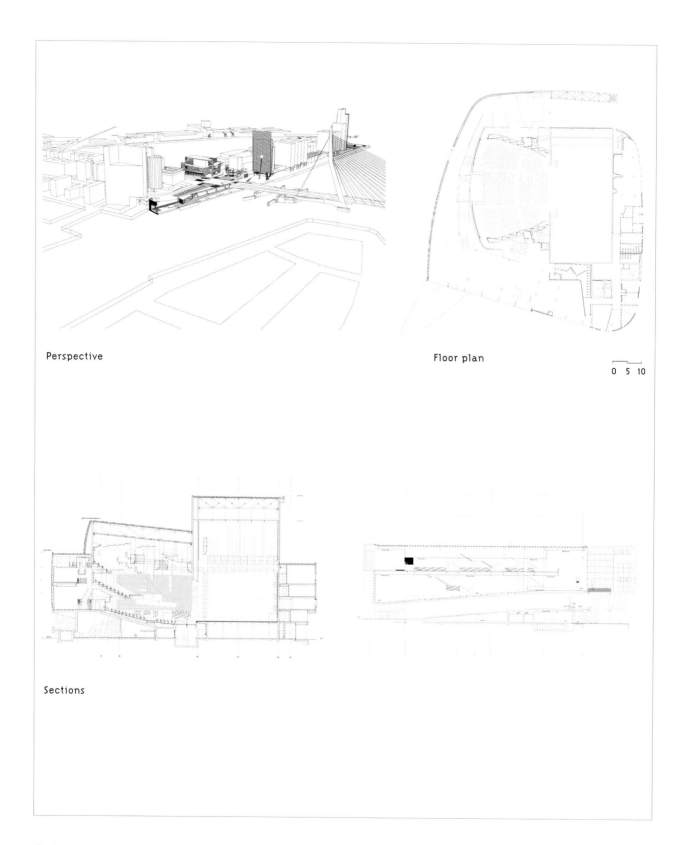

Perspective

Floor plan

0 5 10

Sections

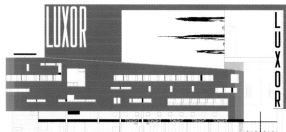

Elevations

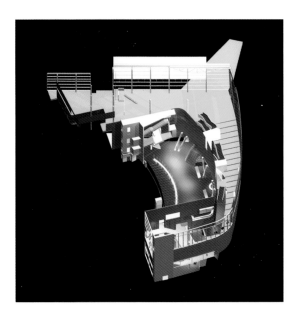

Point sectional model

Chair detail

LB Dom North Neighborhood Magdeburg, Germany, 2002

This project, encompassing a bank, a chamber of commerce, offices, shops, and restaurants, adjoins the Magdeburg Cathedral, the oldest Gothic cathedral in Germany. The grouping of buildings in this plaza is noteworthy for its nobility and for its extremely heterogeneous character. The blocks that comprise the commercial and office complex are divided into three long units which highlight and frame the view of the Cathedral, creating a sequence of scenographic external and internal spaces, with meaningful details, strict geometry, and poetic spots.

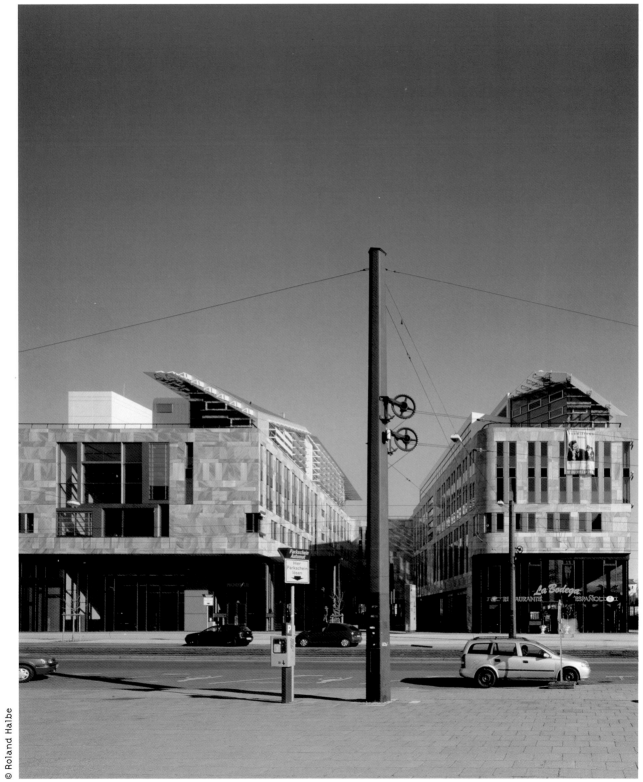

Schematic design sketches

Interior perspective (design development)

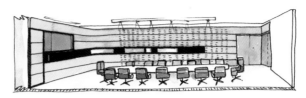

Interior perspective (design development)

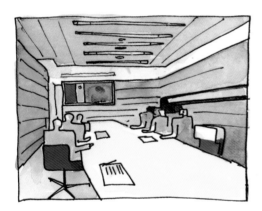

Interior perspective (design development)

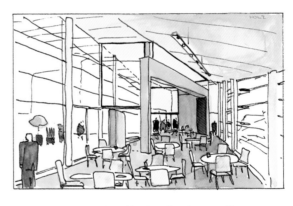

Interior perspective (design development)

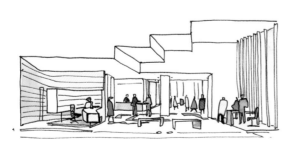

Interior perspective (design development)

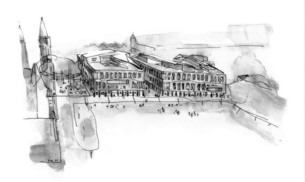

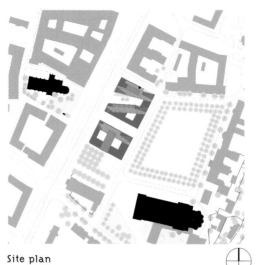

Site plan

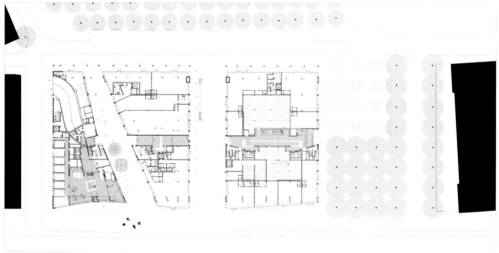

Ground floor plan

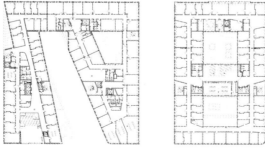

Type plan

0 5 10

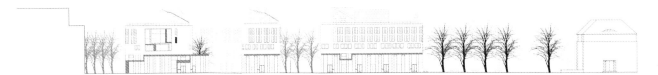

Elevation

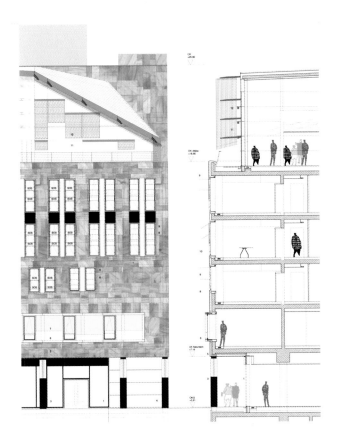

Detail of elevation and section

RS + Yellow Furniture Magdeburg, Germany, 2002

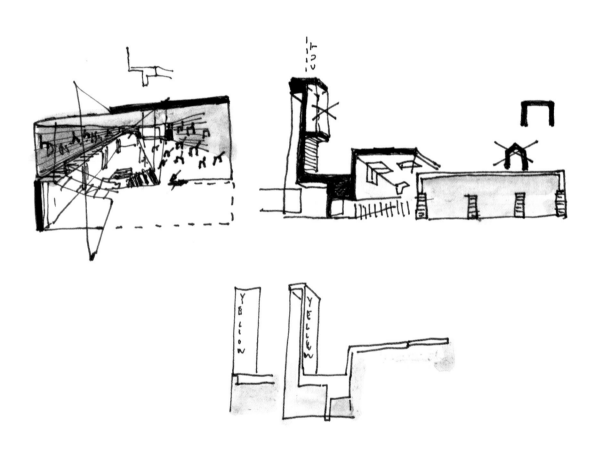

The architects themselves define this building as "a stage for buying." The typical facade of a point of sale, generally located on the outskirts of a city, is reinterpreted to adapt it to a decidedly urban setting. The building houses the sales outlets for three brands, a large warehouse, and a shipping area with its own parking lot. An advertising tower was placed at one end of the building to lure business and as a way of interacting and combining with the urban environment, playing with the towers of the nearby church and fire station.

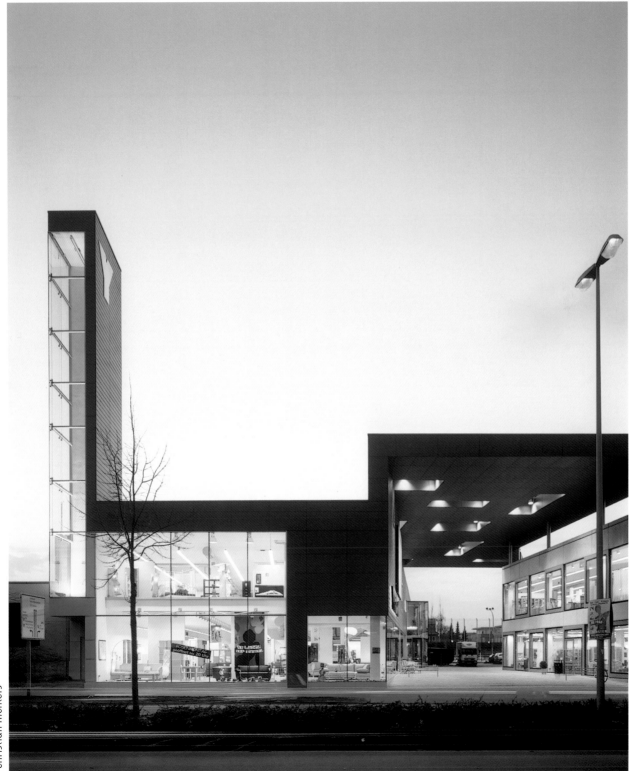

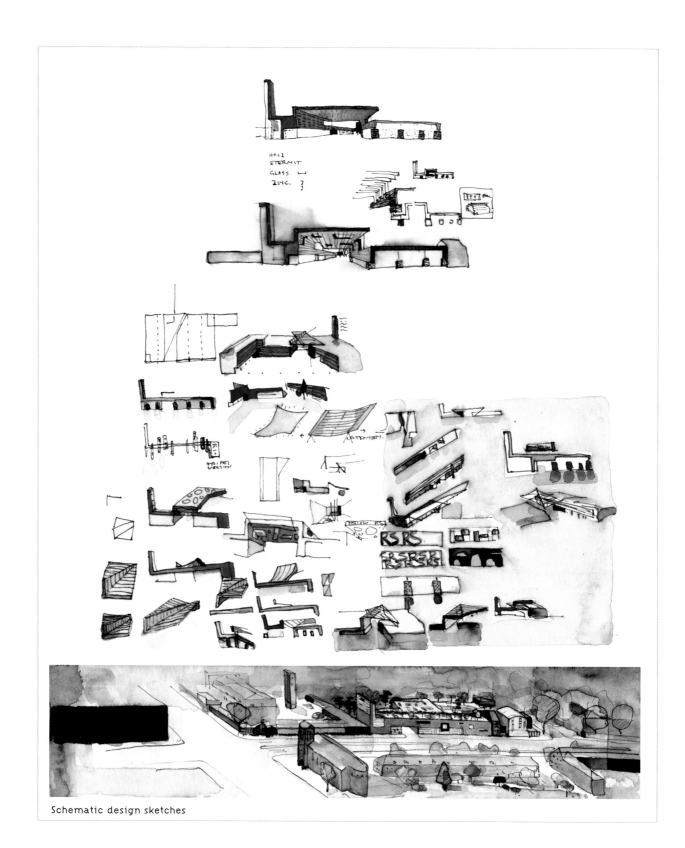

Schematic design sketches

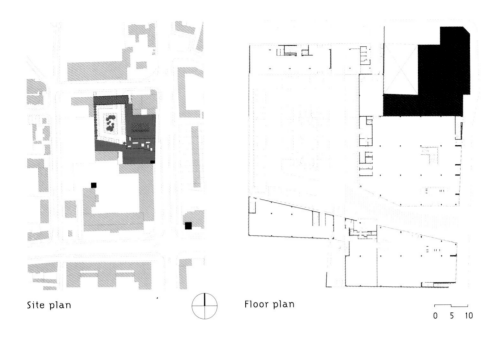

Site plan Floor plan

0 5 10

Elevation

Longitudinal section

Longitudinal section

César Pelli

César Pelli was born in Tucumán, Argentina. In 1977 he became Dean of Yale University's School of Architecture. In that same year, he founded César Pelli & Associates in New Haven. His vast body of work has earned him international recognition, including eight monographs devoted to his projects and theories. He has received several awards from the American Institute of Architects (AIA). In 1989 César Pelli & Associates received the Firm Award; in 1990 he was named one of the 10 most influential architects of the Americas, and in 1995 he received the AIA Gold Medal. The firm now has more than 80 people working on corporate, government, and private projects. Its wide range of projects includes everything from airports and educational complexes to hotels, offices, and residential buildings. The number of assignments the firm accepts is carefully limited to ensure that the staff assigned to the project have a high level of personal commitment.

César

☐ National Museum of Art, Osaka

☐ Extension of the Pacific Design Center

Pelli

National Museum of Art, Osaka Osaka, Japan, 2004

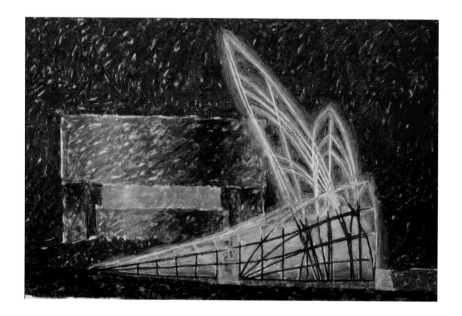

The National Museum of Art is located in Osaka, on the island of Nakano, between the Tosabori and Dojima Rivers. Once situated on the outskirts of the city, the museum operators chose this strategic position as a gateway to this growing hub of art and culture. A key part of the city's revitalization, the museum building forms a large plaza where exhibitions are held and people gather. The building, comprised of three stories below ground level, was erected on a tight plot adjacent to the Science Museum.

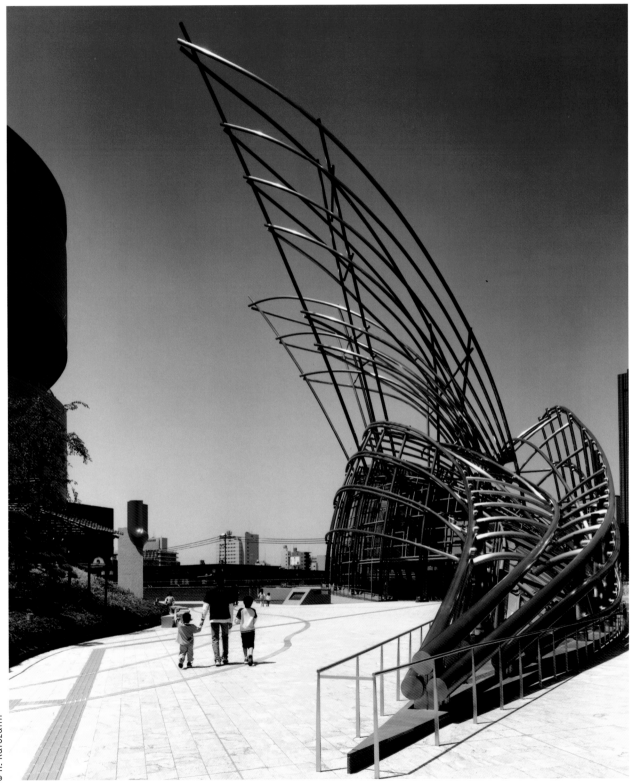

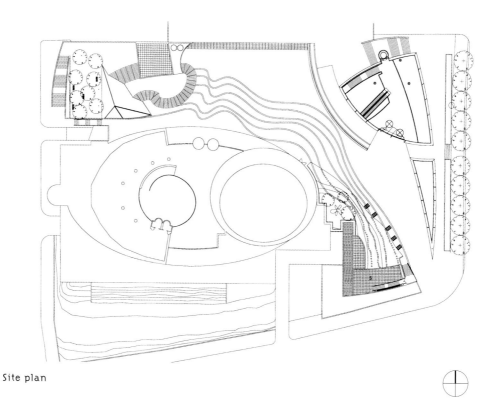

Site plan

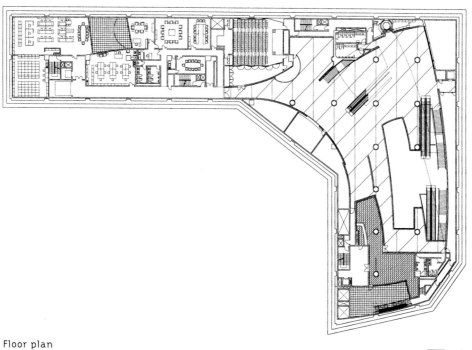

Floor plan

0 5 10

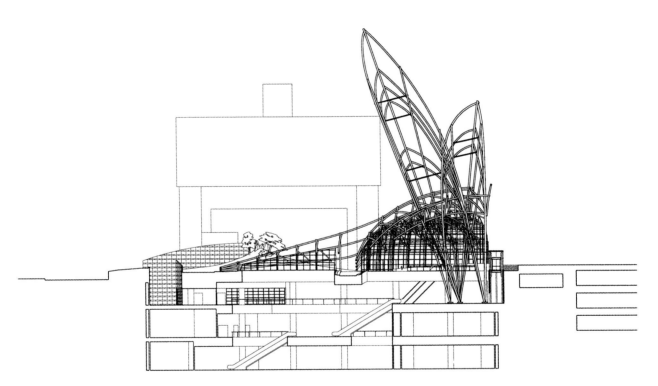

Longitudinal section

■ César Pelli

Extension of the Pacific Design Center West Hollywood, CA, USA, 2003

The Pacific Design Center, affectionately known as the "Blue Whale," was designed by César Pelli when he worked at Gruen Associates. The first phase of the building, located in the heart of the city, contains an exhibition hall for the specialized needs of interior designers, decorators, architects, and merchants in connection with residential design. The second phase, easily distinguishable from the first phase by its green color, expanded the exhibition area and supplemented the plan with a conference center, auditorium, and public plaza.

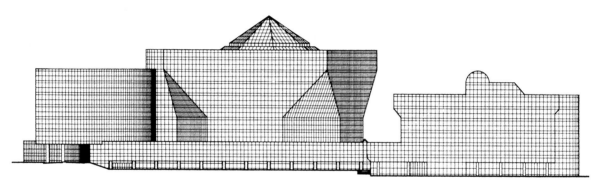

Elevation

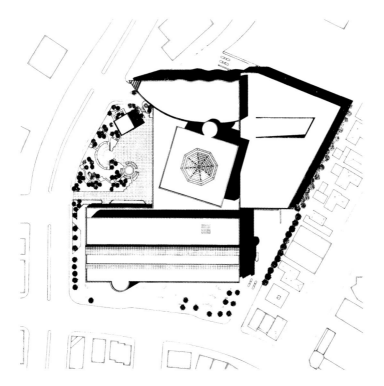

Roof plan

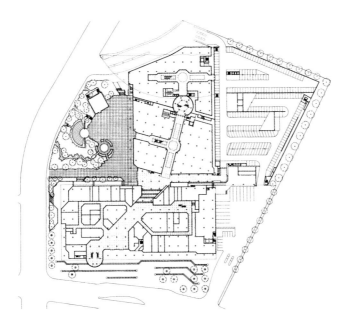

Ground floor plan

0 10 20

Claesson Koivisto Rune

Mårten Claesson, Eero Koivisto, and Ola Rune established this architecture and design firm in 1995. Despite its relative newness, its unique, rigorous approach to design has earned it international recognition. The three architects studied together at the University College of Arts, Crafts, and Design in Stockholm, and went on to study abroad at the Parsons School of Design in New York and the Southwark College of Art & Design in London. The firm's passion for arts and crafts is reflected in the careful construction details and in the scope of the projects they undertake, which range from large buildings to furniture design.

Koivisto Rune

Kråkmora Holmar House Kråkmora Holmar Island, Sweden, 2003

This project consists of a leisure home for a young family with two small children. Local regu-
lations limit its size to 484 sq. ft. because it is considered a guest house for a main house. And
since the main house is just 26 feet away, the facade facing it is completely closed. But the other
facades are wide open to the splendid views of the Baltic Sea, just 13 feet from the house.

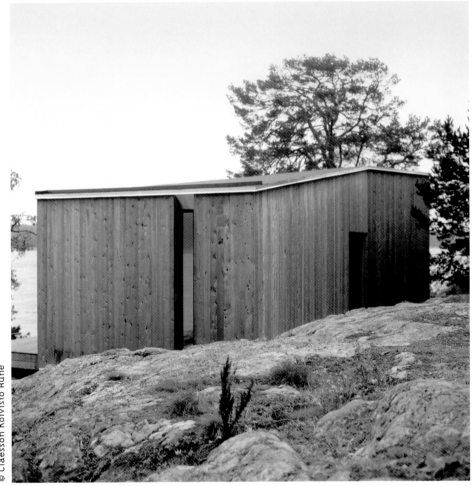

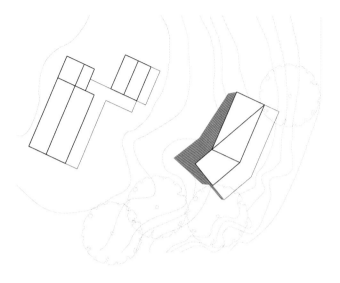

Site plan

0 2 4

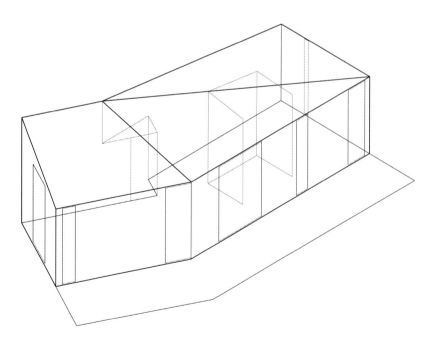

Axonometric

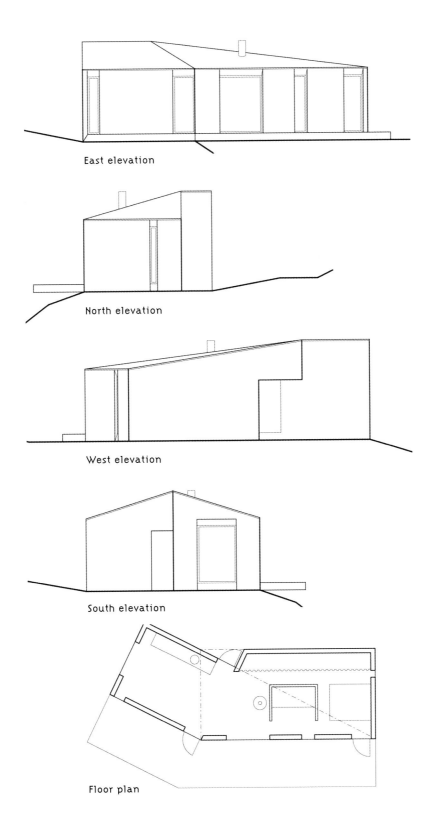

East elevation

North elevation

West elevation

South elevation

Floor plan

No. 5 House Nacka, Sweden, 2003

The point of departure for this house, intended as a home for a graphic designer and his family, was a geometric unit in which the interior and the exterior were equally important. In some ways, it can be thought of as an inverted volume, a box with a series of openings or a space with a series of partitions. The structure is based on a grid, whose dimensions are standard for construction materials, and on which the exterior box is superimposed. The grid subdivides the interior spaces into simple, functional areas.

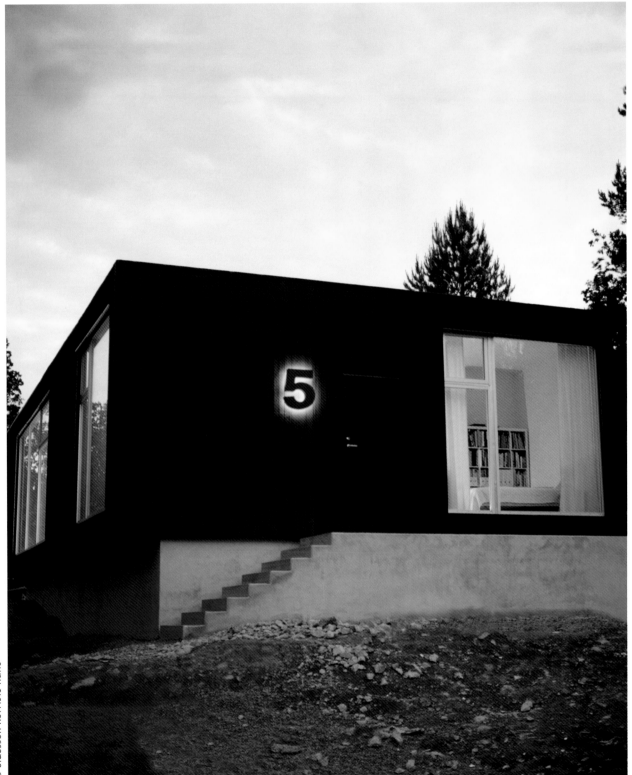

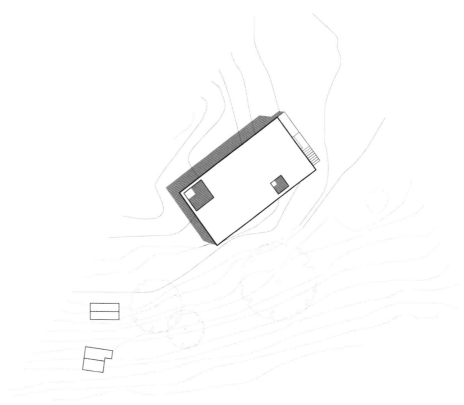

Site plan

0 2 4

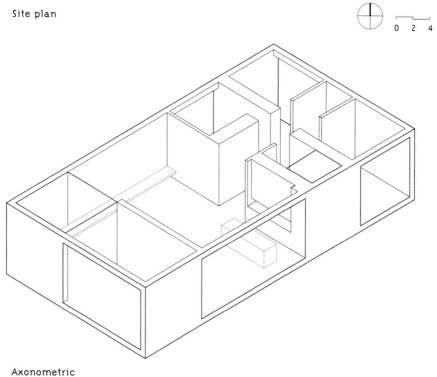

Axonometric

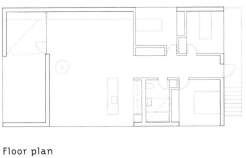

Floor plan

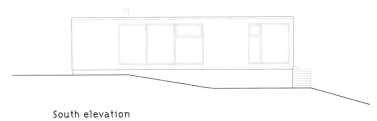

South elevation

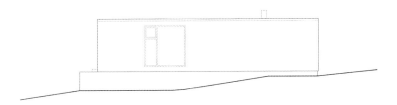

North elevation

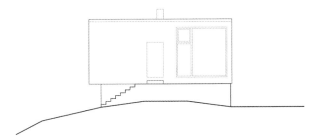

East elevation

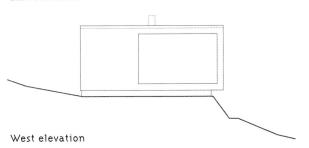

West elevation

Sfera Building Kyoto, Japan, 2003

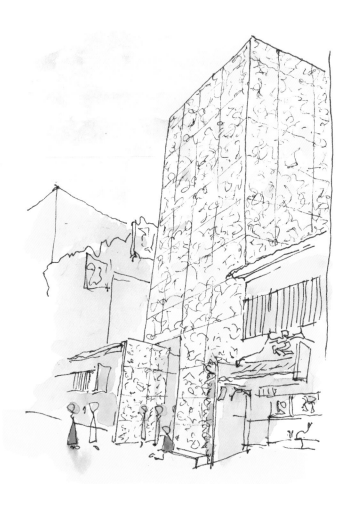

The Sfera building consists of a cultural center that contains an art gallery, bookstore, exhibition hall, and a café and restaurants. It is situated in Gion, Kyoto's famous cultural district. The challenge was to interpret the aesthetic of this traditional district, and at the same time to create a contemporary language. Inspired by traditional screens of bamboo, wood, and paper, the facade contains a pattern of cherry tree leaves. By photographing leaves and the light that shines through them, the designer produced a repetitive pattern that creates a monolithic image for the facade.

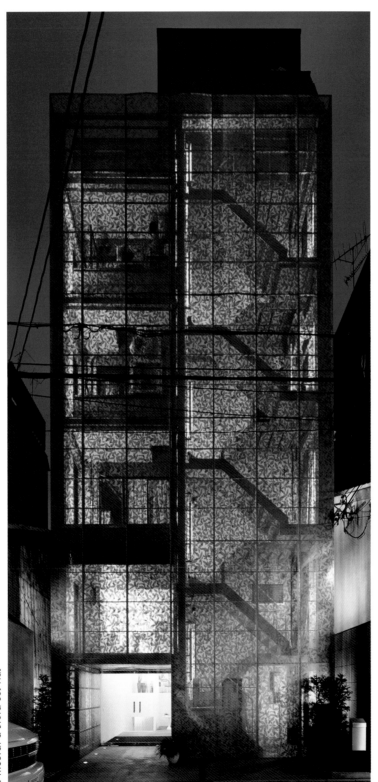

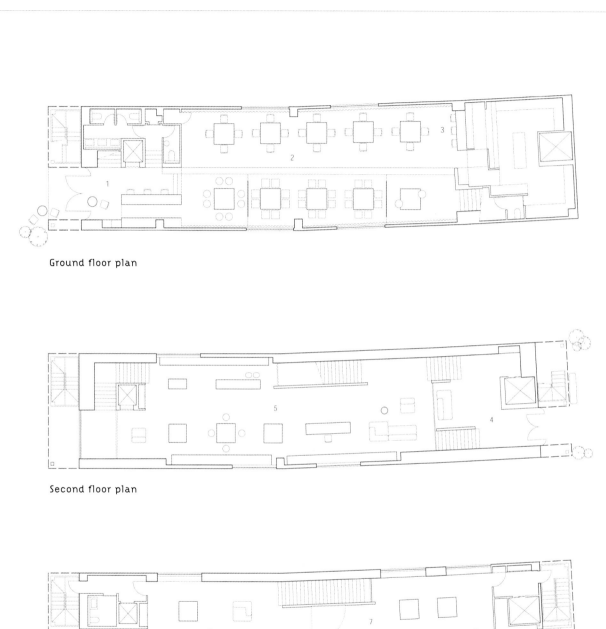

Ground floor plan

Second floor plan

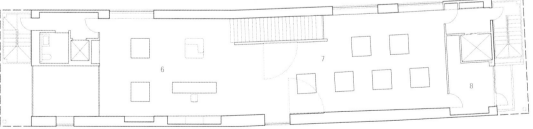

Third floor plan

0 1 2

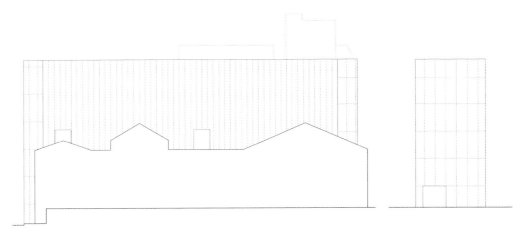

Elevation

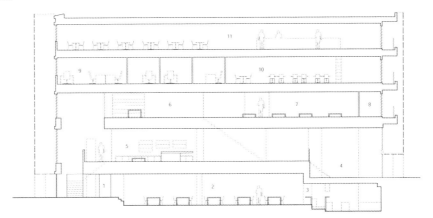

Longitudinal section

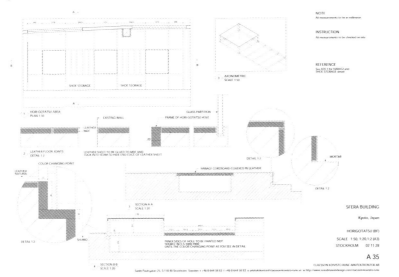

Construction details

Coop Himmelb(l)au

Coop Himmelb(l)au was established in 1968 in Vienna, Austria by Wolf D. Prix and Helmut Swiczinsky. Since then, they have worked in the fields of city planning, architecture, design, and art. In 1988 and 2000, branch offices were opened in Los Angeles, California and Guadalajara, Mexico. Coop Himmelb(l)au has undertaken projects ranging from renovations in Vienna to urban master plans in France. Their work all over the world has won several international prizes and has been the subject of a comprehensive retrospective in 1992 at the Georges Pompidou Center in Paris. The Mexico office is currently working on several projects in Mexico and Bogotá, Colombia.

☐ SEG Apartment Tower

☐ BMW Welt

☐ Confluences Museum

Himmelb(l)au

SEG Apartment Tower Vienna, Austria, 1998

This 200-foot-tall building, two other high-rises, and a student housing complex comprise
Vienna's new Donau City district. The building's 70 apartments range in size from 600 sq. ft.
to 1400 sq. ft. and have open floor plans. The concept of the tower is based on the idea of
stacking two houses to create a common space at the intersection. The shape is a reference
to the specific forces that prevail at the site, such as wind speed and the angles of the sun.

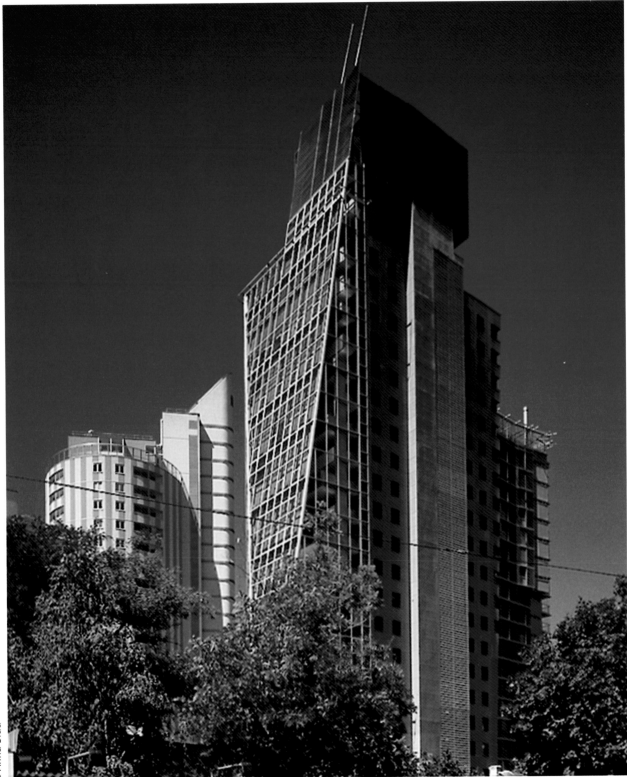

© Anna Blau

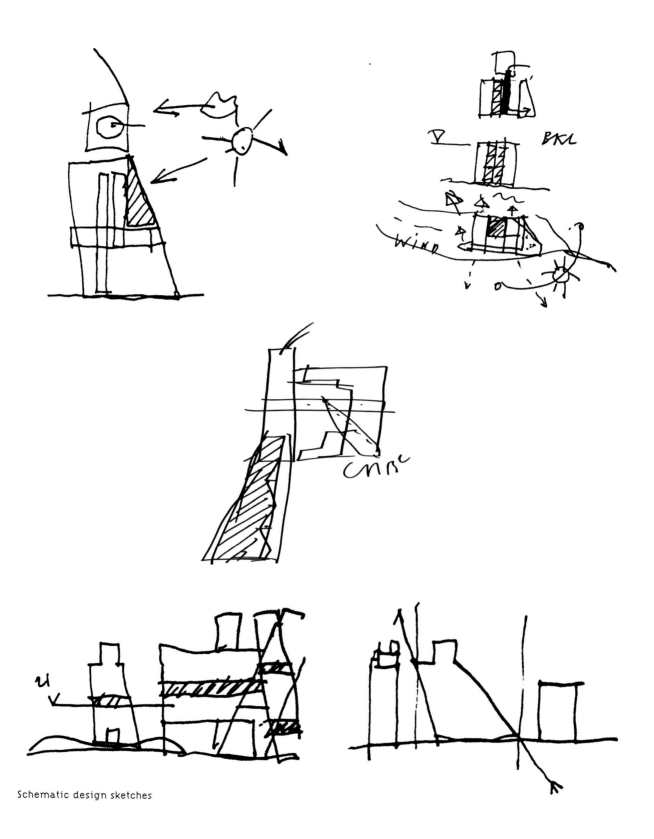

Schematic design sketches

Diagrams of composition

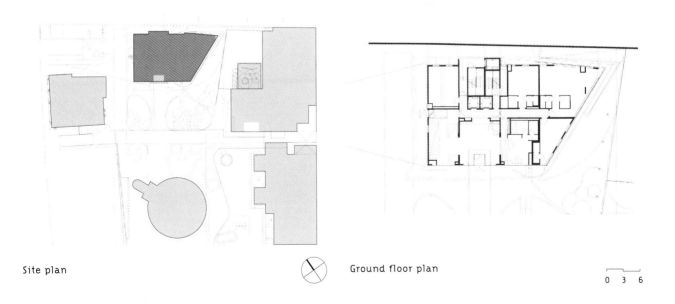

Site plan

Ground floor plan

0 3 6

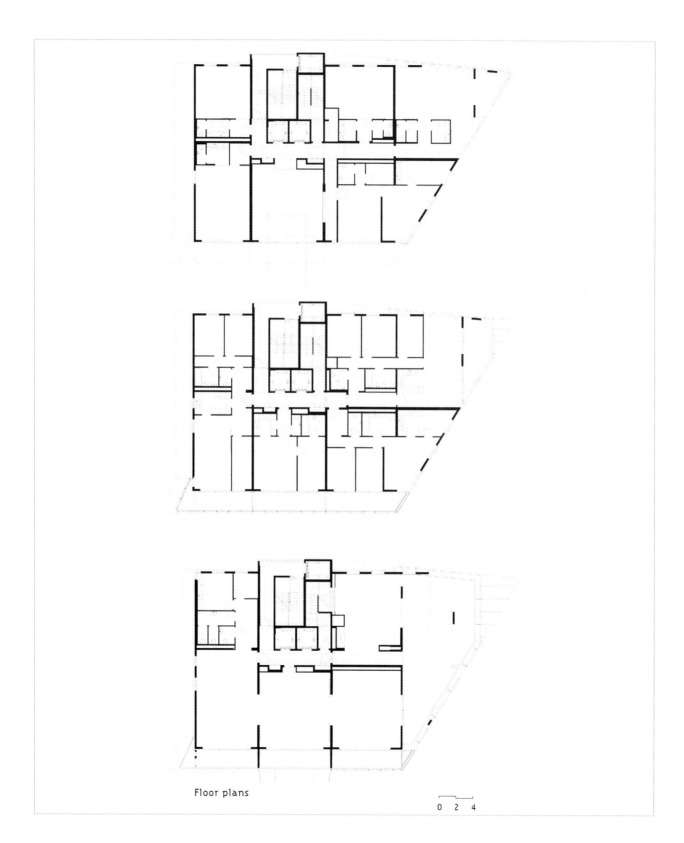

Floor plans

0 2 4

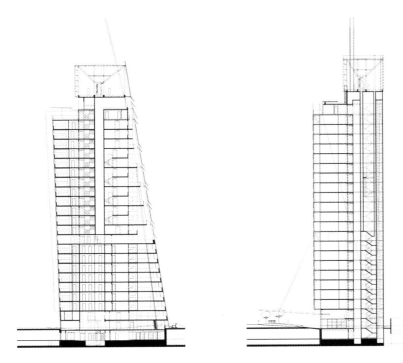

Sections

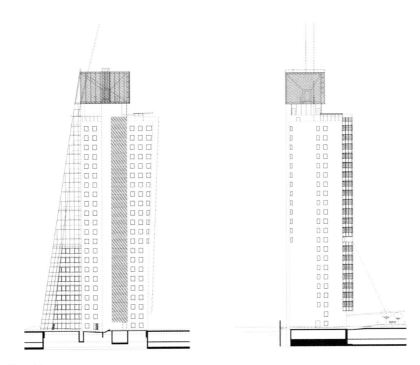

Elevations

BMW Welt Munich, Germany, 2006

The BMW group is planning to open this center, where one can experience and accept delivery of vehicles, between the company's headquarters and Munich's Olympic Complex. The principal element proposed by the architects is a large, permeable hall with a sculptural roof and the double cone, which emerges in relation to the existing headquarters complex. The hall is intended as a place for the locating and commercial exchange of the company's different products, and as a building that symbolizes the trademark. The interior contains a variety of spatial qualities, creating a dense topography with fluid subspaces.

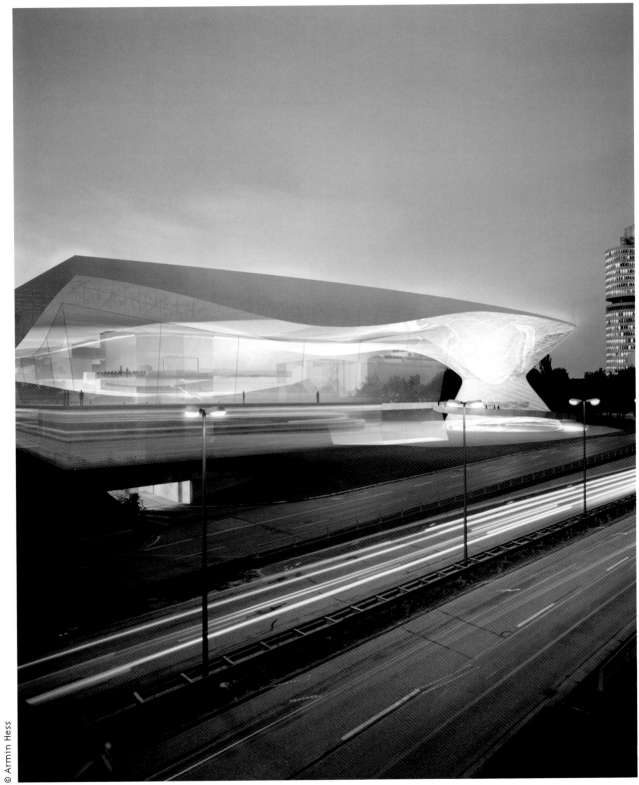

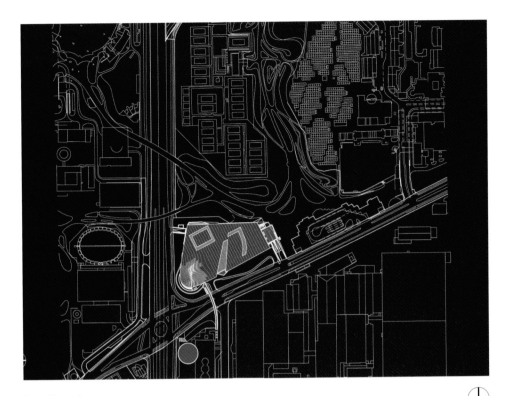

Location plan

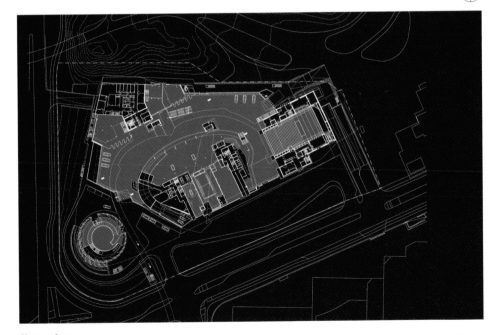

Floor plan

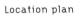

0 10 20

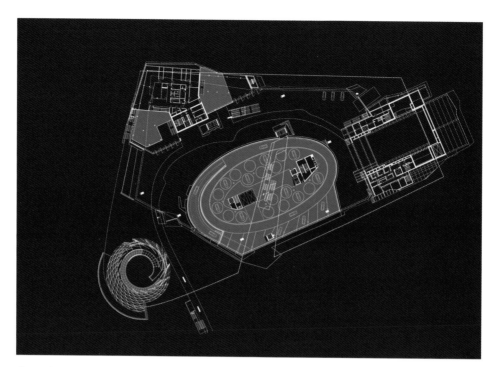

Ground floor plan

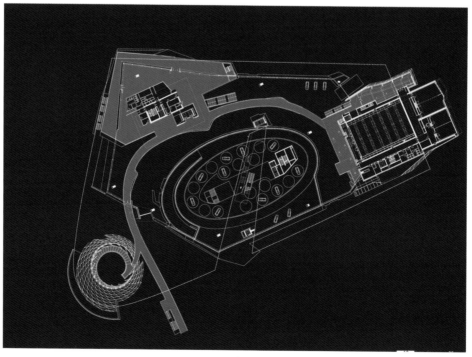

Second floor plan

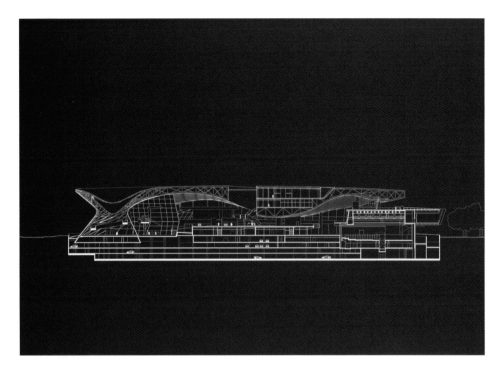

Longitudinal section

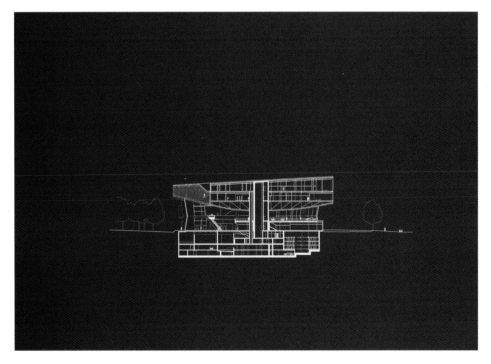

Transverse section

Confluences Museum Lyon, France, 2007

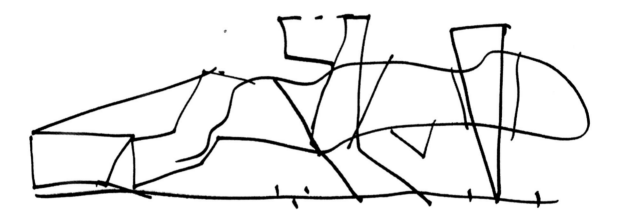

The Confluences Museum is a building emblematic of the evolution of this type of architecture. The approach replaces the idea of a temple of art, intended for a social and academic elite, with a place that encourages public access to knowledge about the times we live in. The building tries to directly and actively stimulate its own use as both a museum and an urban meeting place. It was conceived as a museum to which people will come to spend their free time and be motivated to gain information.

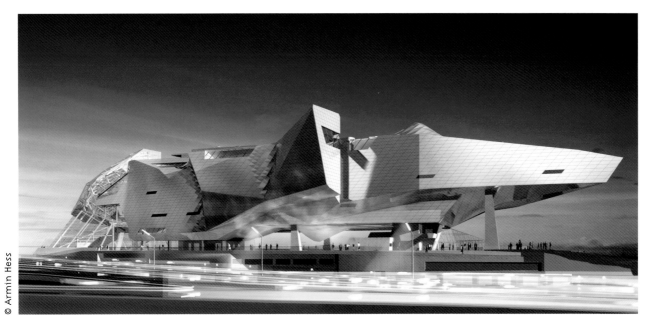

© Armin Hess

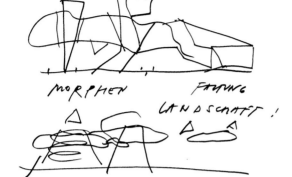

MUTATION D. FORM

MORPHEN FALTUNG

LANDSCHAFT !

RÄUME D. PRODUKT →

RÄUME D. WISSENS

Schematic design sketches

Model rendering

Renderings

Model rendering

Model rendering

Renderings

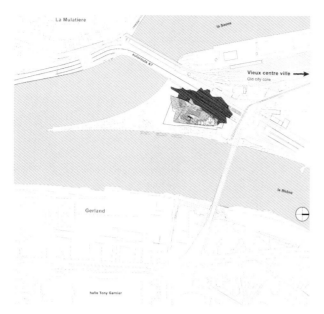

Site plan

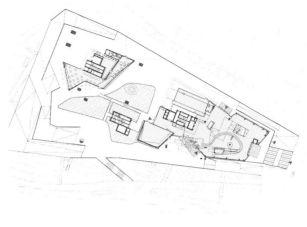

Ground floor plan

0 5 10

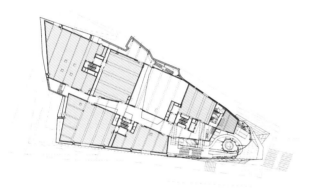

Second floor plan

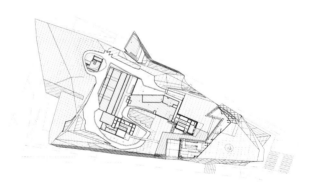

Third floor plan

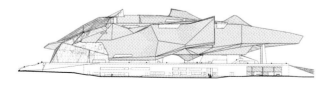

Sections

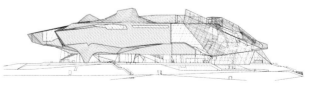

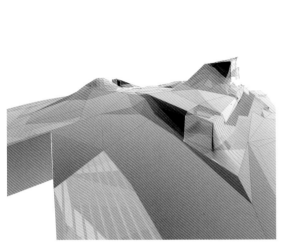

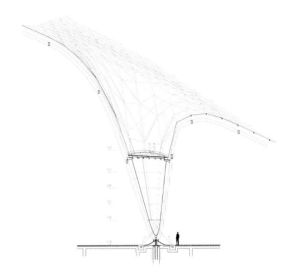

Model rendering

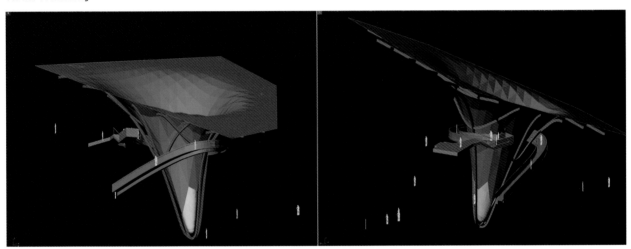

Model rendering

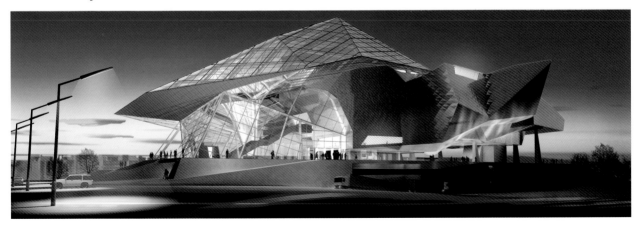

Renderings

Cruz y Ortiz Arquitectos

Antonio Cruz and Antonio Ortiz were born in Seville,
Spain, and both received their architecture degrees from
the Escuela Superior de Arquitectura in Madrid, Mr. Cruz
in 1971 and Mr. Ortiz in 1974. They started working together
in 1971 and, since then, have been involved in a great
variety of projects, widely publicized both nationally
and internationally, winning several prizes and featured
in various exhibitions. They have been guest professors at
the Eidgenössische Technische Hochschule in Zürich, the
Graduate School of Design at Harvard, the School of
Architecture at Cornell, the Ecole Polytechnique Fédérale
in Lausanne, the Escuela de Arquitectura in Pamplona,
and Columbia University in New York.

Arquitectos

Madrid Community Sports Stadium Madrid, Spain, 1994

Situated in the eastern part of Madrid, in an area delimited by highways, this stadium is the jewel in the crown of the Madrid Community sports complex. The designers' solution emphasizes unity and consists of a square platform on which the stadium rests and to which future sports pavilions will be connected. The platform houses the general services, illuminated by a series of courtyards, while the stands resemble an inclined plane that opens up to the field and the surrounding landscape.

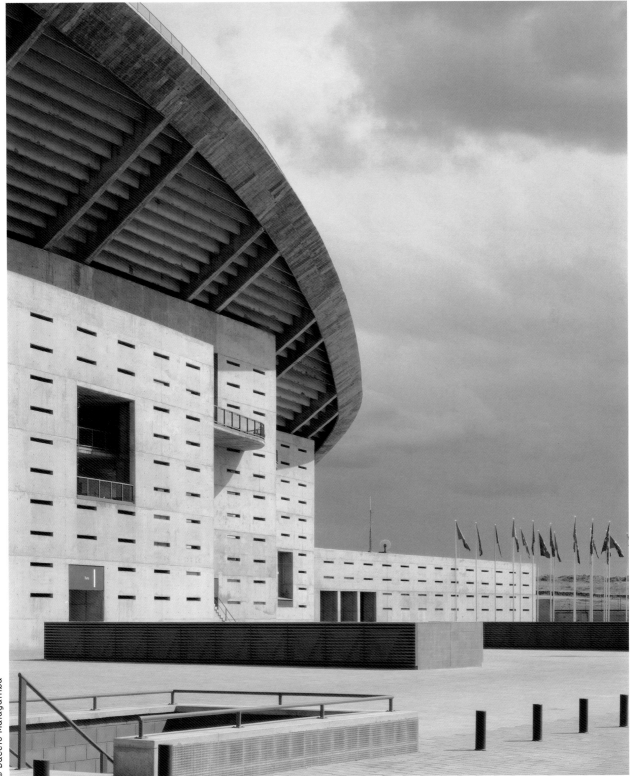

© Duccio Malagamba

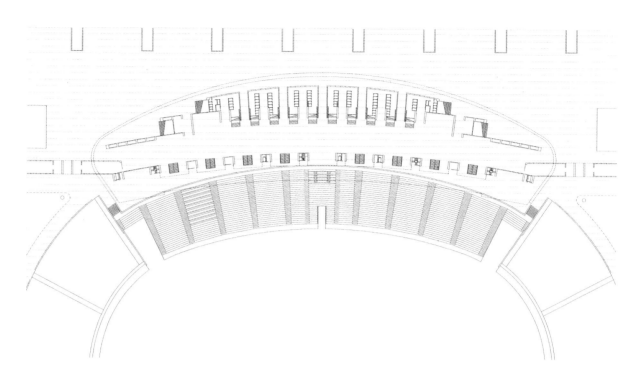

Ground plan

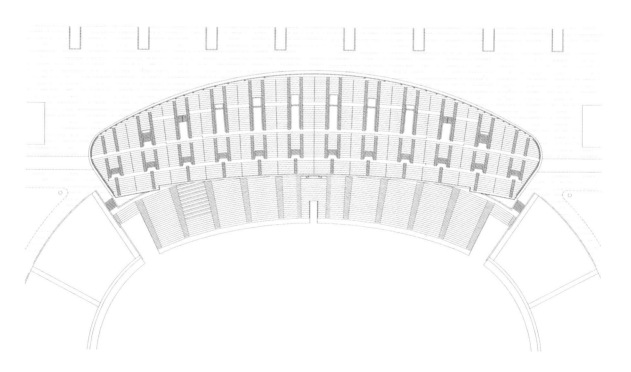

Floor plan

0 5 10

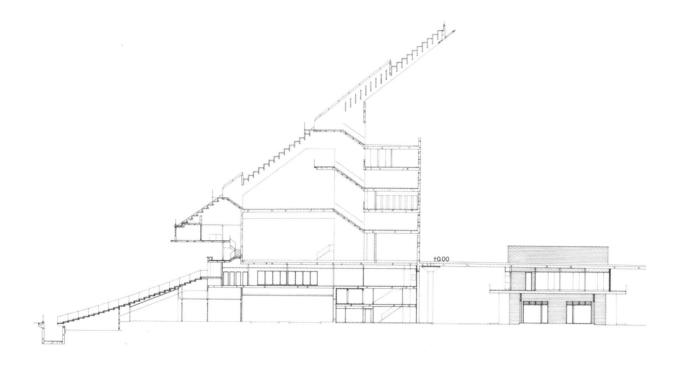

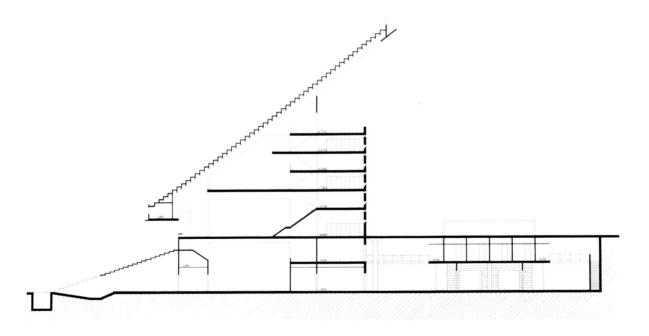

Sections

Spanish Pavilion at 2000 Hanover Expo Madrid, Spain, 1994

In contrast to the excess that can characterize the architecture found at expos, the plan for Spain's pavilion at the 2000 Hanover Expo is based on a message of balance and simplicity. From the outside, the building resembles a prism with broken facades of deeply-fissured natural cork, a hermetic and nearly mute presence. Contrasting with the fragile, uncertain geometry of the volume is the precise, canonical geometry of the interior space. An unexpected, energetic space, its memory remains with the visitor.

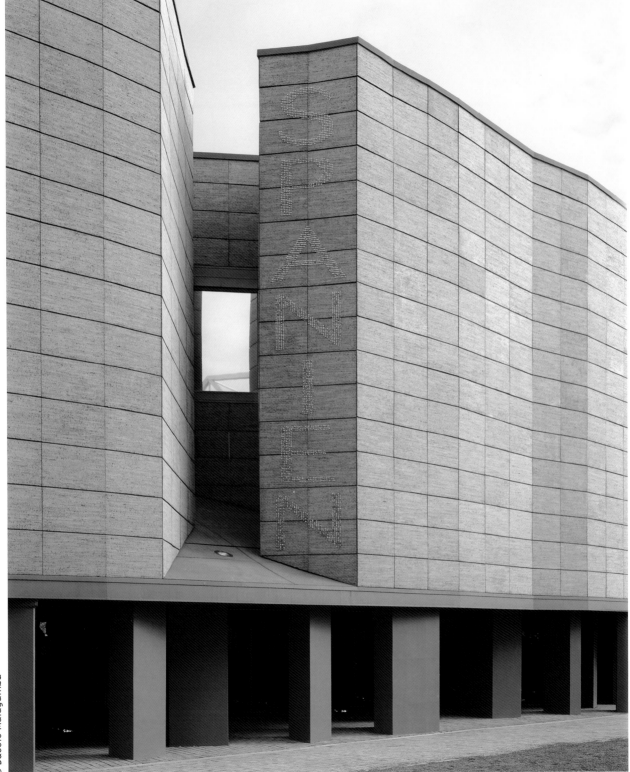

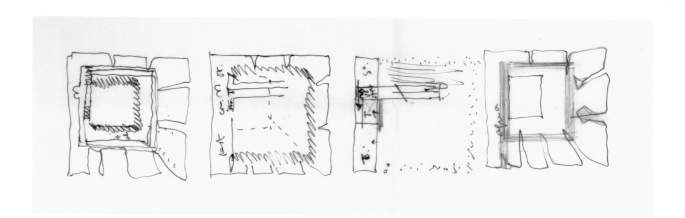

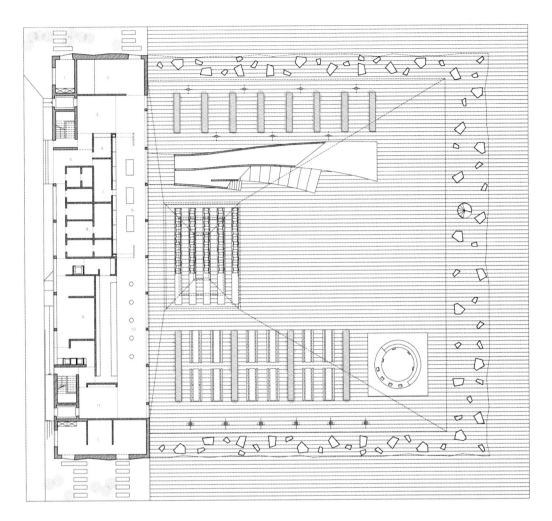

Floor plan

0 2 4

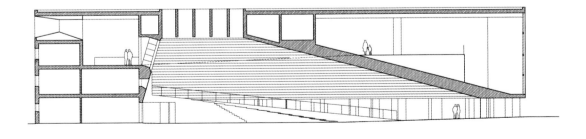

Section

Remodeling of Basel Station Basel, Switzerland, 2003

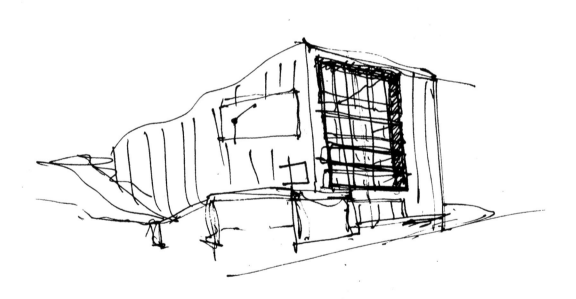

The original Basel Station is a late 19th century building with an imposing main hall and vast roofs over the platforms. The platforms were connected by an underground passageway that extended into the part of the city situated beyond the tracks. This project replaced the passageway with an elevated walkway, beginning with a large opening in the hall, passing under the original roof, and ending at a new public plaza in the Gundeli district.

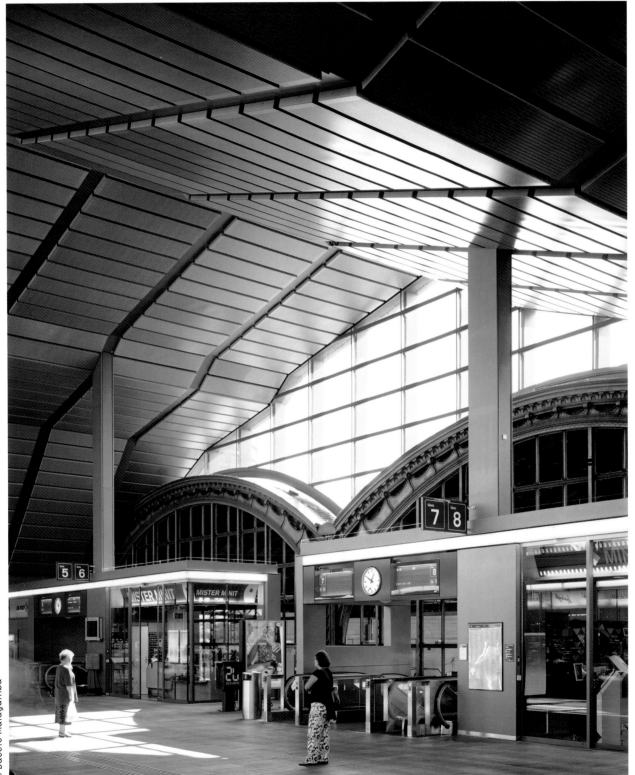

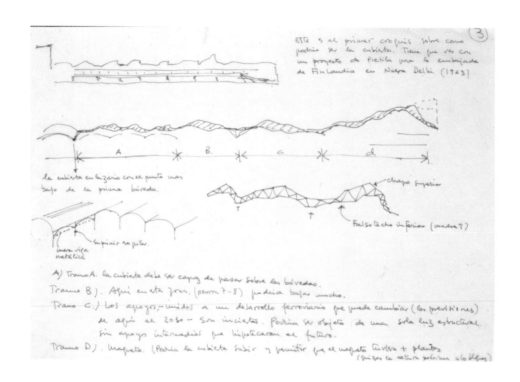

Site line study

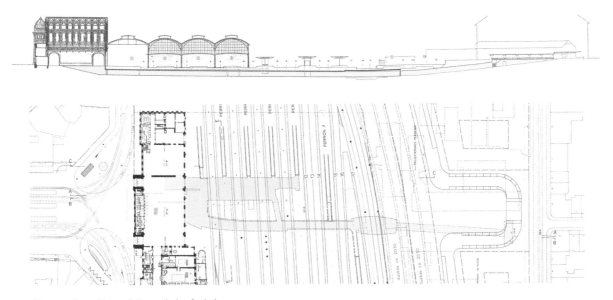

Plan and section of the original state

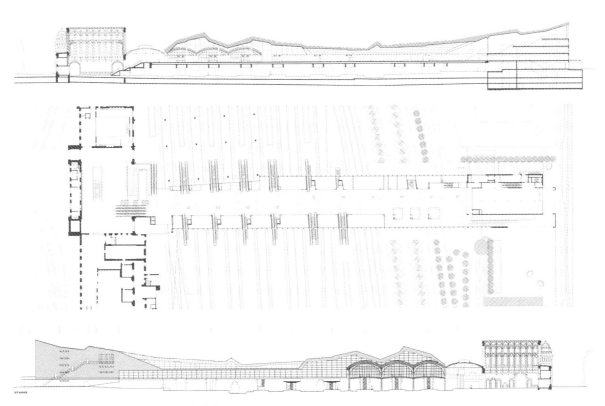

Plan and sections of the present state

0 5 10

Daniel Bonilla

Daniel Bonilla earned his degree in architecture at the University of the Andes in Bogotá, Colombia and took advanced training at Oxford Brookes University in Oxford, the College of Technology in Dublín, and the Milan Polytechnic. He has worked for the Office of the Mayor of Bogotá and with the offices of Llewelyn-Davies in London and Ospinas in Bogotá. It was there that he set up his own architectural firm in 1997. International recognition came when he was chosen to do the Colombian Pavilion for the 2000 Hanover Expo and when he was chosen as a finalist in the competition for the José Vasconcelos Library in Mexico City. The prestigious institutions at which he has been invited to lecture include the Royal Institute of British Architects, the Danish Royal Academy, and Harvard University. In addition, he has received recognition at various biennial exhibitions in his native country and from Italy's Frate-Sole Foundation, the Chilean Biennial of Architecture, the Architectural Review, and D-Line, which honored him with the "Highly Commended" award for emerging world architecture.

☐ Colombian Pavilion at 2000 Hanover Expo

☐ Milagrosa Chapel

Bonilla

■ Daniel Bonilla

Colombian Pavilion at 2000 Hanover Expo Hanover, Germany, 2000

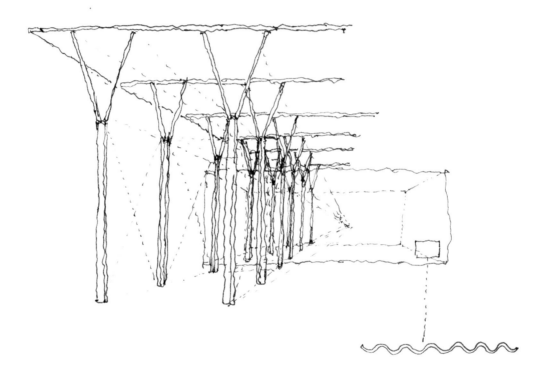

The three central themes of the 2000 Hanover Expo: man, nature, and technology, were the point of departure for the pavilion's design. Its architecture represents the Colombian jungles by means of a geometric group of trees, using a technological and contemporary language for that country's valuable natural resources. This artificial forest serves not just as an exterior image but as a transition zone between the public space of the expo and the closed volume located in the central part of the composition, where the pavilion's diverse exhibits and activities are flexibly laid out.

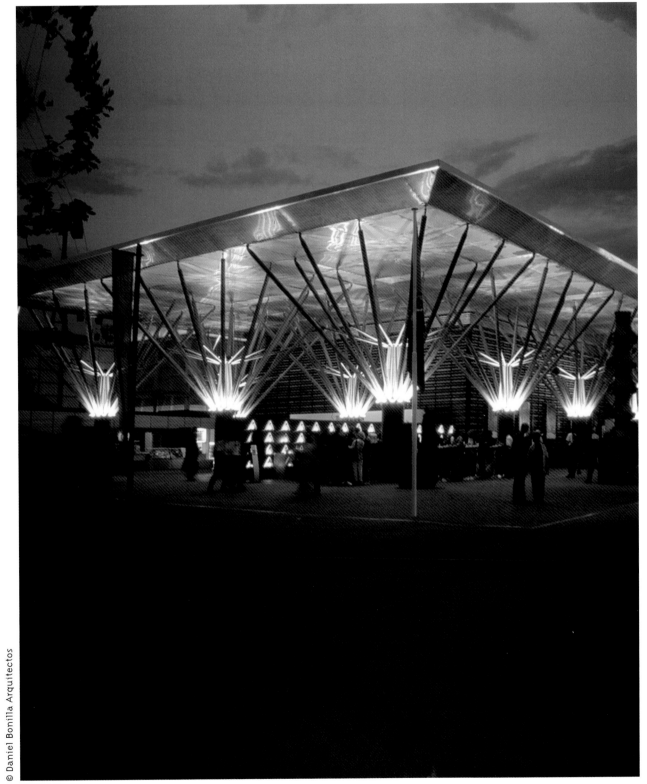

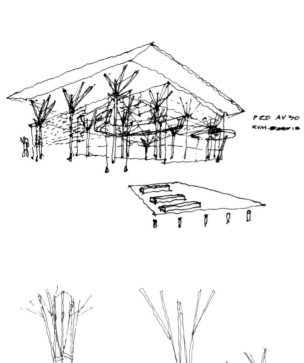

PZD AV 30
RVM.-gráfic

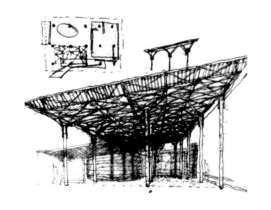

Schematic design

Design development

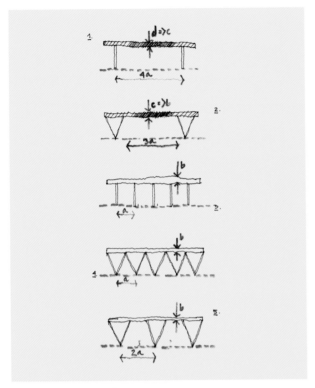

Design development

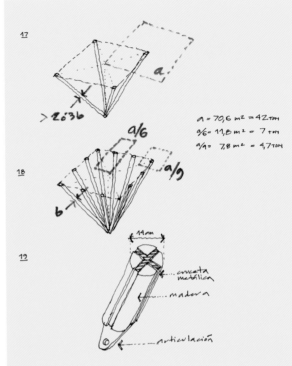

Design development

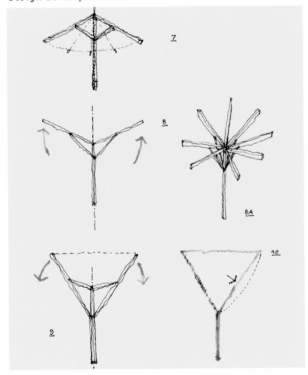

Design development

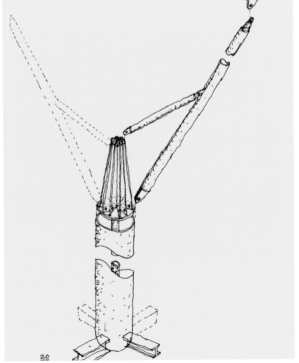

Design development

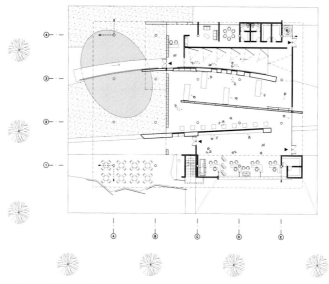

Ground floor plan

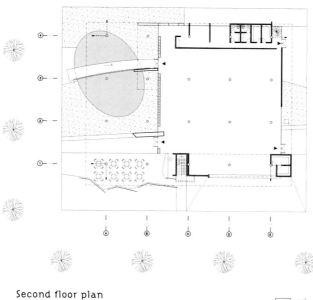

Second floor plan

0 5 10

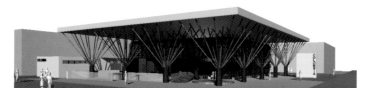

Model rendering

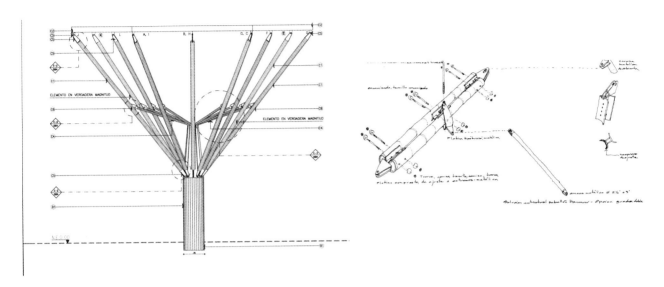

Construction document detail

Design development

■ Daniel Bonilla

Milagrosa Chapel La Calera, Colombia, 2004

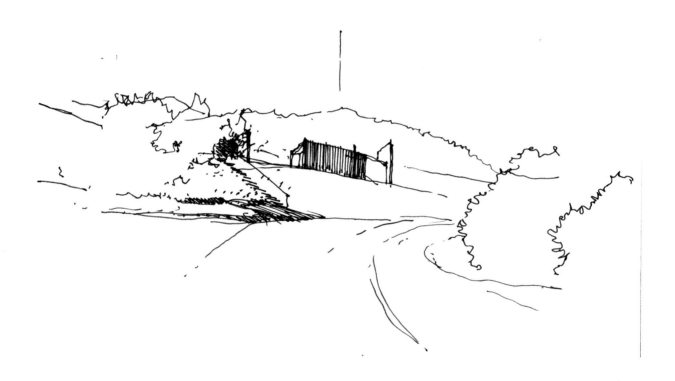

This project sought to create a space that would change from an axial enclosure for thirty people to an open area by means of a transverse configuration, with the building becoming an altar, accommodating a large group of congregants on its gentle hillside. This dual nature of the building, respecting and interpreting its natural setting, is evidence of the concern for an architecture which starts from the very private, yet allows for a public and democratic role in a country filled with contrasts.

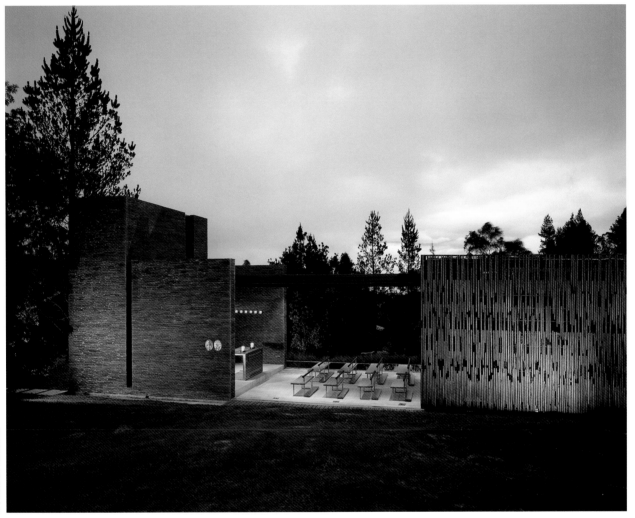

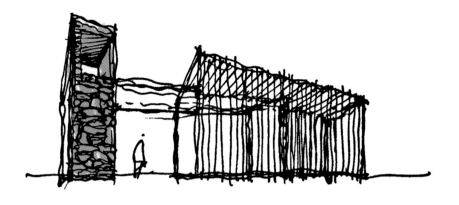

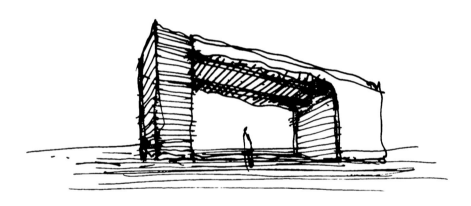

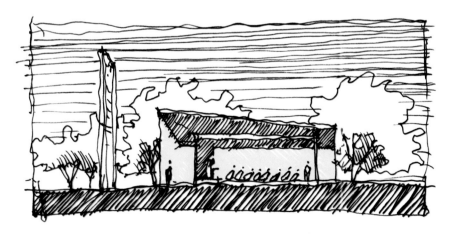

Schematic design sketches

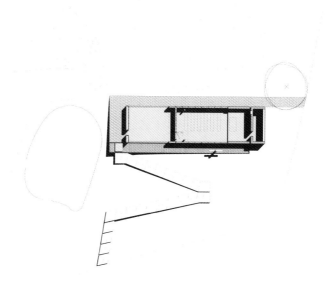

Site plan

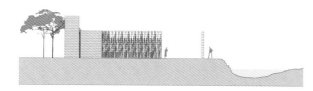

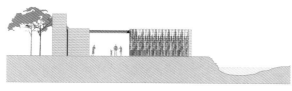

Elevations

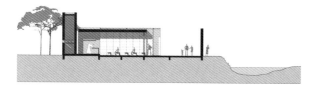

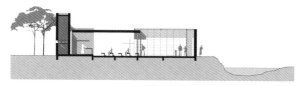

Sections

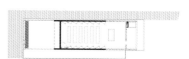

Plan of the closed chapel

Plan of the open chapel

Plan of the chapel opened with outer public

Model renderings

Dominique Perrault

Dominique Perrault was born in Clermont Ferrand
in 1953 and earned his architecture degree from Paris'
Ecole Nationale Superieure des Beaux-Artes in 1978. After
completing his studies in urban design at the Ecole
Nationale des Ponts et Chaussées in Paris, and in history
at the Ecole des Hautes Etudes en Sciences Sociales, also
in Paris, he opened his own architecture and urban
design firm there in 1981. National recognition came as a
result of two major projects: the ESIEE engineering school
in Marne-la-Vallée and the Hôtel Industriel Berlier in
Paris. A short time later, with the construction of the
National Library of France in Paris and the award of first
prize for the Velodrome in Berlin, he received the
international recognition that led him to open offices in
Berlin (1992), Luxemburg (2000), and Barcelona (2001).

Dominique

une manière de lire

Dominique Perrault

☐ French National Library

☐ Olympic Velodrome and Swimming Pool

☐ New Mariinsky Theater

Perrault

French National Library Paris, France, 1989

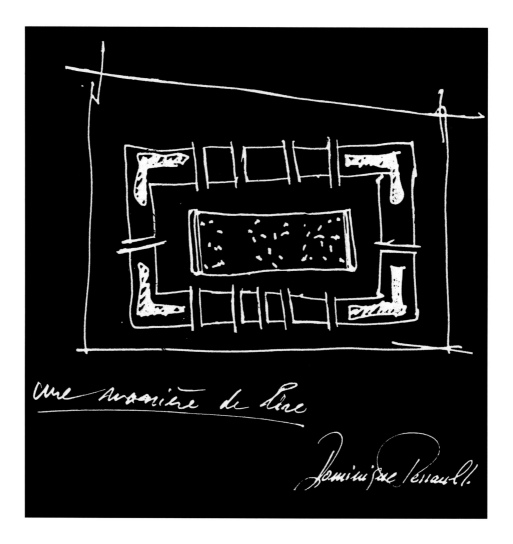

une manière de lire

Dominique Perrault.

The National Library of France was the first project by Dominique Perrault to win international recognition. The project's strategic location, on the banks of the River Seine in Paris, and a forceful plan, rich in symbolism, have made this complex a new icon of the Parisian urban landscape. The surrounding glass, exposing the interior wood panel partitions, rests on a plinth that serves as an urban plaza and vantage point and accommodates the library's principal service areas, such as reading rooms and reference desks. The reading rooms look out on the central courtyard, which is a rich green space and a focal point of the grouping.

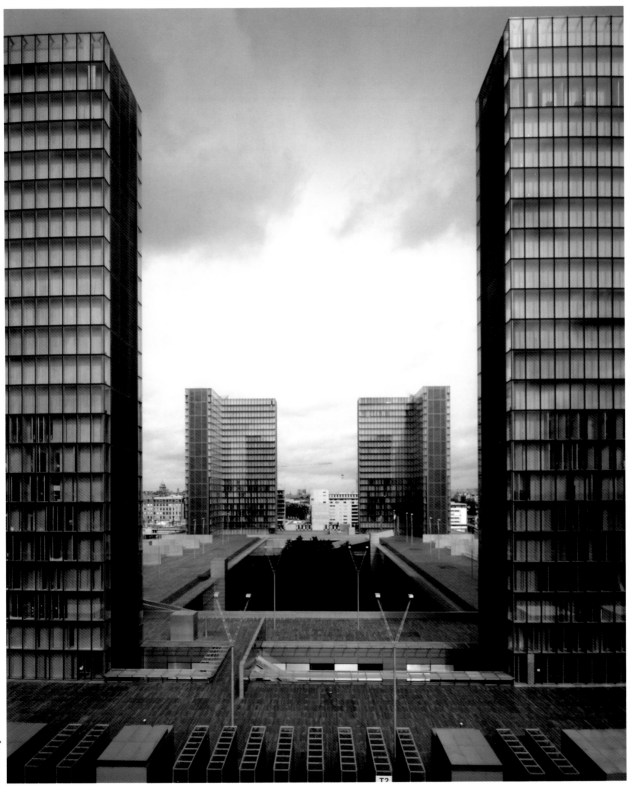

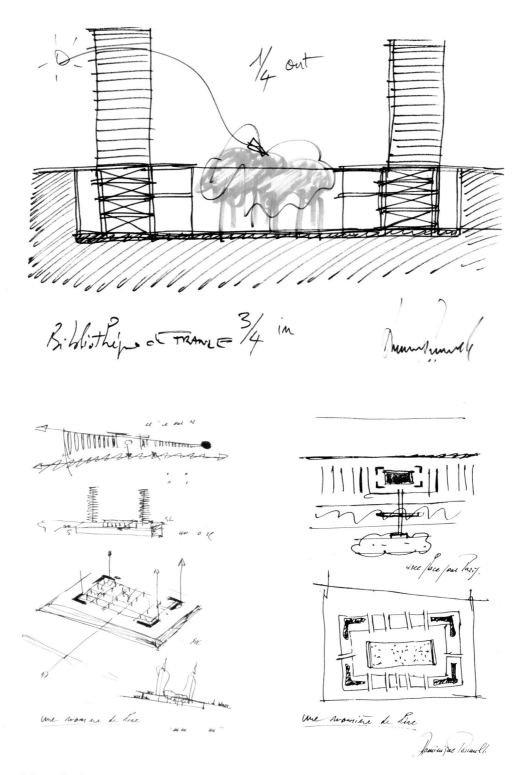

Schematic design sketches

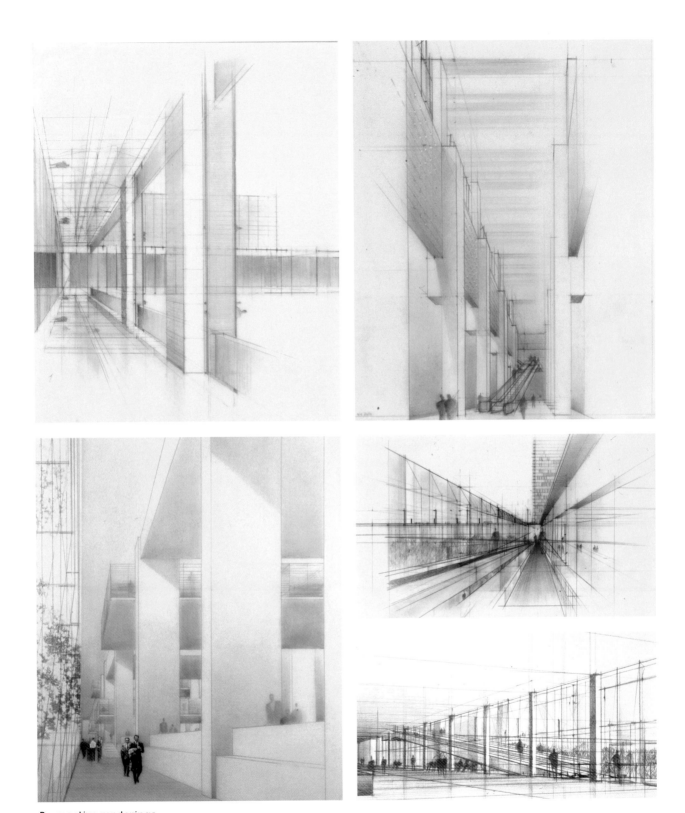

Perspective renderings

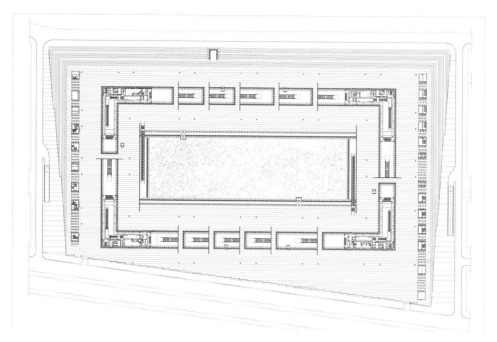

Ground floor plan

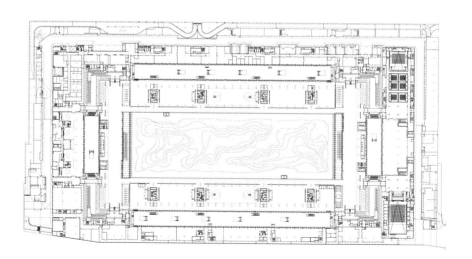

Basement floor plan

0 5 10

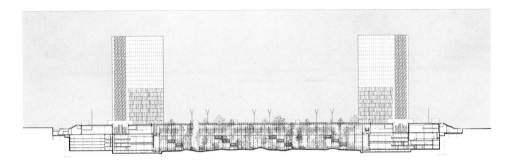

Northeast elevation

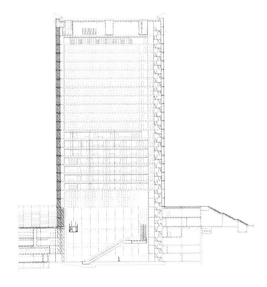

Sections

Olympic Velodrome and Swimming Pool Berlin, Germany, 1999

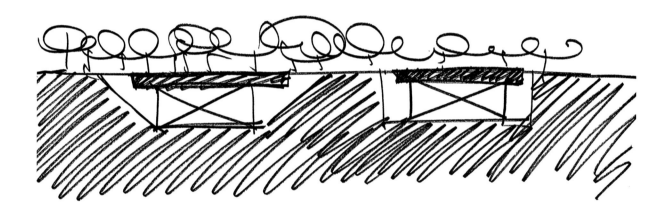

Dominique Perrault won first prize in the international competition for the design and construction of the Olympic Pool and Velodrome project. The vast size of the complex, which can accommodate 11,420 spectators in the velodrome and 4,200 at the pool, is minimized through the use of a landscaping strategy in which the two units are hidden, slightly submerged into the earth under a green platform that surrounds the complex. The platform not only integrates the two geometric shapes that define the buildings, but houses the complementary common-use areas, such as dressing rooms, restrooms, offices, and so forth, shared by the two venues.

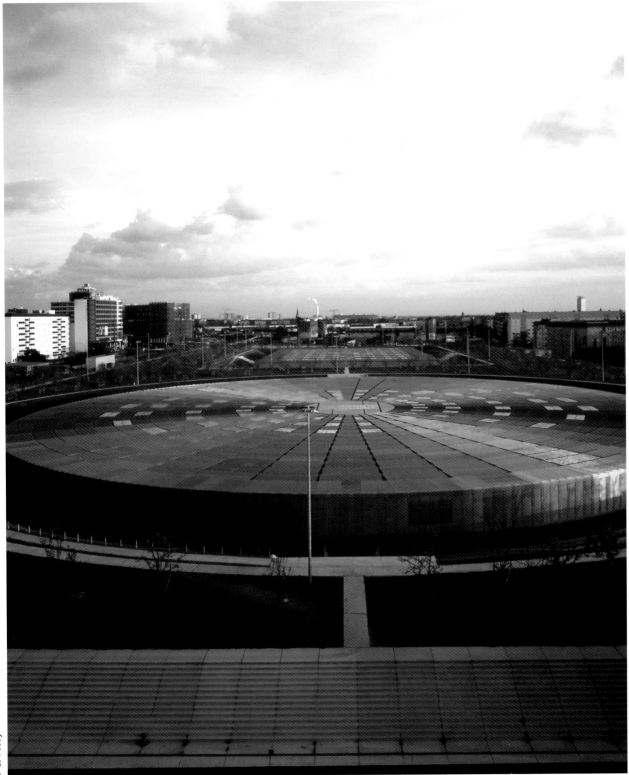

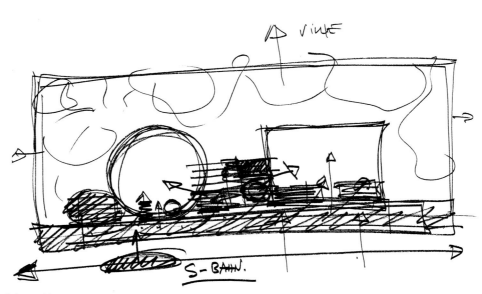

Schematic design

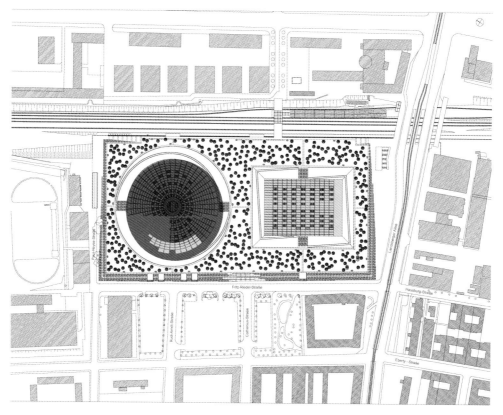

Site plan

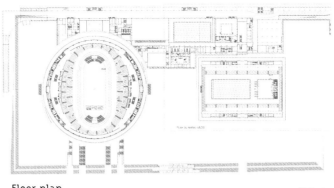

Floor plan

0 10 20

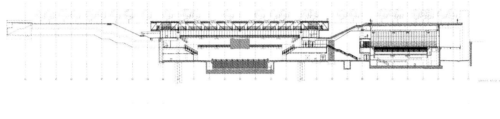

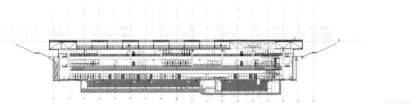

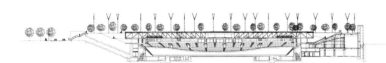

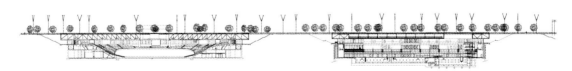

Sections

New Mariinsky Theater St. Petersburg, Russia, 2008

The project consists of the construction of the second phase of the Mariinsky Theater, formerly known as the Kirov Theater, next to the original, on the Kryukov Canal in St. Petersburg. The golden shell that covers the building is inspired by the color traditionally used in this city to make its most noble buildings stand out. The complex plan includes two halls, one for 2000 spectators and a smaller one for 350, and spaces for workshops, offices, warehouses, shops, and restaurants. A telescopic bridge over the canal will join the old and new theaters.

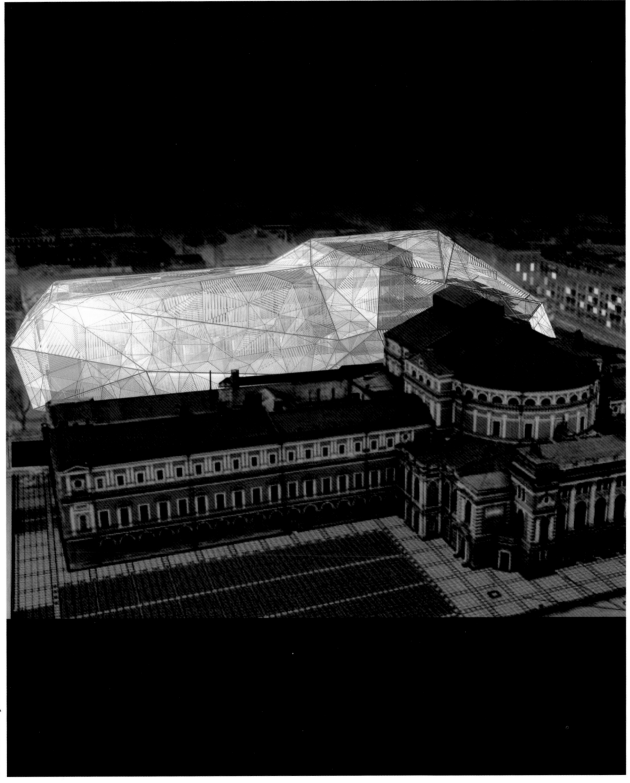

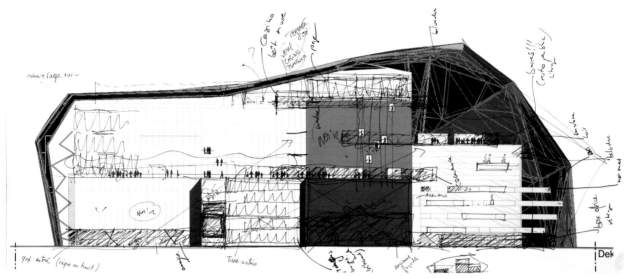

Design development

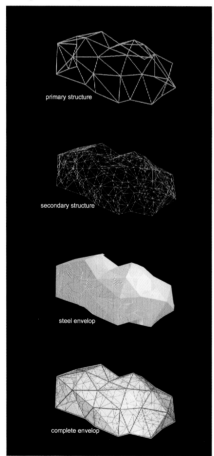

primary structure

secondary structure

steel envelop

complete envelop

Model renderings

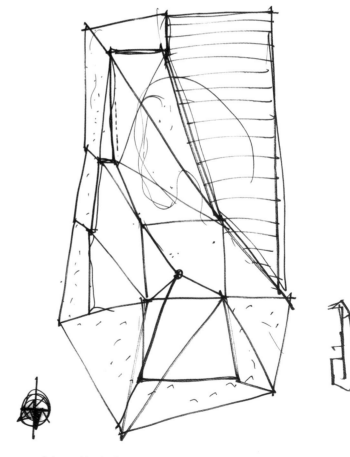

Schematic design

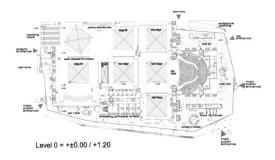

Level 0 = +±0.00 / +1.20

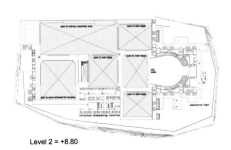

Level 2 = +8.80

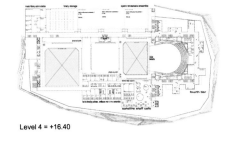

Level 4 = +16.40

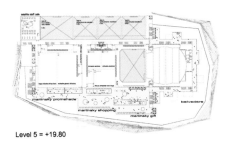

Level 5 = +19.80

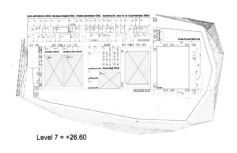

Level 7 = +26.60

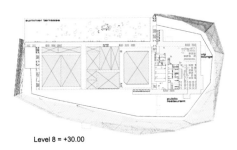

Level 8 = +30.00

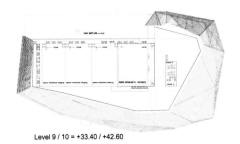

Level 9 / 10 = +33.40 / +42.60

Floor plans

0 5 10

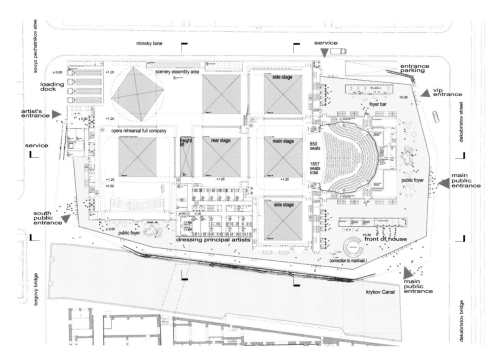

Floor plan

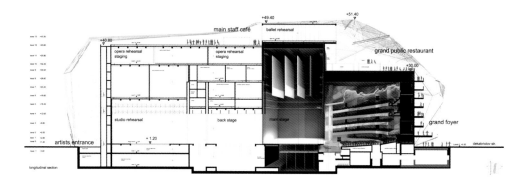

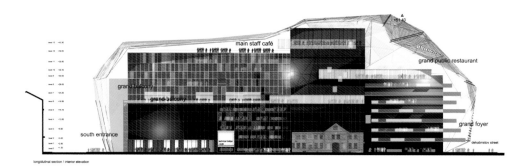

Sections

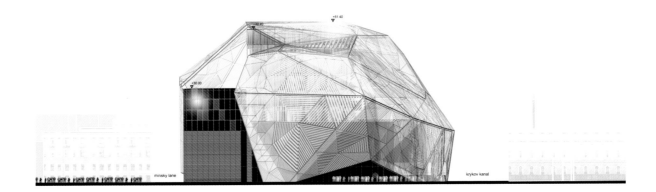

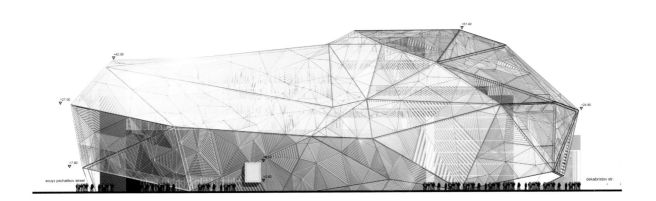

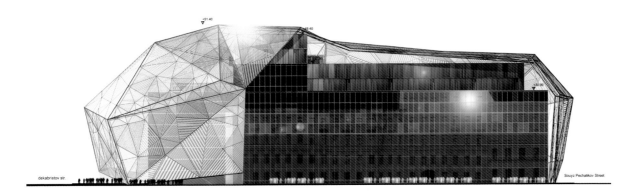

Elevations

Döring Dahmen Joeressen

DDJ was established in Düsseldorf in 1996. Its staff
includes Wolfgang Döring, an architect with vast
experience and a long career behind him, as well as
Michael Dahmen and Elmar Joeressen, whose training
and professional activity are strongly linked to those of
Döring. Wolfgang Döring has many exhibitions and
publications to his credit. An internationally-renowned
figure, he planned the Módena Cultural Center, several
sports complexes in Saudi Arabia, rehabilitation of the
old quarter of Istanbul, and Moscow's Museum of
Constructivism. He has been an honorary and guest
professor at the Universities of Tokyo and Buenos Aires.
DDJ are the creators of Shiseido Germany and part of
the renovation of the Dusseldorf metro's installations.

☐ Kai 13

☐ Metropolitan

☐ Panthöfer Single Family Home

Joeressen

Kai 13 Düsseldorf, Germany, 2003

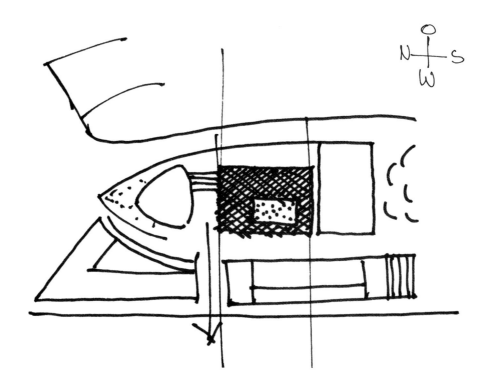

In a move to combat the feeling of urban congestion, this building's extended ground floor was planned to occupy almost the entire plot, except for a central plaza. The building has two units, one with five stories and diamond-shaped, and the other, three stories and triangular. Between them, at the level of the first floor, is a garden. Located in the port of Düsseldorf, Kai 13, with its monolithic body and perforated facade, contrasts starkly with the predominantly glass facades of the surrounding buildings.

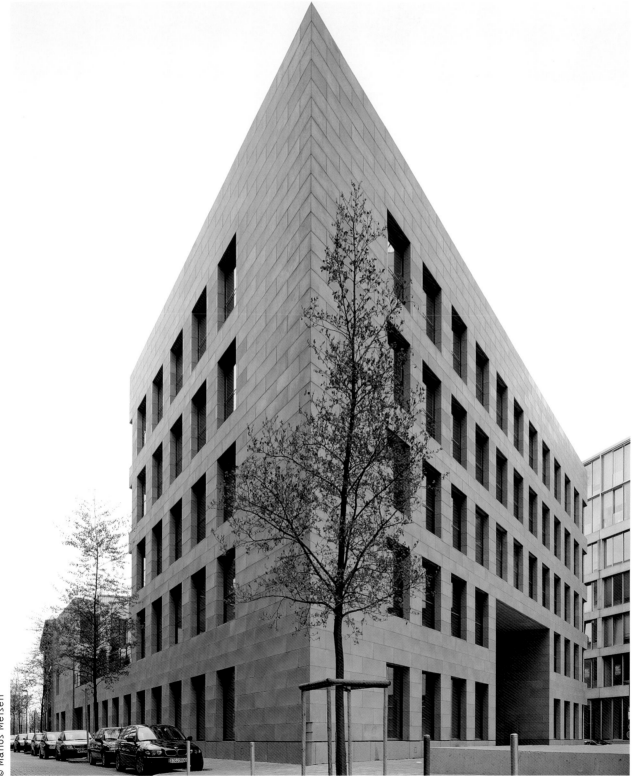

Döring Dahmen Joeressen 185

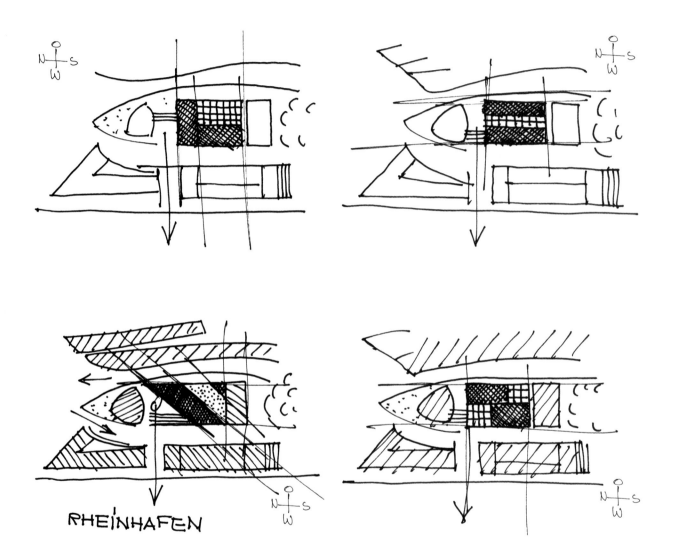

RHEINHAFEN

Location plan

Basement floor plan

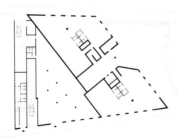

Ground floor plan

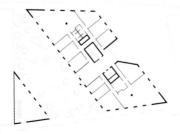

Second floor plan

0 5 10

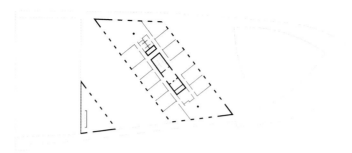

Third floor plan

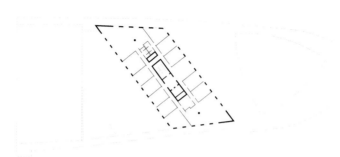

Fourth floor plan

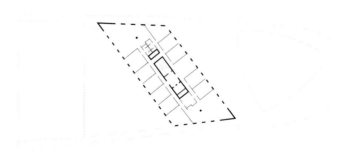

Fifth floor plan

Sixth floor plan

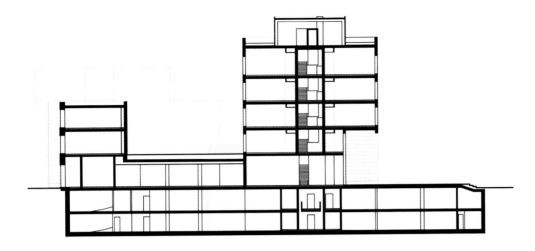

Section

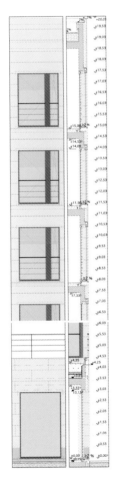

Details of the facade

■ Döring Dahmen Joeressen

Metropolitan Düsseldorf, Germany, 2001

Designing a house located in an area with two monuments demands containment and an appropriate dialogue, in terms of proportion and structure, with the existing buildings. The black of the windows contrasts with the white limestone of the facade, a reference to Bernhard Pfau's nearby theater. The different depths of the windows also contrast with the theater's absolutely smooth facade. The house was positioned to ensure that the treetops would have plenty of space.

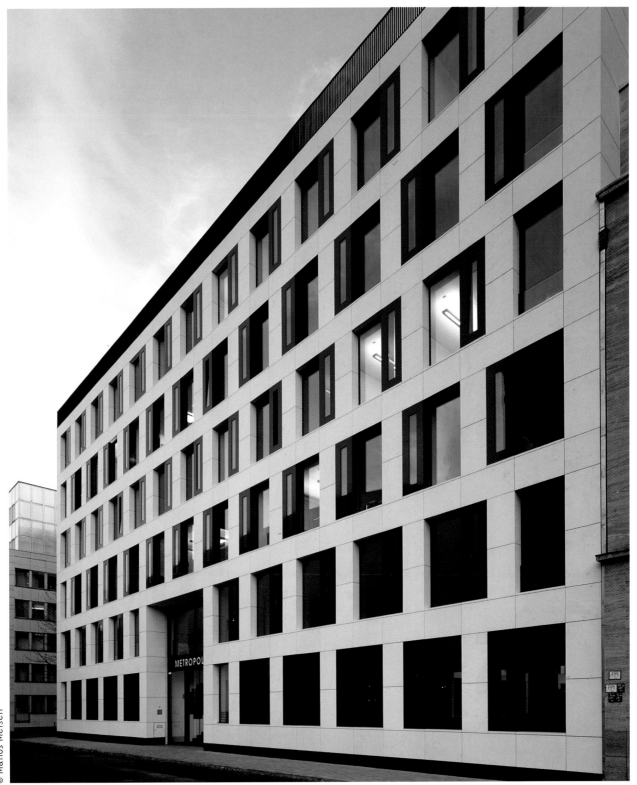

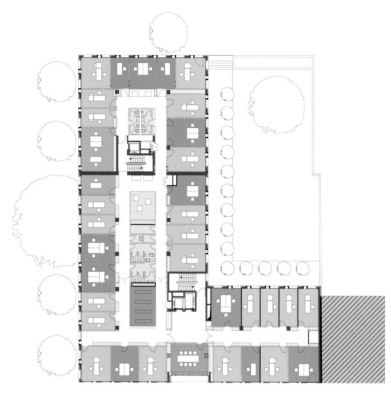

Second floor plan

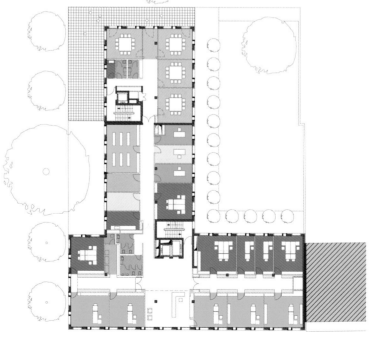

Ground floor plan

0 2 4

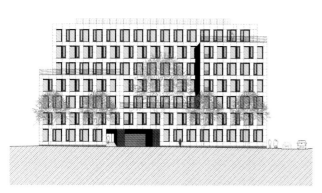

Elevation

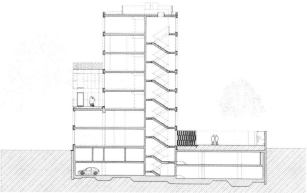

Section

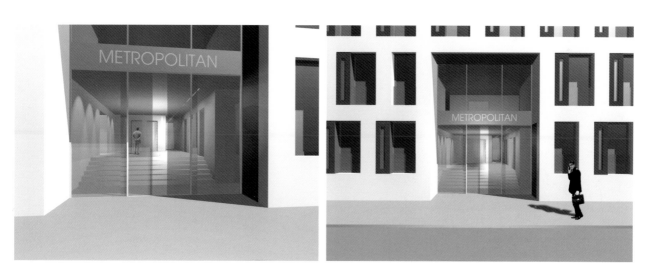

Renderings

■ Döring Dahmen Joeressen

Panthöfer Single Family Home Düsseldorf, Germany, 2003

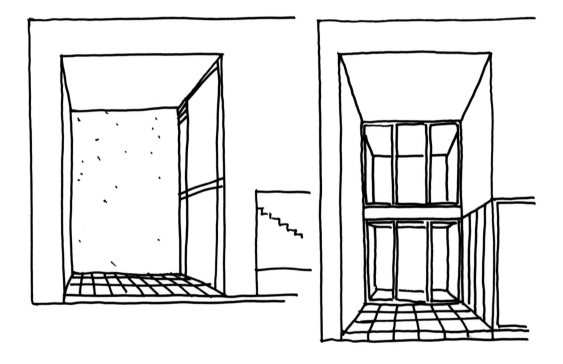

This part of the house was intended for the family's son, with two bedrooms and a private bath added on, and separate entrances. The kitchen, situated right at the entrance, has access to the garage for easy garbage disposal and is separated from the dining room by a sliding door. The two-story living room is lit by a window measuring 33.5 feet by 8.2 feet and extends into a covered corridor which is also two stories high. Stairs by the window provide access to the upper floor and a terrace with a panoramic view, and continue downward, ending at the parents' bedroom door.

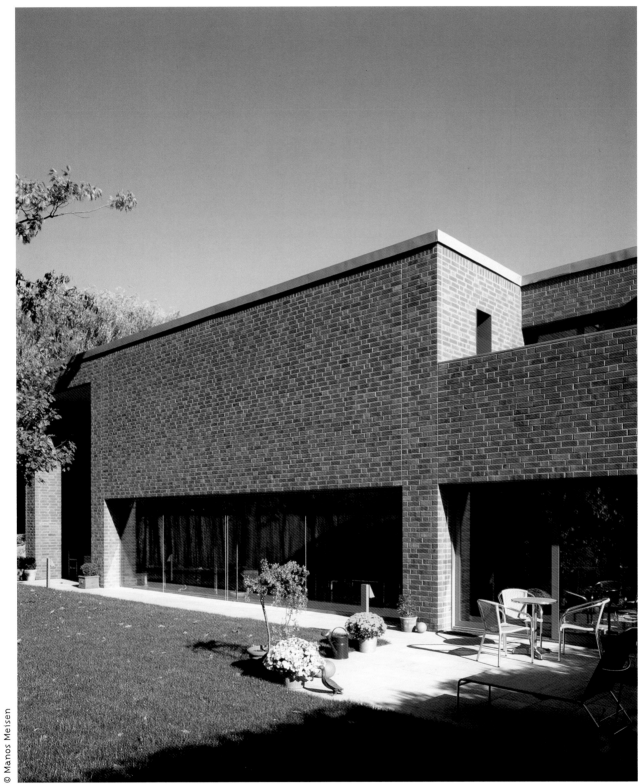

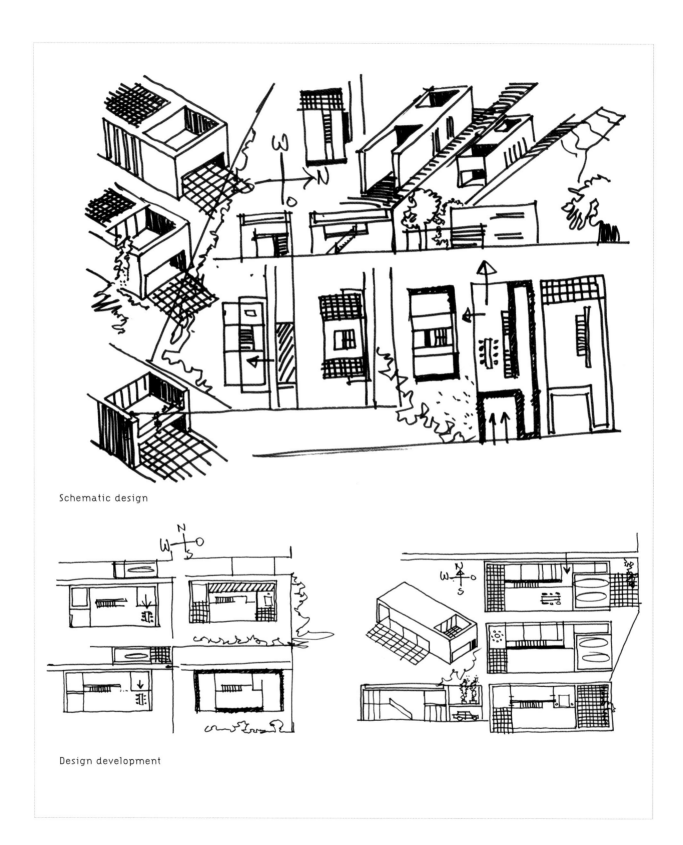

Schematic design

Design development

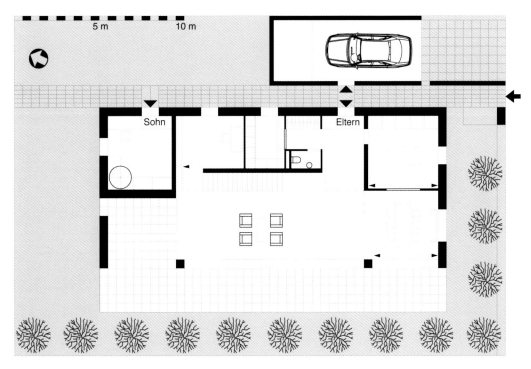

Ground floor plan

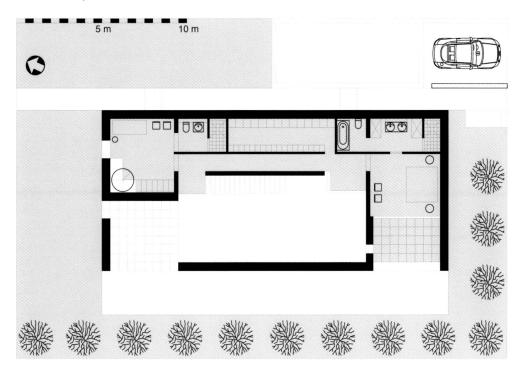

Second floor plan

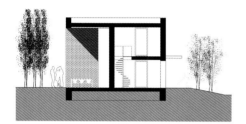

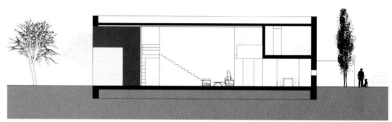

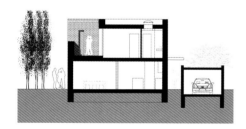

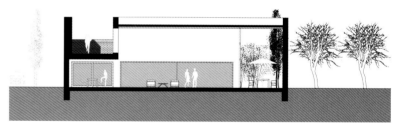

Sections

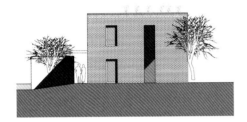

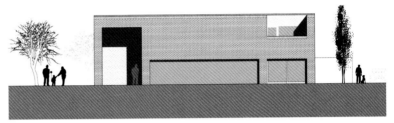

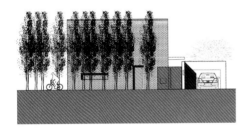

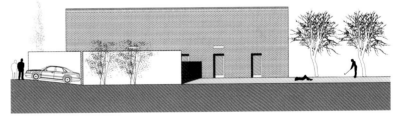

Elevations

Eduardo Souto de Moura

Eduardo Souto de Moura was born in Porto, Portugal in
1952 and studied architecture at the School of Fine Arts
in his native city. In 1980 he opened his own office,
after having worked for several years with Álvaro Siza,
with whom he has continued to collaborate. He has
never stopped combining his work as an architect with
that of a teacher, giving classes and lectures at
architecture schools throughout the world. The
international recognition of his work is a result of the
success with which he has melded modernity and
tradition, reconciling materials and construction
techniques, always with profound respect for the
enclaves in which the projects are located. Noteworthy
in his work is the use of native materials, mastery in
their treatment, and his understanding and
interpretation of climate and setting. These have
enabled him to complete works as emblematic as the
house in Matosinhos and the cultural center in Braga,
which are considered icons of our recent architecture.

Moura

■ Eduardo Souto de Moura

Braga Stadium Braga, Portugal, 2003

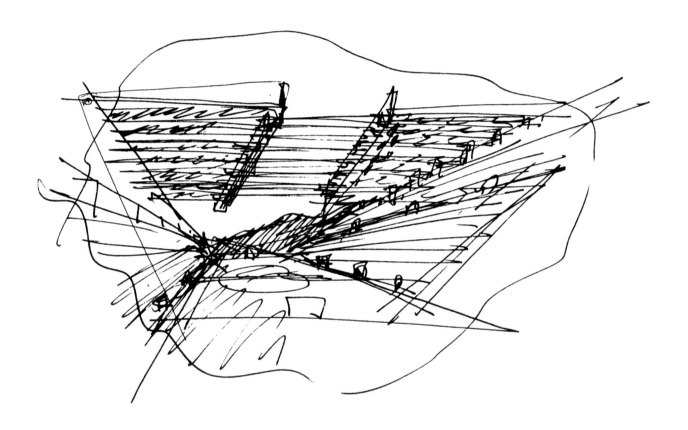

The municipal stadium in Braga is part of the Dume sports complex, an urban development plan to revitalize the Monte Castro area on the outskirts of the city of Braga. The location on the lower part of the slope, and the stadium's orientation, allow the structure itself to contain and channel the water that enters the valley. Thus, like the Roman amphitheaters, its strategic location takes advantage of the local topology. The two parts that cover the stadium's long stands look, from higher up on the mountain, like tectonic plates dislodged after an earth tremor.

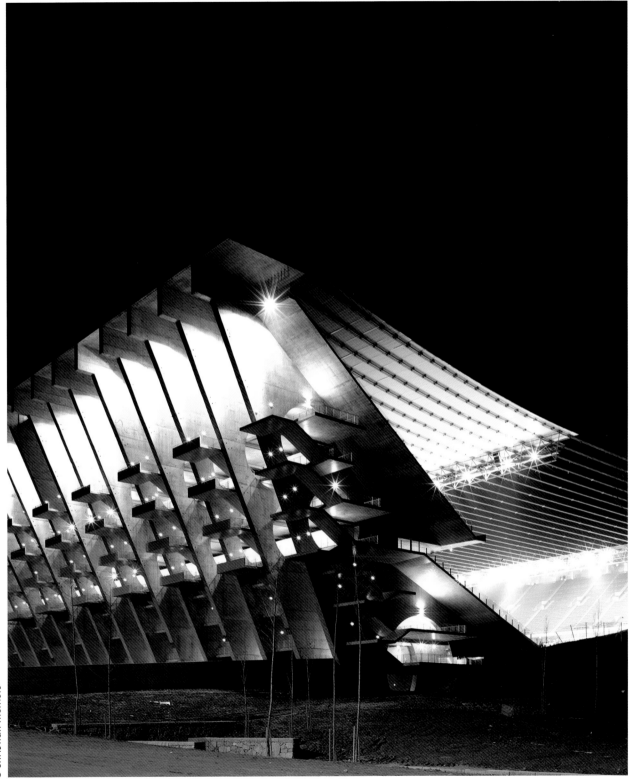

Eduardo Souto de Moura 203

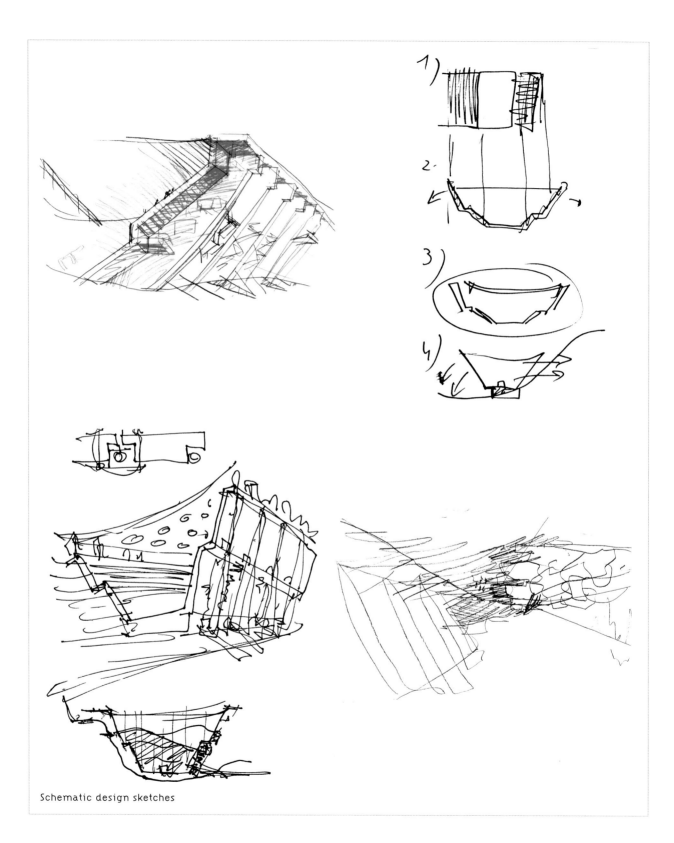

Schematic design sketches

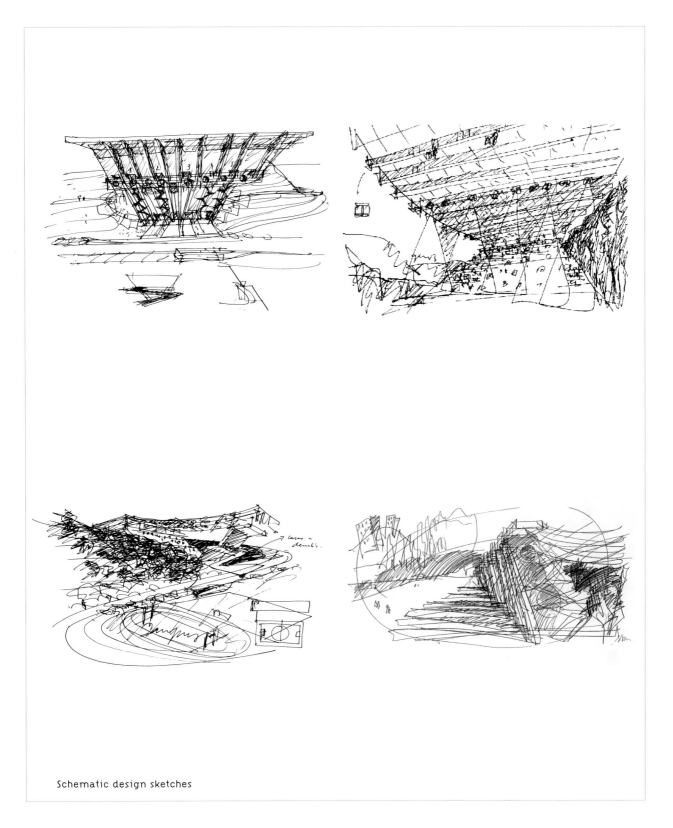

Schematic design sketches

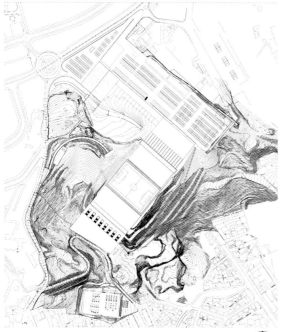

Location plan

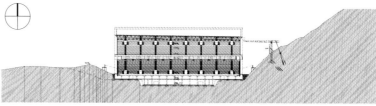

Elevation

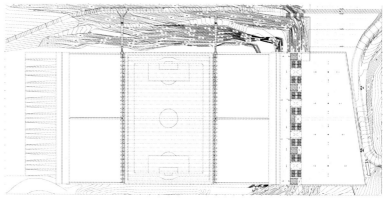

Floor plan

10 2

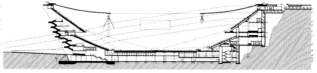

Section

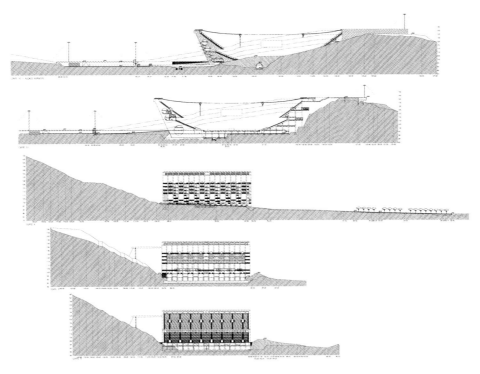

Sections

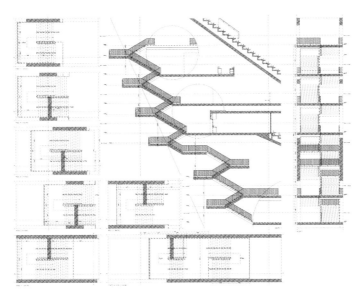

Staircase detail

Manoel de Oliveira House of Cinema Porto, Portugal, 2003

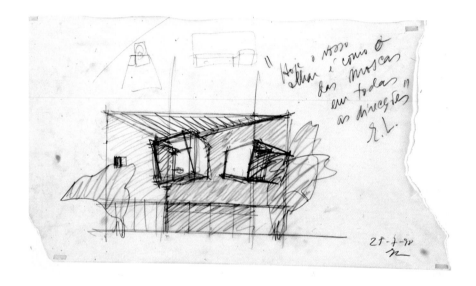

This complex dedicated to movie research occupies a central location in the city of Porto. Its particular location, near fifteen-story buildings, made it necessary to use deliberate formal strategies to find the most attractive views of the river and sea. The building, constructed on the basis of an irregular plan, an adaptation to the shape of the plot, was placed so that the library, one of the rooms with the most glass, would overlook the water. Thus, the areas containing the tables for meetings, reading, and study enjoy magnificent views of the Duero.

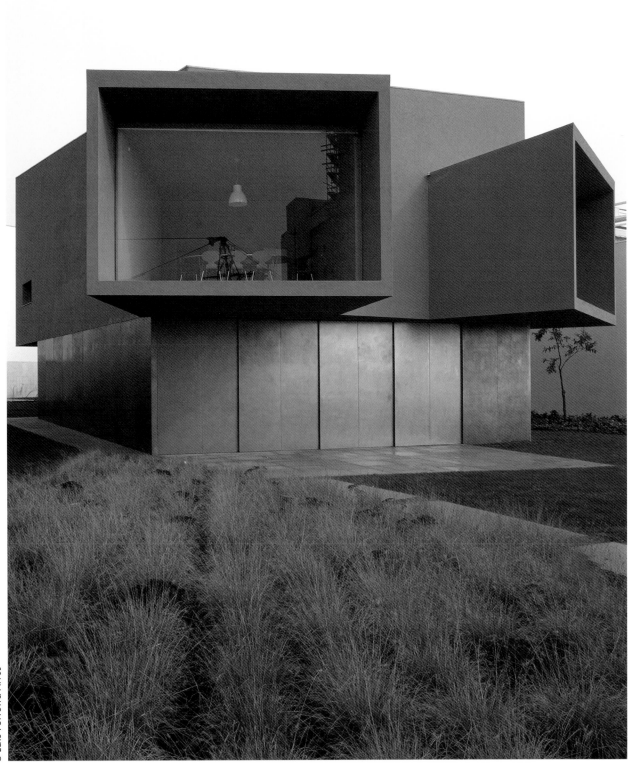

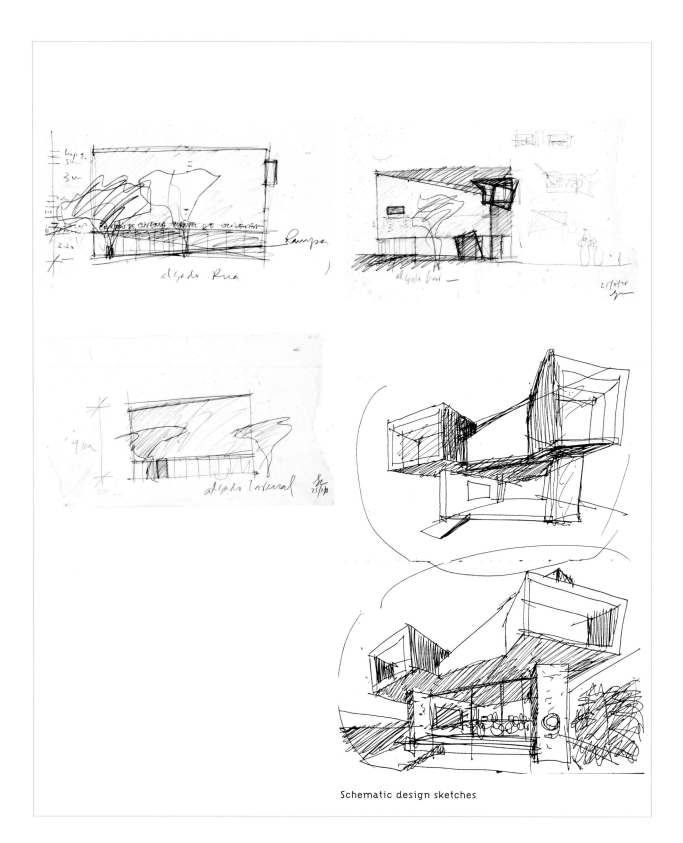

Schematic design sketches

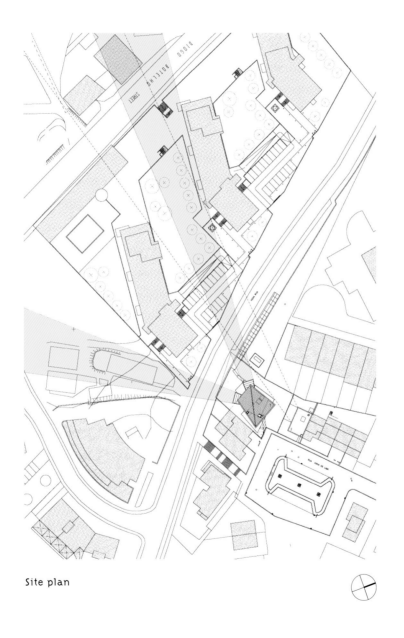

Site plan

Ground floor plan

Second floor plan

Basement floor plan

Roof plan

0 2 4

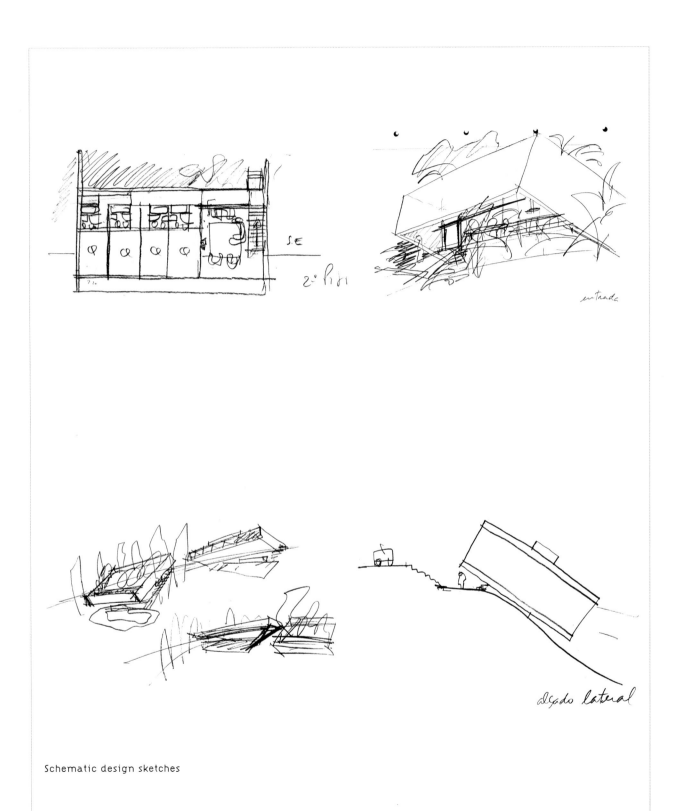

S.E

2º Pido

entrada

alçado lateral

Schematic design sketches

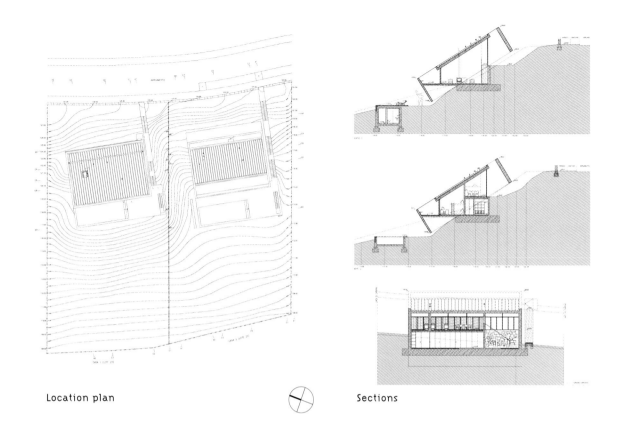

Location plan Sections

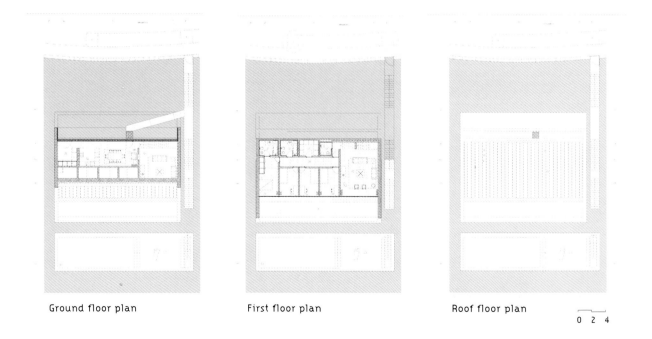

Ground floor plan First floor plan Roof floor plan

0 2 4

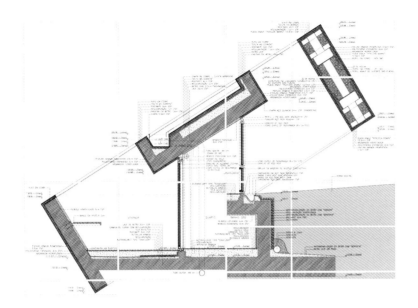

Construction detail

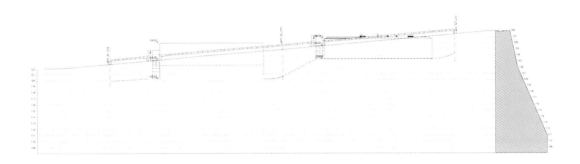

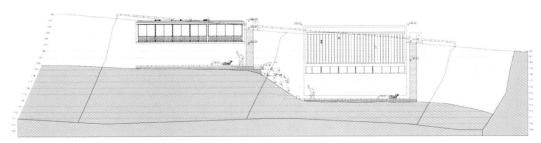

Elevations

EMBT Arquitectes

EMBT Arquitectes Associats was established in Barcelona in 1990 by Enric Miralles and Benedetta Tagliabue. Its areas of expertise are architecture, public space, restoration, and exhibition spaces, and its goal is to keep alive the spirit of the artisanal workshops typical of the Spanish and Italian tradition. EMBT was really launched with the 1992 Barcelona Olympics, through projects such as the Archery Range and the roofs on Avenida Icaria in the Olympic Village. After that, the firm started taking on international projects, notably the Town Hall in Utrecht (the Netherlands), the School of Music in Hamburg (Germany), and the recently-completed Parliament

□ Restoration of Santa Caterina Market

□ University Campus in Vigo

Arquitectes

Restoration of Santa Caterina Market Barcelona, Spain, 2003

The restoration of the Santa Caterina Market tries to place itself at a certain point in time, but without insisting. The old building has not been totally demolished, rather, the work is being superimposed on top of existing structures to improve the complex. This is why the EMBT architects like to use the words "hybrid" and "conglomerate" in defining the project, which sits in the midst of the old quarter. The project affords public space and residential density to the network of streets in which it is located, but the objective is to not be able to distinguish between the restoration and new construction.

Study of the plan of the roof

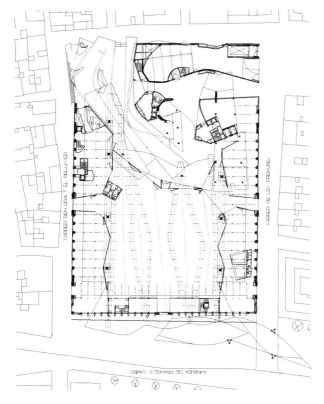

Floor plan

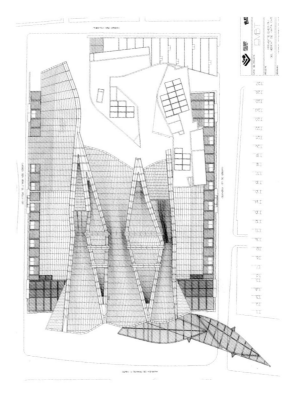

Roof plan

0 5 10

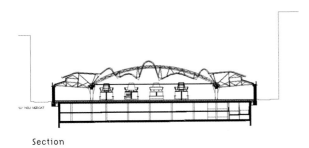

Section

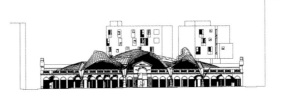

Elevation

University Campus in Vigo Vigo, Spain, 1999

This project involves remodeling the University Campus gateway area and approaches, which have until now been occupied by the sports area and a parking lot. The alternative to these entailed the installation of small lakes, and the edges have been replanted with trees to produce a woodsy effect. Thus, sports activity also becomes a leisure activity. Concepts such as sustainability and care of the environment were major factors in the project.

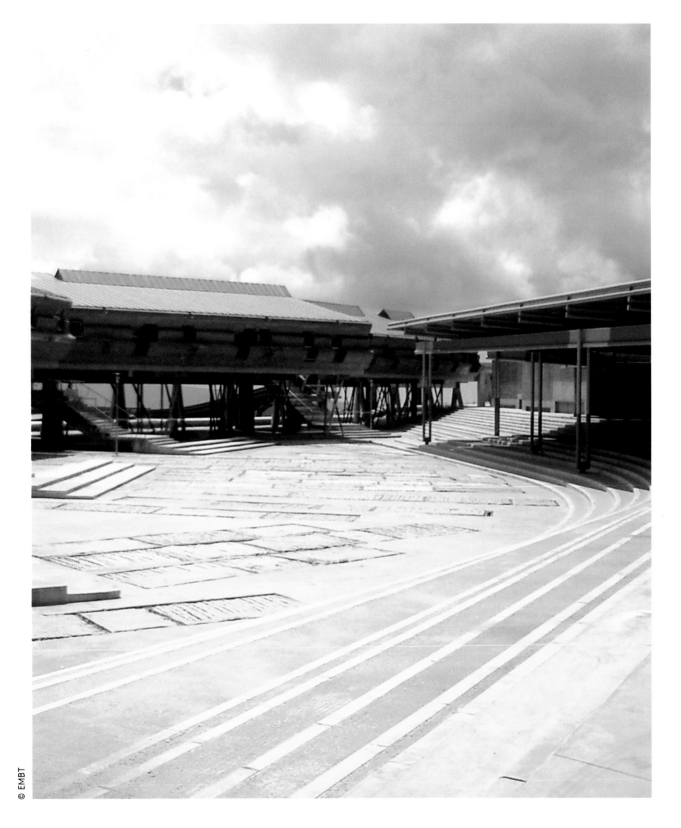

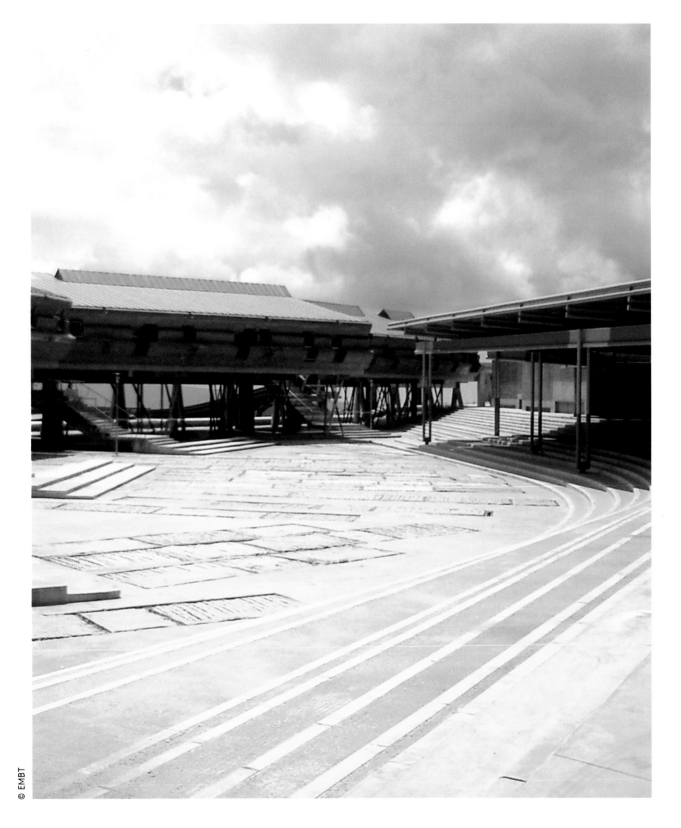

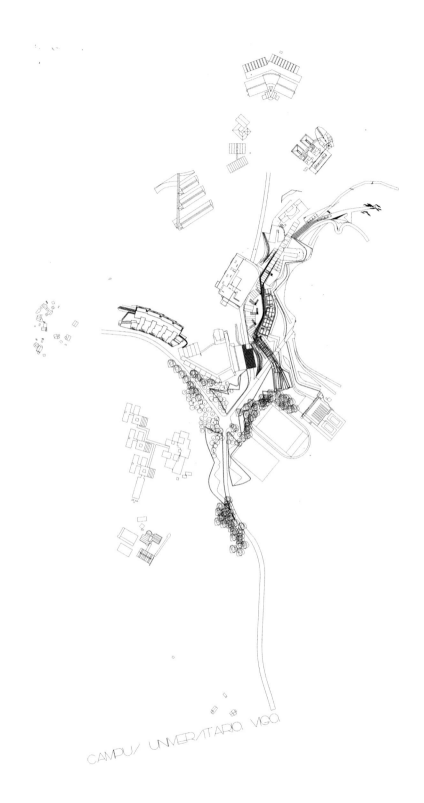

CAMPUS UNIVERSITARIO, VIGO.

Site plan

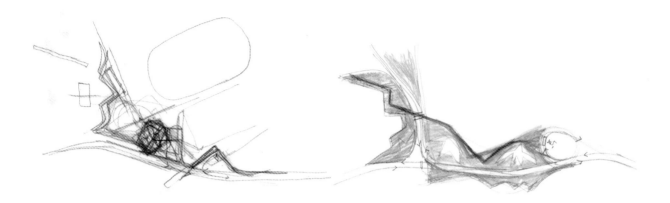

Schematic design sketches

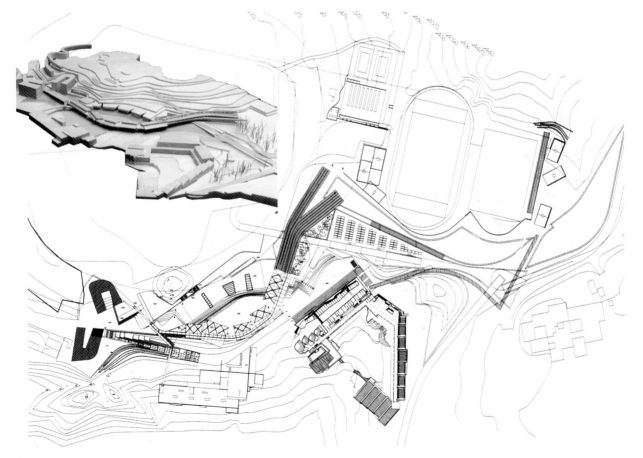

Model rendering

Eric Owen Moss

Eric Owen Moss was born in 1943 in Los Angeles, California and received a Bachelor of Arts from the University of California at Los Angeles. He continued his studies at Harvard, where he earned a Master's in Architecture. He opened his own architectural firm in 1973, and has been teaching design at the Southern California Institute of Architecture for more than 20 years. Eric Moss has, like certain other contemporary architects, joined the deconstructionist movement, and likes to work with elements that are not traditionally associated with each other: iron and wood, wood and glass, glass and stone, all in a fully integrated composition. His firm currently employs more than 25 creative minds who work on a wide variety of projects in the United States and around the world. One of the firm's guiding principles is that of working closely with clients and the functional plan to achieve a unique, extraordinary project every time.

☐ **The Box**

☐ **Stealth**

☐ **Guangdong Museum**

en Moss

The Box Culver City, CA, USA, 2000

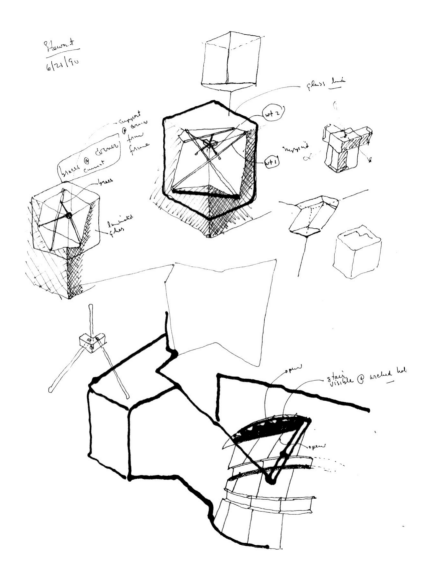

The Box rises out of an existing wooden shed which is now used for offices. The lower volume retained the original structure, providing a bright, open workspace for several people in a single company. The idea behind the project was to create an independent area for meetings without changing the layout of the original space. The solution is a metal box, accessed by an internal stairway, which enjoys panoramic views of the city and valley.

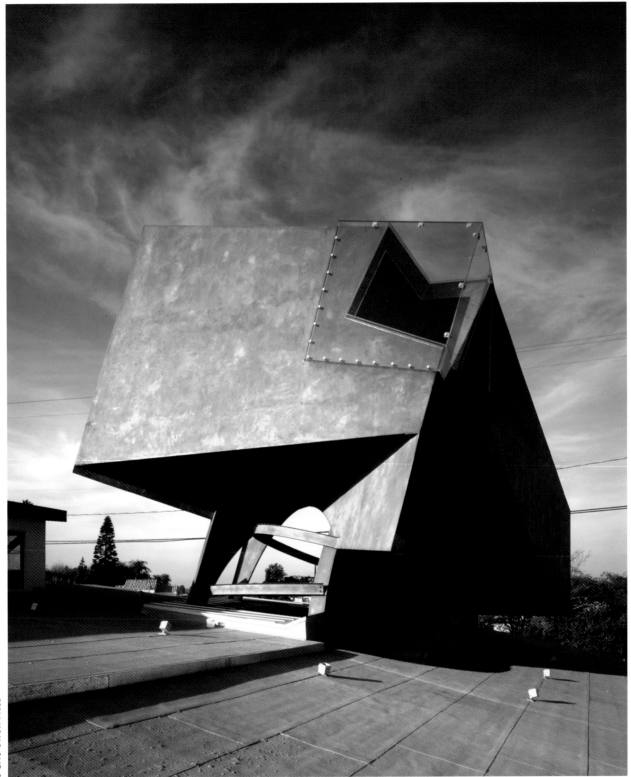

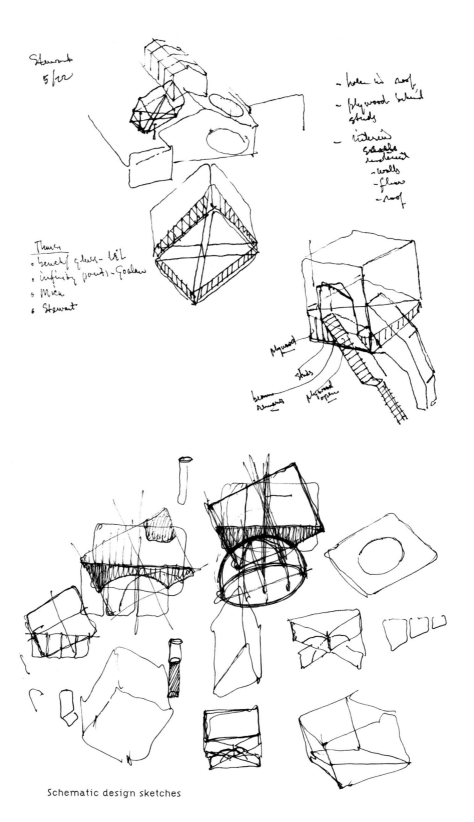

Schematic design sketches

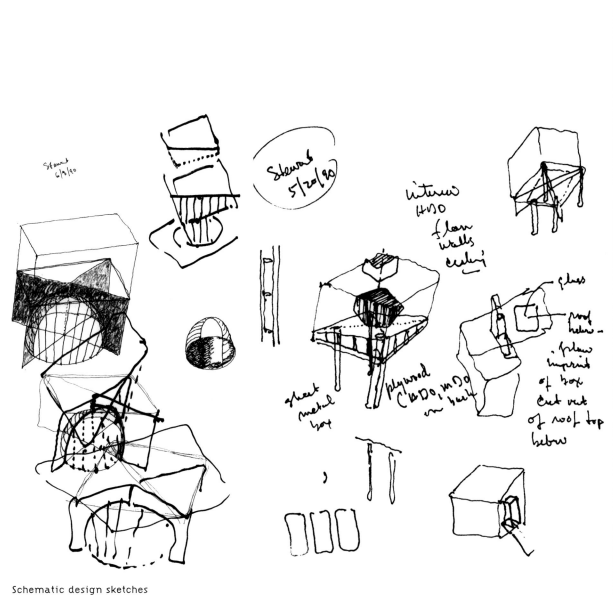

Schematic design sketches

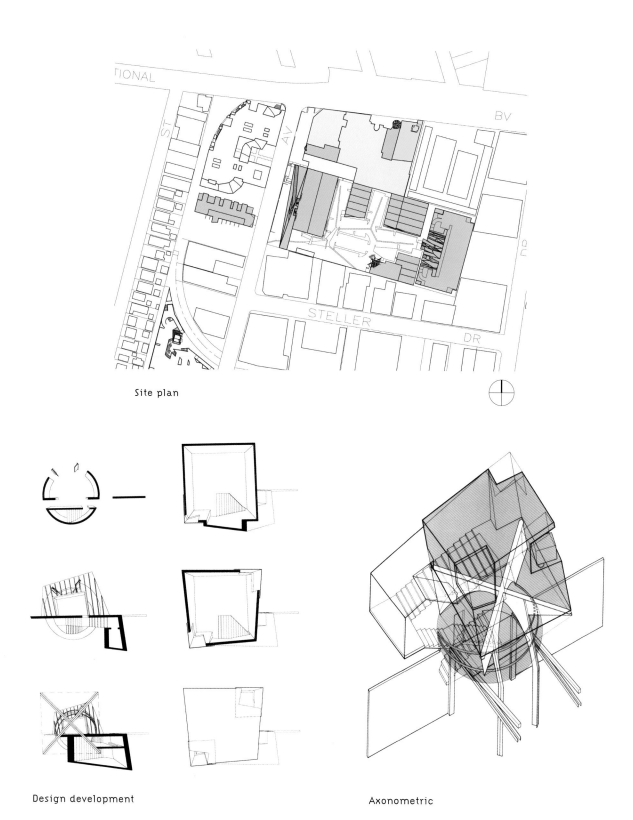

Site plan

Design development

Axonometric

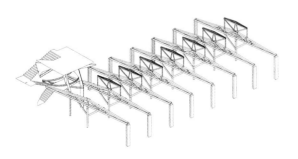

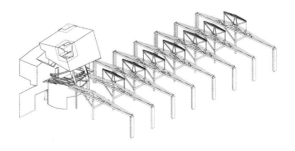

Axonometric development

■ Eric Owen Moss

Stealth Culver City, CA, USA, 2001

The design for this project began as a consequence of earth removal on the formerly indus-
trial site. The excavation that was left after an old warehouse had been removed was
re-shaped to form a large, sunken courtyard to be used as an outdoor theater. The building,
which now contains a complex of offices for several companies, consists of a long volume
accessed through a vast glass-enclosed hall. This hall, along with a varied sequence on the
longitudinal façade, creates a close relationship between the exterior and the interior.

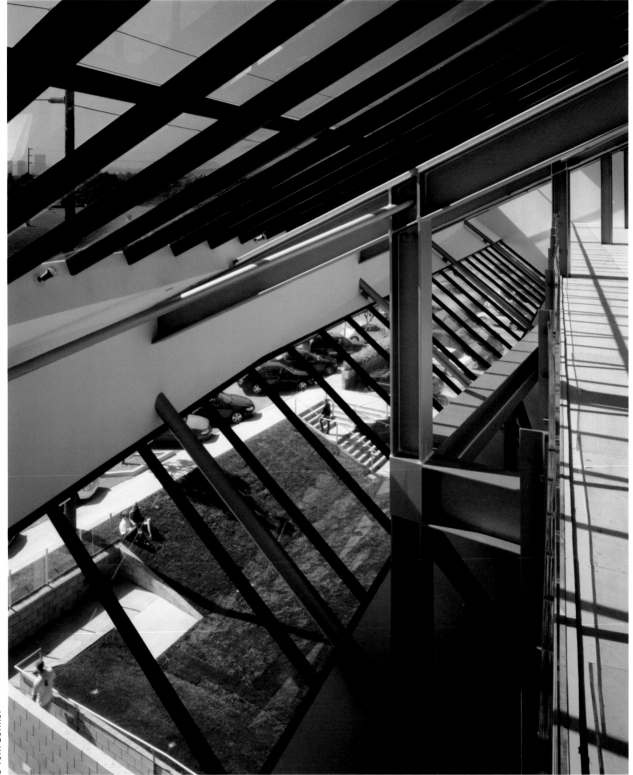

© Tom Bonner

Axonometric development

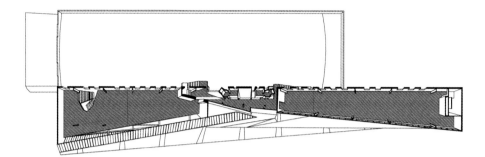

Third floor plan

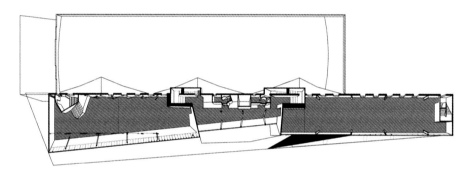

Second floor plan

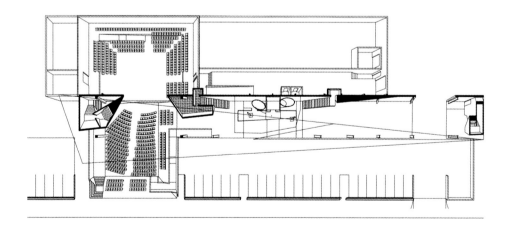

Ground floor plan

0 5 10

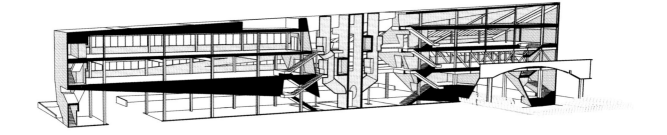

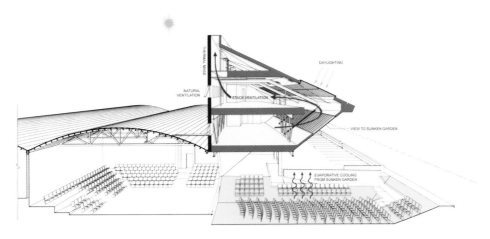

Plans in perspective

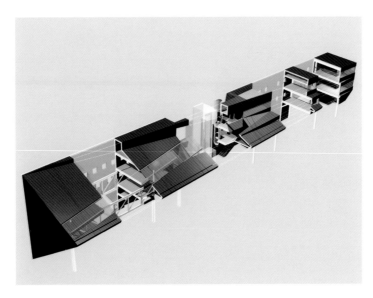

Section in perspective

Guangdong Museum Guangzhou, China, 2006

The City of Guangzhou is growing at an unprecedented rate, especially toward the south, in the direction of the Pearl River. The site of the new Guangdong Museum and Opera House offers a unique planning opportunity to deal with this rapid growth and afford its residents new experiences in the world of art and culture. To address the area where the city and the river meet, and provide a new quality of public space, the museum design proposes two conceptual metaphors: the mountain with four peaks and the glass forest.

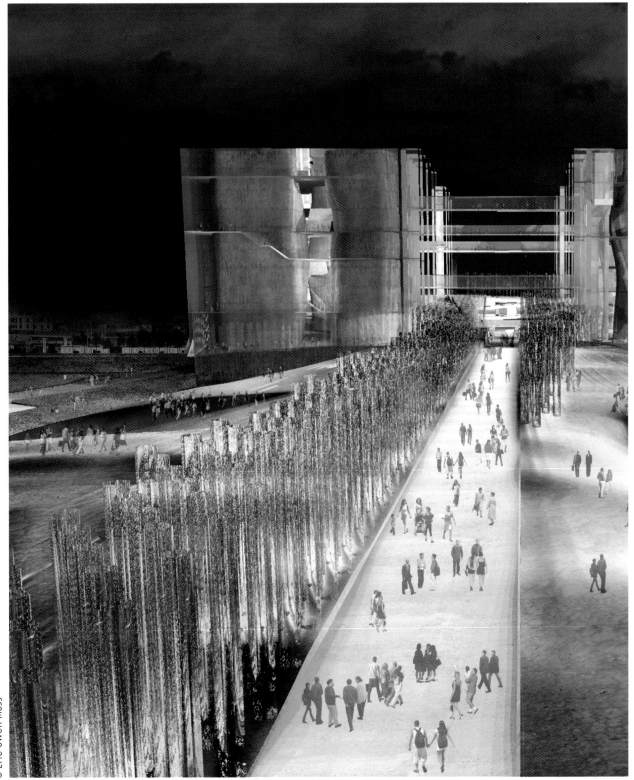

Location plan

Floor plan

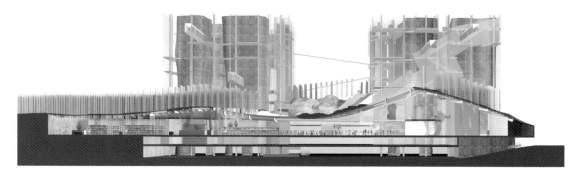

Section perspectives

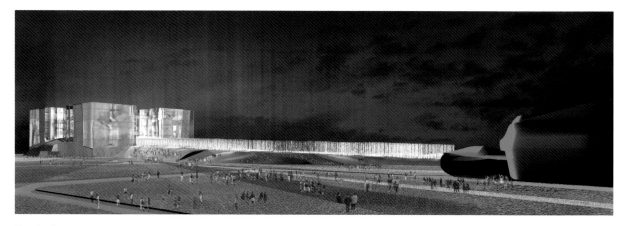

Rendering

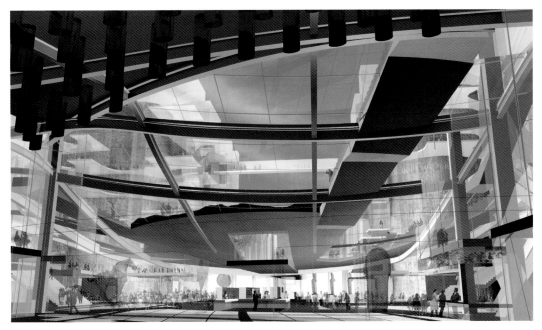

Interior perspective rendering

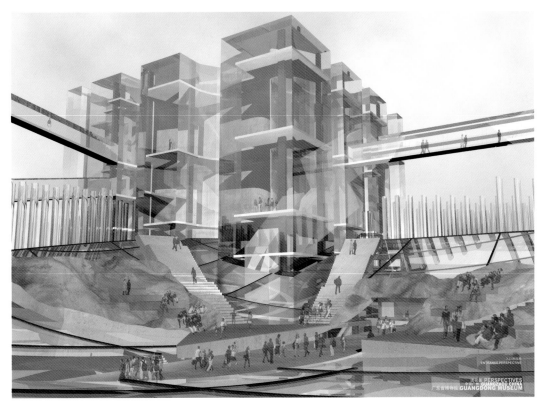

Exterior perspective rendering

Espinet/Ubach

Miquel Espinet and Antoni Ubach are the principals of this architectural firm in Barcelona, Spain, which has been in operation for 25 years. Over their long career they have received a number of national and international awards. What makes them unique is their understanding of the impact of architectural design symbols. Leaders in innovation, creativity, and pragmatism, they have produced noteworthy projects such as the Can Dragó Olympic installations (for the 1992 Barcelona games), the reconstruction of the Spanish Pavilion at the Paris Expo, the V Centenario building in Melilla, the Library of the Autonomous University of Barcelona, the School of Medicine of the University of Barcelona, the Ra Beach Thalasso Spa Hotel, and the Natura Hotel chain.

Ubach

Ra Beach Thalasso Spa Hotel El Vendrell, Tarragona, Spain, 2003

This hotel occupies the former Sanitarium of Sant Joan de Déu de Calafell, designed by Rodríguez Arias, which had been in ruins. The new project embraces the old, but clearly identifies the differences between the new and old parts. The new building is U-shaped, with each wing stretching out from the former sanitarium to embrace the water. Cloister-like in form and function, these wings welcome visitors from the rooms; some take advantage of the spaces created by the original architecture.

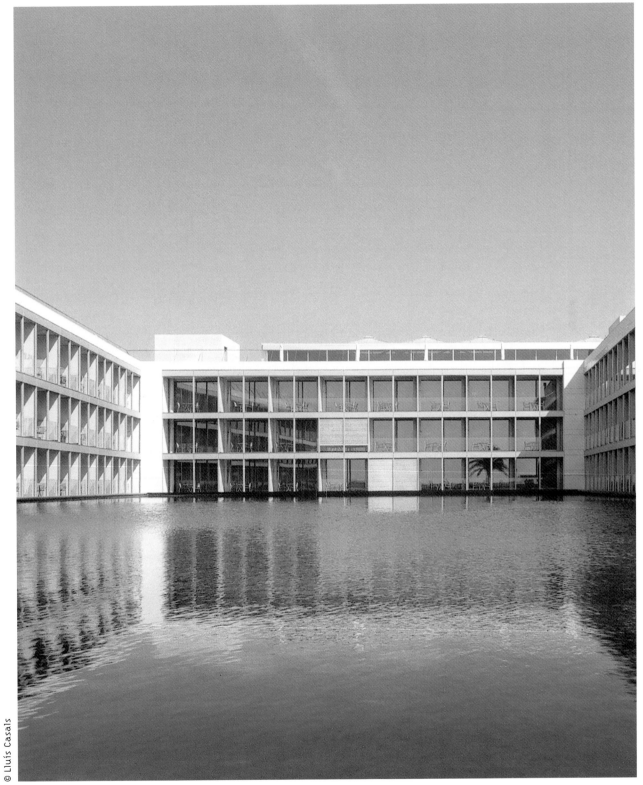

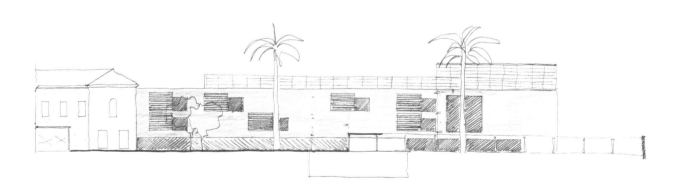

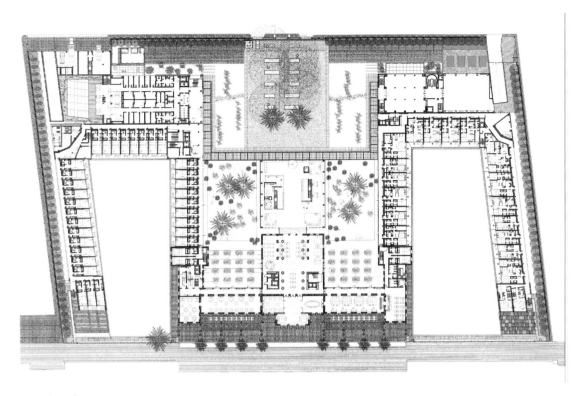

Location plan

0 5 10

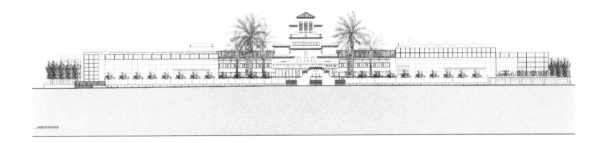

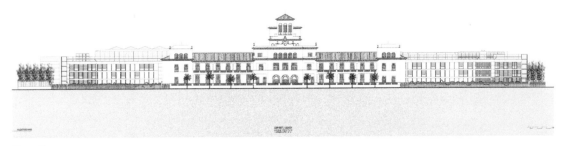

Elevations

V Centenario Building Melilla, Spain, 1998

This building is part of the urban renewal of the city of Melilla, specifically the former "mineral loading bay." Housing offices, an administrative center for the city, and, on the top floor, a restaurant with panoramic sea views, this new building is the most important part of the complex. Structurally, it consists of two symmetrical towers, each about 215 feet tall. Orienting the offices toward the facades affords exquisite views, since the entrances are in the center part. The restaurant rests on a high disk that joins the two towers.

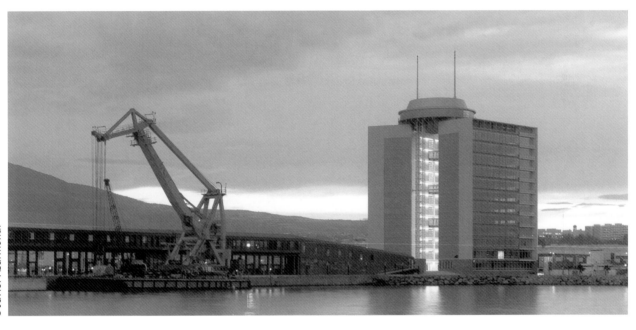

Schematic design sketches

Design development

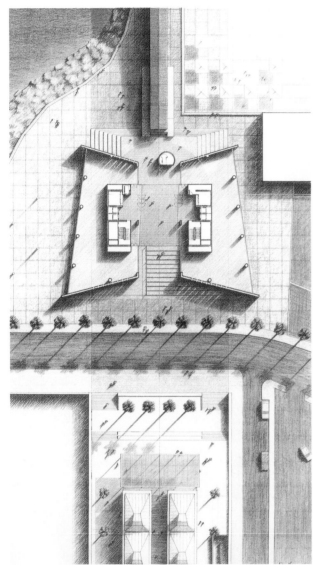

Site plan

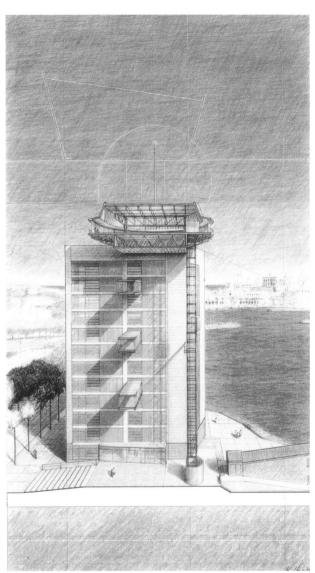

Perspective

Espinet/Ubach 259

Library of the Universidad Autónoma de Barcelona Bellaterra, Barcelona, Spain, 2002

The new library was erected on a steep slope between a stream and woods, so the building acts as a containing wall in the natural environment as well as a connection between two levels marked by their different natural conditions. At one side of the building, on the lower level, is the Plaça Cívica, the heart of the campus; at the other side, on the upper floor, the building opens up to nature, being in the woods. In all, there are five levels: a multi-purpose lower level, a first level of offices, and three levels of general and newspaper/periodical library services.

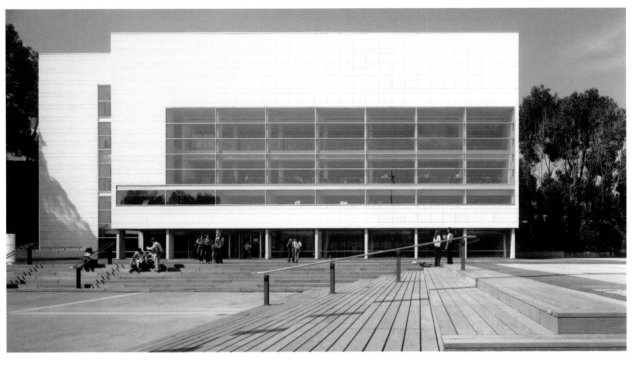

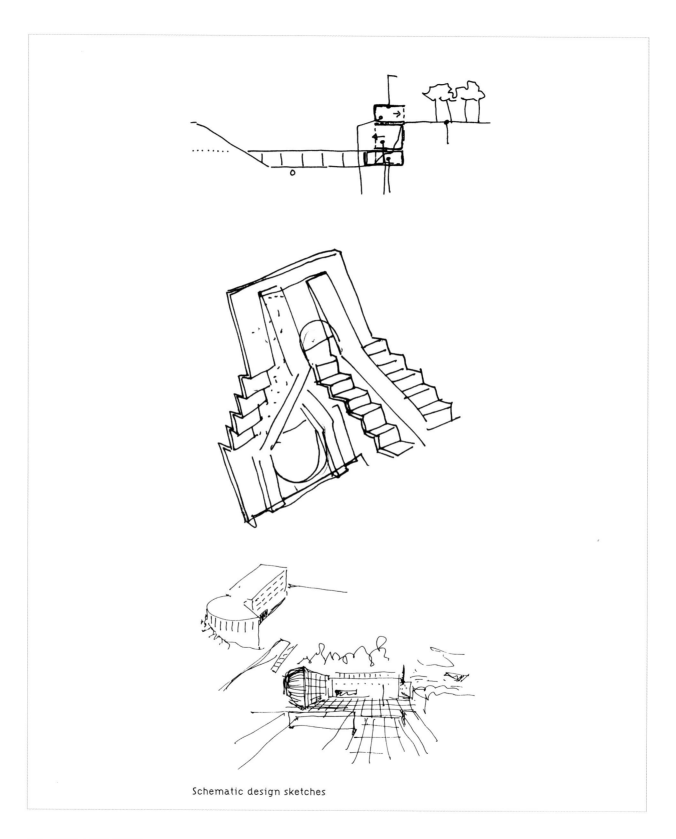

Schematic design sketches

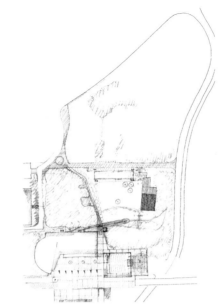

Design development site plan

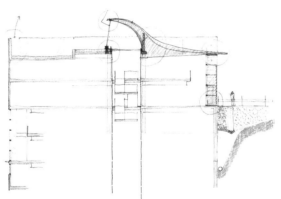

Design development section

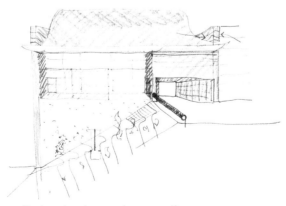

Design development perspective

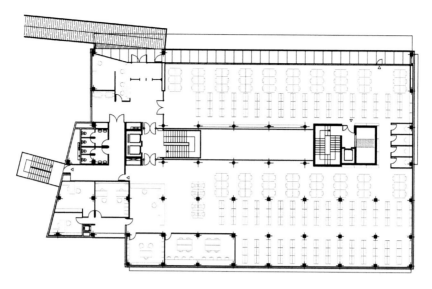

Second floor plan

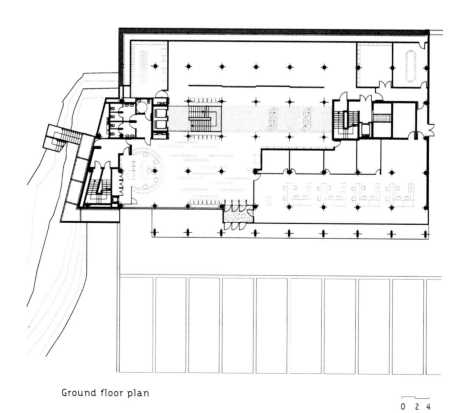

Ground floor plan

0 2 4

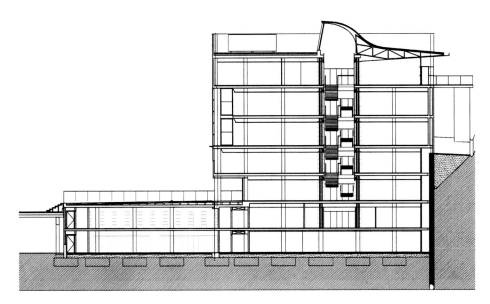

Longitudinal section

Future Systems

Jan Kaplicky and Amanda Levete are the principals of Future Systems, a London-based architecture and design firm committed to producing highly original work. Their projects are characterized not just by innovative and striking design, but also by their high level of functionality, inspired by nature as well as technologies transferred from other disciplines. Future Systems is internationally recognized for its continuing redefinition of traditional concepts of space and its clear commitment to the environment and efficiency. Research is fundamental to the firm, as is the quest for an appropriate balance between experimental and actual projects. Its work, which runs the gamut from private homes and commercial buildings to large institutional structures, has become a vital part of the modern British landscape.

Selfridges

Systems

Selfridges Birmingham, UK, 2003

1' PONT *1:50* *12 – 7 – 00*

This building was intended to be an architectural landmark for Birmingham and the point of reference for this British city's urban renewal. This large downtown department store sits amid impressive buildings of the 1960s and structures that reflect the area's industrial decline. One of the project's objectives was to reinterpret the concept of the large department store, not just in terms of form, but also in terms of the social dynamic established inside. Both the interior and exterior are on the cutting edge of architecture, previously reserved for the most elite fashion labels.

20 - 12 - 00

Schematic design sketches 29 - 10 - 99

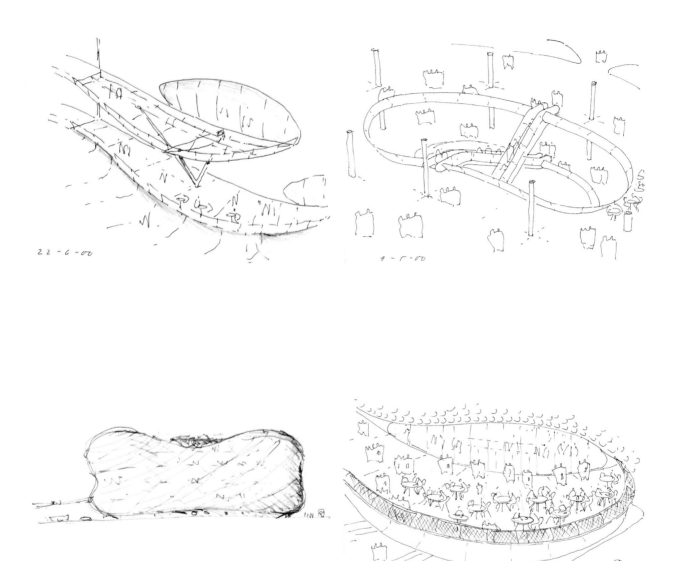

22-6-00

9-5-00

22-10-99

1-8-00

Design development drawings

Sketch

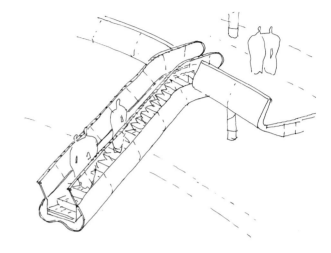

Design development perspectives

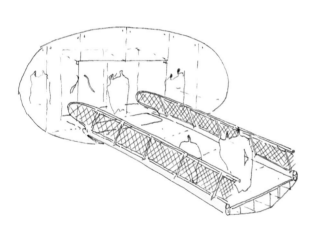

Design development perspectives

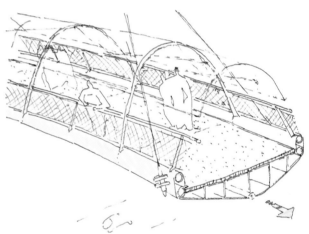

Design development perspectives

10 - 5 - 00

Exterior perspectives

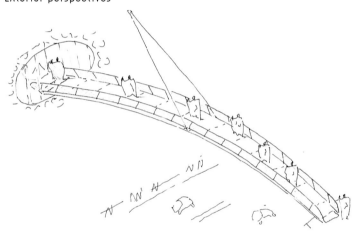

Study perspectives

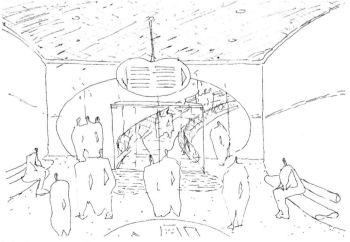

Interior perspectives

Kengo Kuma

Kengo Kuma was born in the prefecture of Kanagawa, Japan in 1954. He received his degree in architecture in 1979 and went on to study at Columbia University in New York. He opened the Spatial Design Studio in 1987 and founded Kengo Kuma & Associates in 1990. His stellar career in Japan, with projects such as the Stone Museum, the Great (Bamboo) Wall house, and ONE Omotesando, has earned him various national and international awards. His work is characterized by a commitment to the environment, the sculptural quality of his buildings, and exquisite care in the handling of materials, which result in just the right balance between nature and architecture.

☐ Hiroshige Ando Museum

☐ Stone Museum

Kuma

Hiroshige Ando Museum Nasu-gun, Tochigi, Japan, 2000

This museum is composed of a series of wooden-structured grids, used in the roof as well as the walls. The intersection of these reticles results in effects that change in accordance with the changing light that pours into the interior space. The pattern is sometimes perceived as a solid plane and sometimes as a translucent texture. Also, depending on the nature of the weather, the pattern shows different, more or less lively, nuances of the material. The design of the museum is inspired by Hiroshige's prints, which are characterized by their changing view of nature.

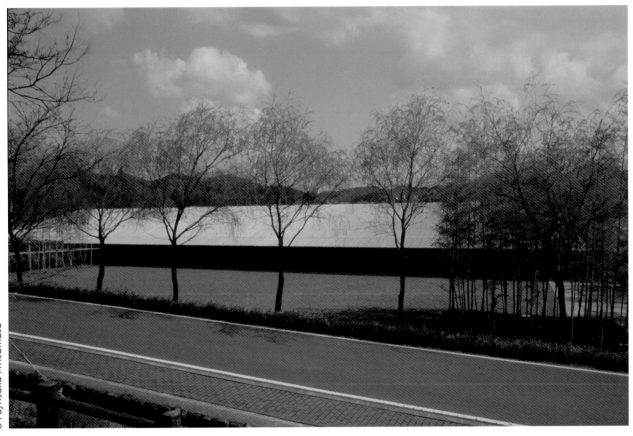

Studies

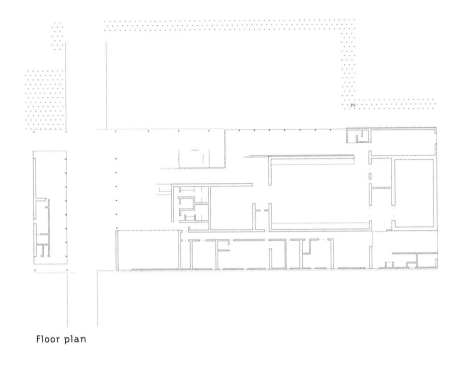

Floor plan

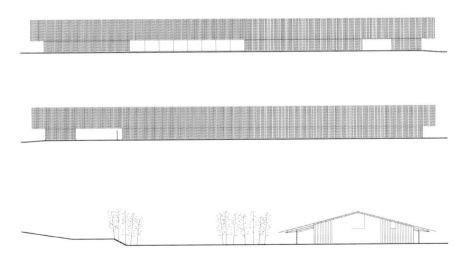

Elevations

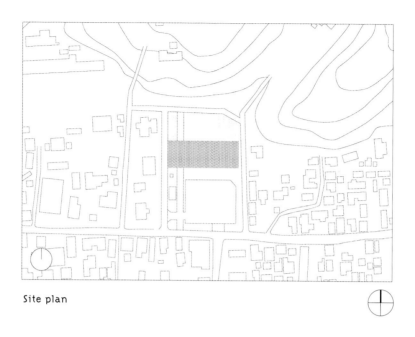

Site plan

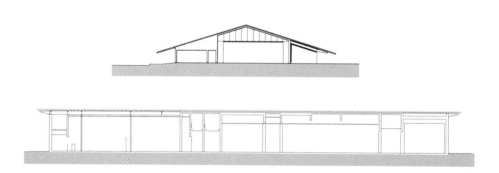

Sections

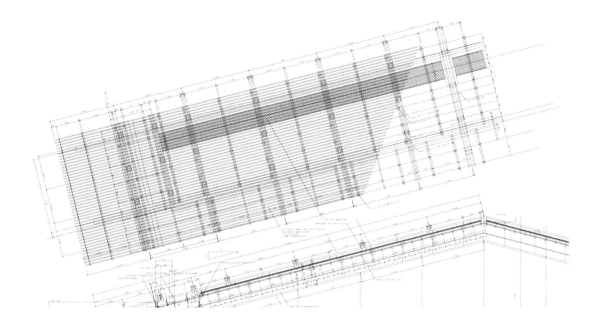

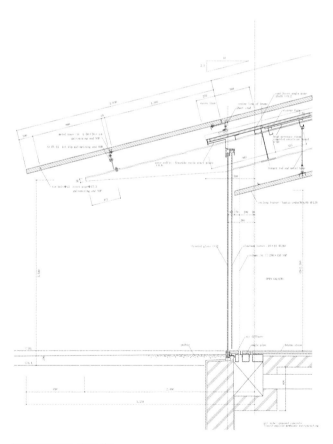

Construction details

Kengo Kuma

Stone Museum Nasu, Tochigi, Japan, 2000

This project attempts to restore the three original, traditional Japanese stone warehouses built long ago in the Ashino region of Nasu. The new program seeks to reactivate this complex by means of units that function as connectors between the original volumes and create a close relationship between interior and exterior. The great challenge was using stone as the raw material while producing a smooth, light, permeable appearance. The solution was in creating a texture of fine horizontal lines, making the material look lighter, and including a series of openings that blurs the boundaries between the interior and exterior.

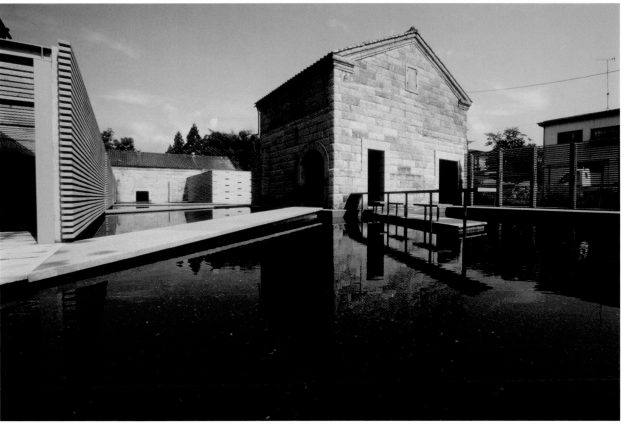

Facade study

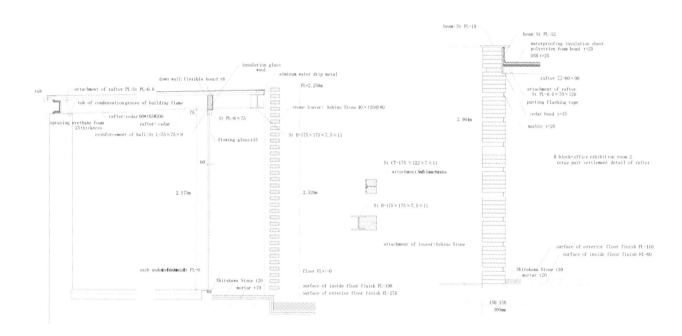

beam: St PL-19
beam: St PL-12
waterproofing insulation sheet
polystylen foam boad t=25
OSB t=25

insulation glass
wool
down wall: flexible board t6
aluminum water drip metal
FL+2.250m

rafter □-60×90
attachment of rafter
St PL-6.0×70×120
putting flashing tape

attachment of rafter PL:St PL-6.0
tub
tub of condensation groove of building flame
75
St PL-6×75

cedar boad t=15

rafter:cedar 60*165@300
rafter: cedar
St H-175×175×7.5×11

marble t=20

spraying urethane foam
25 thickness
reinforcement of hall:St L-75×75×9
flowing glass t15

stone louver: Ashino Stone 40×120@80

2.964m

60

St CT-175×122×7×11
attachment Ashino Stone

B block·office exhibition room 2
verge part settlement detail of rafter

2.175m

2.520m

St H-175×175×7.5×11

attachment of louver:Ashino Stone

surface of exterior floor finish FL-110
surface of inside floor finish FL-60

sash under mullion:St PL-6
Shirakawa Stone t20
mortar t70
floor FL+/-0
surface of inside floor finish FL-190
surface of exterior floor finish FL-270

Shirakawa Stone t30
mortar t20

150 150
300mm

Construction detail

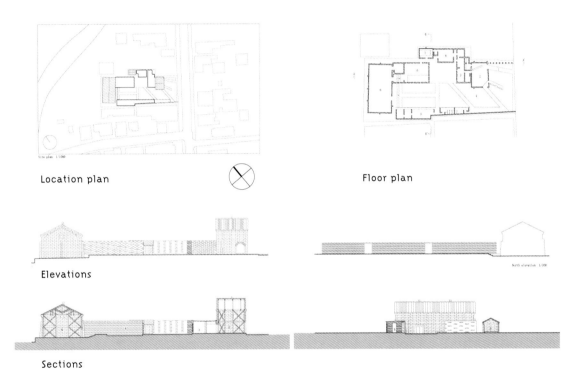

Location plan

Floor plan

Elevations

Sections

Klein Dytham Architecture

Astrid Klein was born in Varese, Italy in 1962 and earned
her degree in Interior Design at the Ecole des Arts
Decoratifs in Strasburg, France. Mark Dytham was born
in Northamptonshire, England in 1964 and graduated
from the Newcastle University School of Architecture.
Both continued their studies at the Royal College of Art
in London, earning Master of Arts degrees in 1988. They
also worked together in the office of Toyo Ito and, in 1991,
opened Klein Dytham Architecture in Tokyo. A bilingual
firm, it specializes in architecture, interiors, and
furniture design. Drawing on their training with Eastern
and Western referents, they try to merge the two cultures.
They never use formulas, but start from their own work
with the client, the plan, and the other project
parameters to develop a unique, appropriate, fun,
and pleasing solution. Materials, color, humor, and
technology are all key elements in their work.

Architecture

Garden Chapel Yamanashi, Japan, 2004

The chapel, located on the grounds of the Risonare Hotel Resort in Kobuchizawa, Japan, sits amid a rich natural landscape with magnificent views of Mount Yatsugatuke and Mount Fuji. It consists of two structures resembling leaves, one glass and the other steel, that seem to flutter. The glass leaf, with its fine lacy pattern, functions like a pergola, and the structure that supports it is reminiscent of the veins that run through leaves, becoming narrower as they approach the tips. The metal leaf, perforated with 4700 holes containing acrylic lenses, is like a delicate bridal veil.

正円

Schematic design sketches

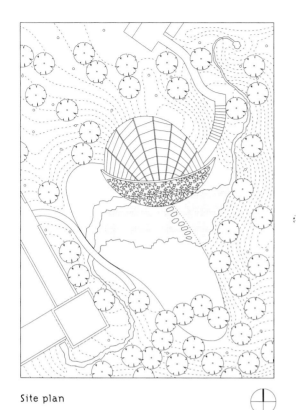

Site plan

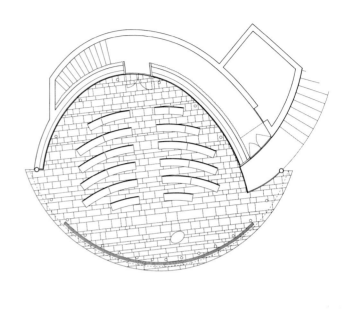

Floor plan

0 1 2

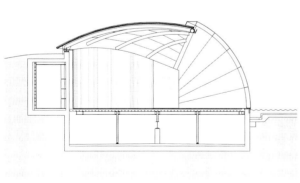

Section

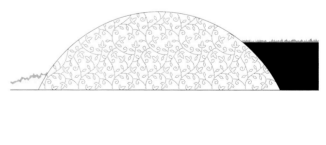

Elevation

Undercover Lab Tokyo, Japan, 2001

This company's name describes one of its principal traits, secrecy, which was used as a point of departure for the project design. Even the plot sits discreetly amid the urban profile, set back from the buildings on the street, with a narrow access passage. This passage was pivotal to the design of the project, a long structure with parking for up to five cars on the lower level and a studio, press showroom, and office on an upper level.

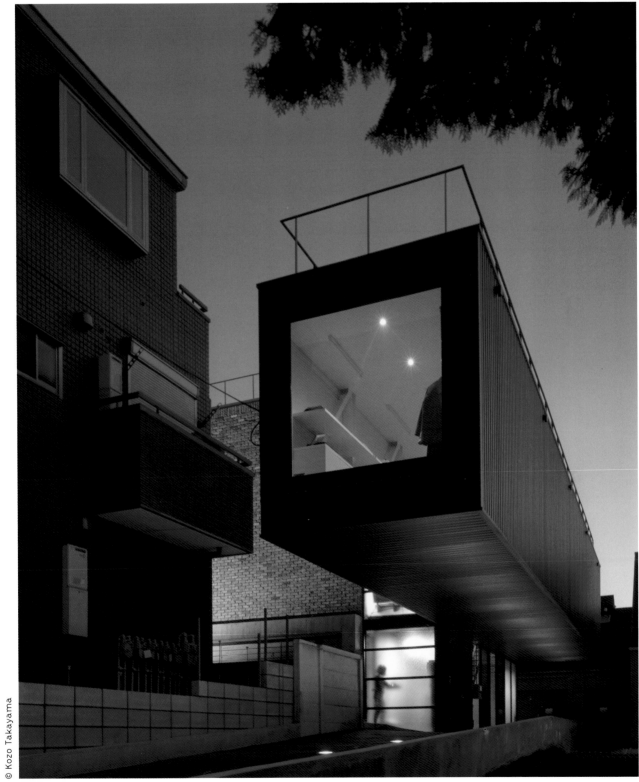

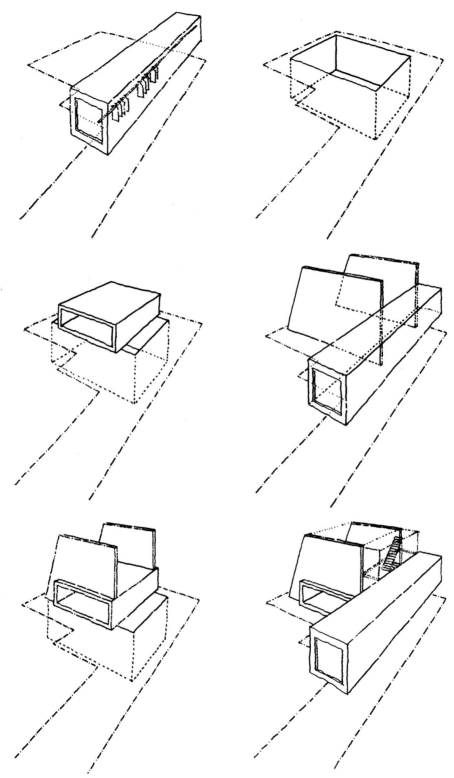

Design development studies

Foundation plan

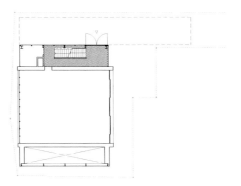

Ground floor plan

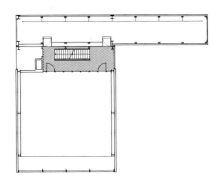

Second floor plan

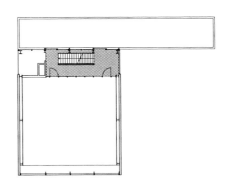

Third floor plan

0 2 4

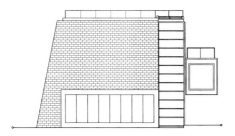

Elevations

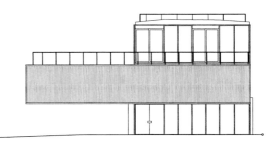

■ Klein Dytham Architecture

Vrooom! Nagoya, Japan, 1999

This unique project consists of a garage in Nagoya, Japan, where a car enthusiast keeps his collection. The challenge was to create a space as suggestive as the six cars it would house, on a very narrow site, with room for a study on an upper level. The solution is a continuous surface that sweeps upward from the ground like a ribbon to become the study's roof. Its curve is reminiscent of a photography studio, giving the space a fluid, aerodynamic feel.

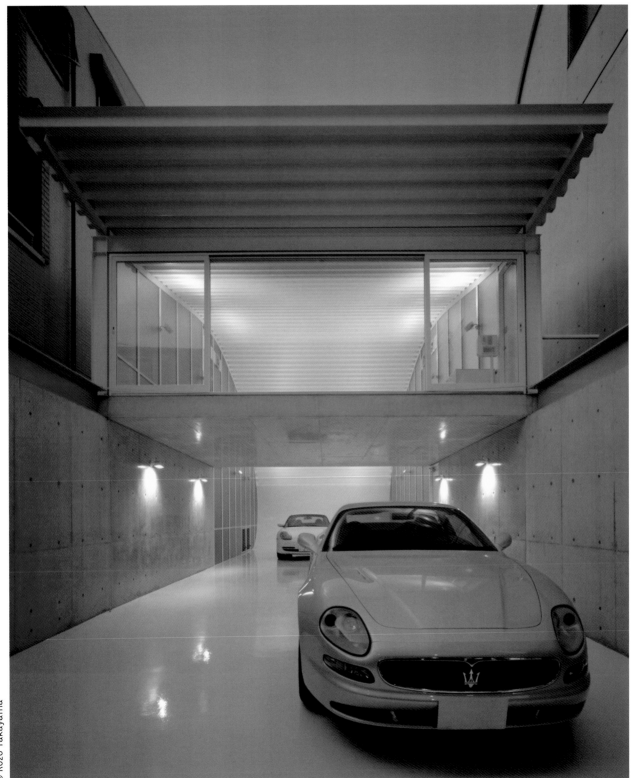

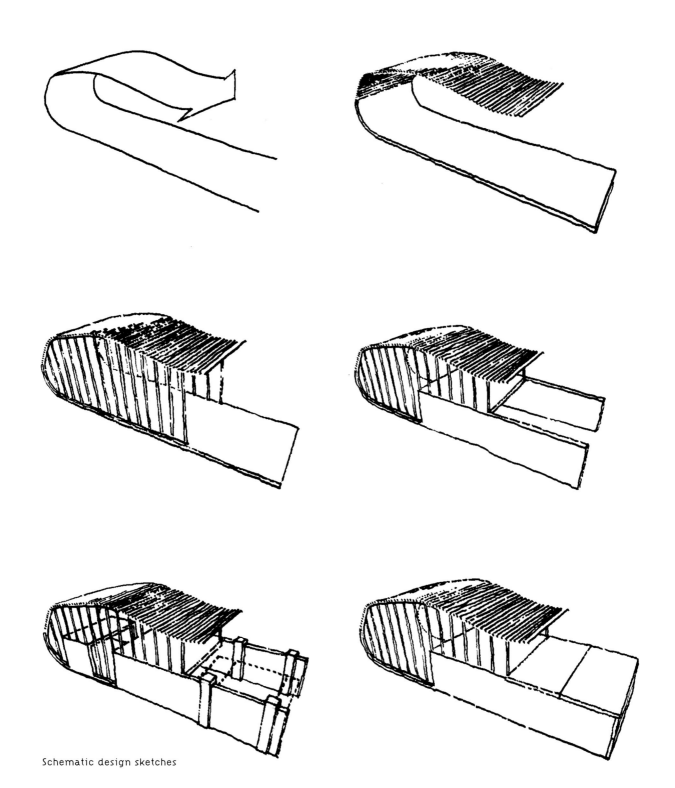

Schematic design sketches

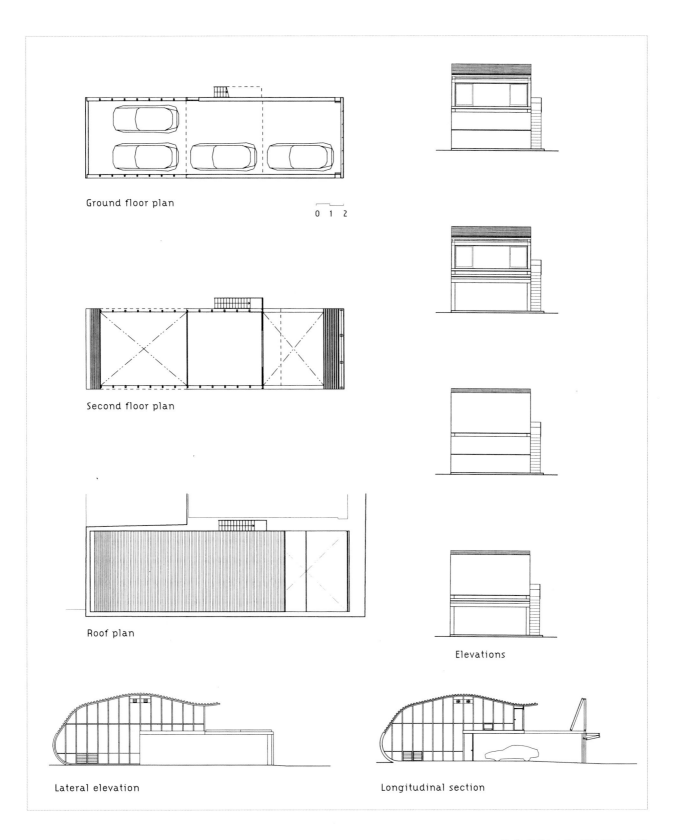

Ground floor plan

0 1 2

Second floor plan

Roof plan

Elevations

Lateral elevation

Longitudinal section

Legorreta + Legorreta

☐ School of Engineering and Business, Qatar

☐ University of Chicago Student Dormitories

☐ Sheraton Abandoibarra Hotel

Legorreta

School of Engineering and Business, Qatar Doha, Qatar, 2006

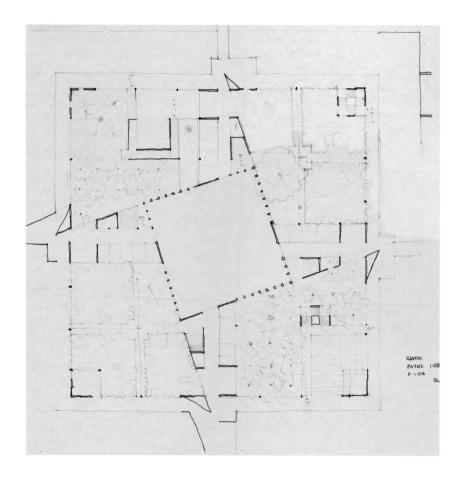

The school is part of a large and ambitious project known as the Qatar Foundation's Education City, commissioned by Sheika Mozah, second wife of the Emir of Qatar. It consists of a vast, state-of-the-art campus in partnership with prestigious universities in the United States. The design for the Engineering School is complete: two buildings, one for academics and one for research, joined by a central courtyard. The academic building is subdivided into four schools distributed around a central tower and four courtyards, which serve as spaces where students and teachers can meet, socialize, and interact.

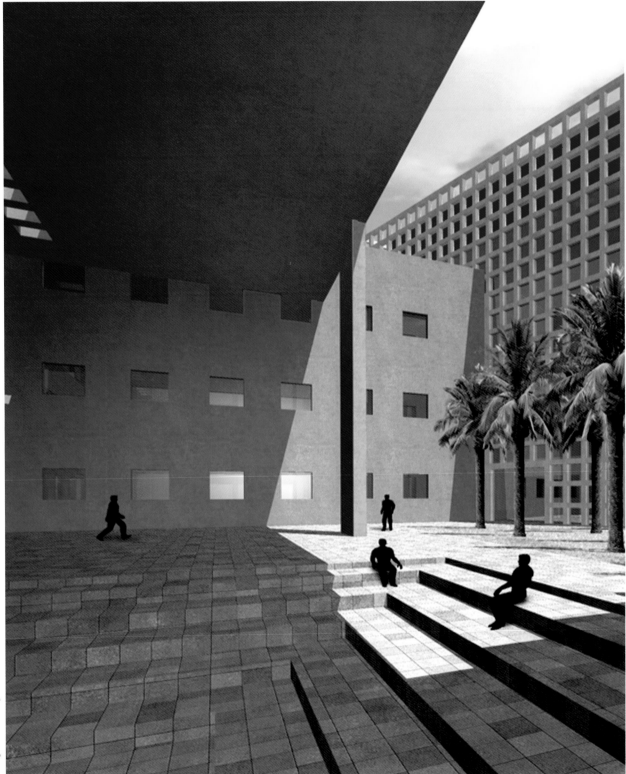

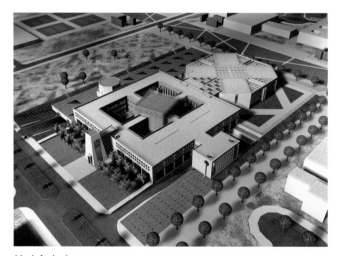

Model study

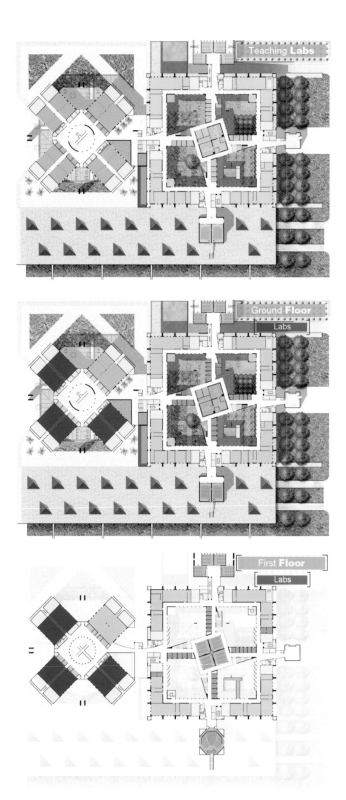

Floor plans

0 5 10

Location plan

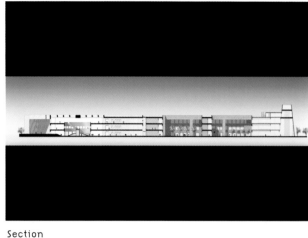

Section

West Elevation

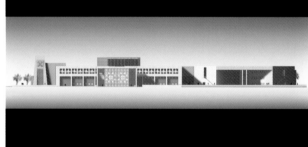
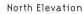

North Elevation

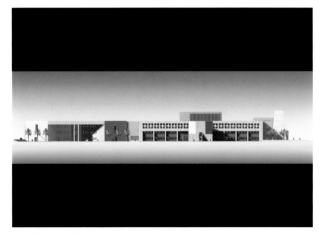

South Elevation

East Elevation

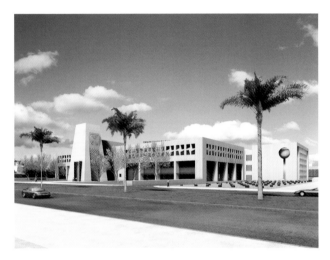

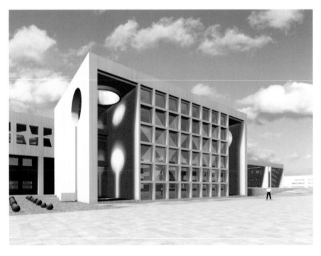

3-D model renderings (exterior & interior)

University of Chicago Student Dormitories Chicago, IL, USA, 2001

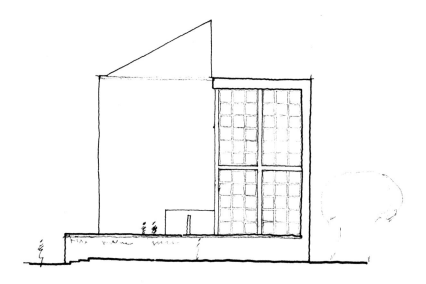

The idea was to create a building that responded to the strong influence, in terms of size and materials, of the gothic buildings that surround it, while using a contemporary language. The relationship to the existing buildings was established through the use of courtyards, generating a series of open spaces that lend character to the academic and dormitory units. The plan consists of three main buildings. The one in the northeast corner boasts a closed atrium which contains the principal public areas; the second is a long unit, and the third is a more closed and introverted building.

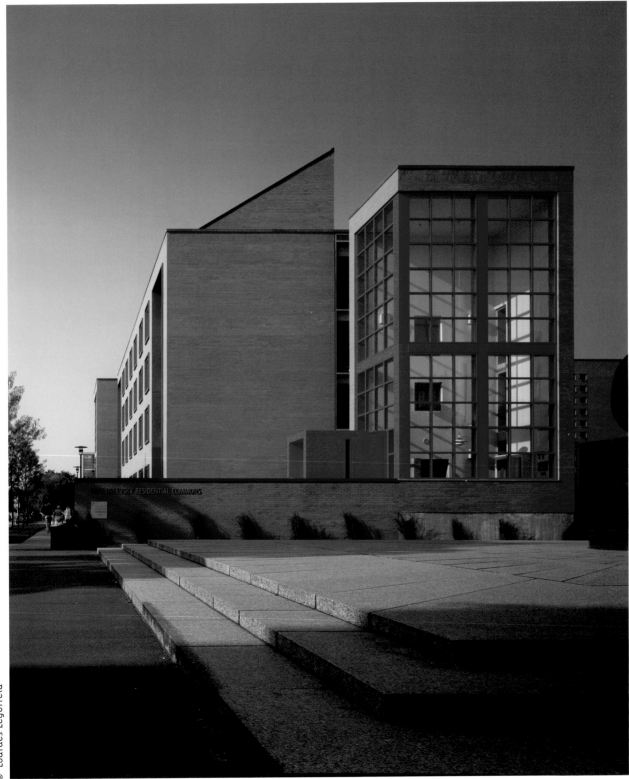

Site plan

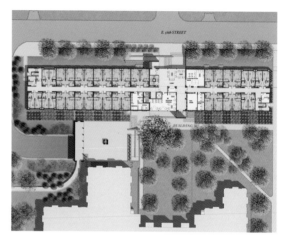

Site building 1 plan

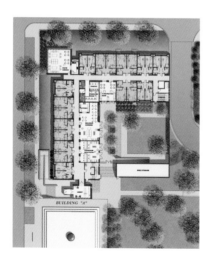

Site building 2 plan

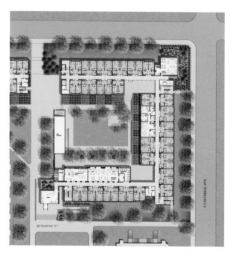

Site building 3 plan

0 5 10

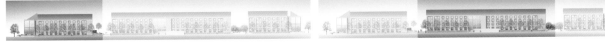

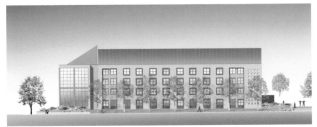

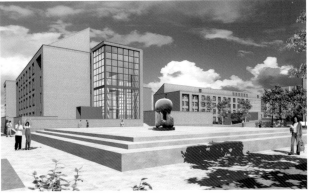

Building 3 elevation

Building 1 elevation

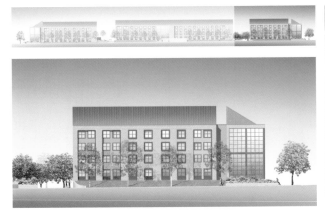

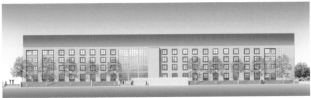

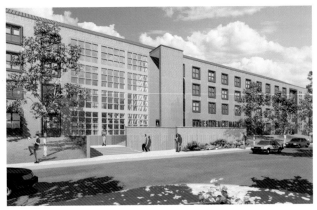

Building 2 elevation

Side of street 3-D Model rendering

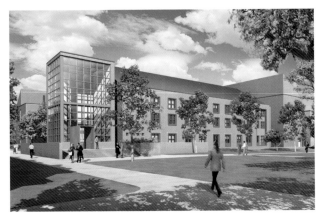

Building 1 3-D Model render

3-D Model rendering

■ Legorreta + Legorreta

Sheraton Abandoibarra Hotel Bilbao, Spain, 2002

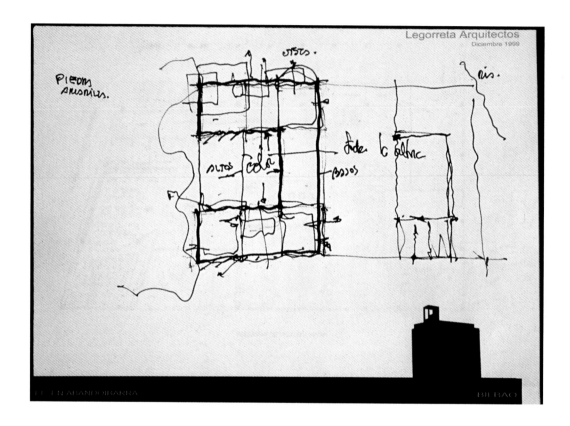

This hotel is part of Ría 2000, Bilbao's project for renewal of the Nervión River waterfront. The building completely covers a 17,653-square-foot plot and has ten stories and a recessed penthouse. Taking Basque Country history and culture as a point of departure, the architects designed a large, solid block, like a sculpture which they carved in accordance with the needs of the program. The perforations in the walls allow sunlight to filter through to the interior, creating changing patterns of light and shadow as the day wears on.

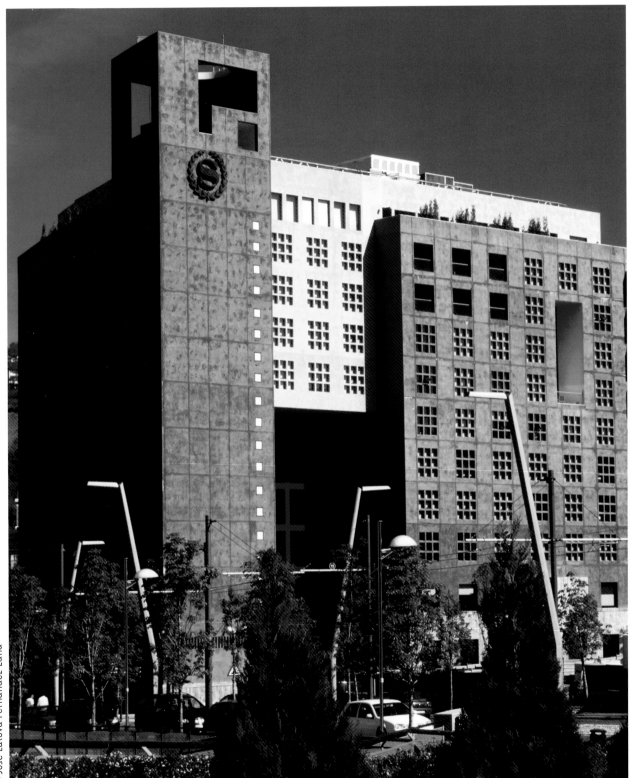

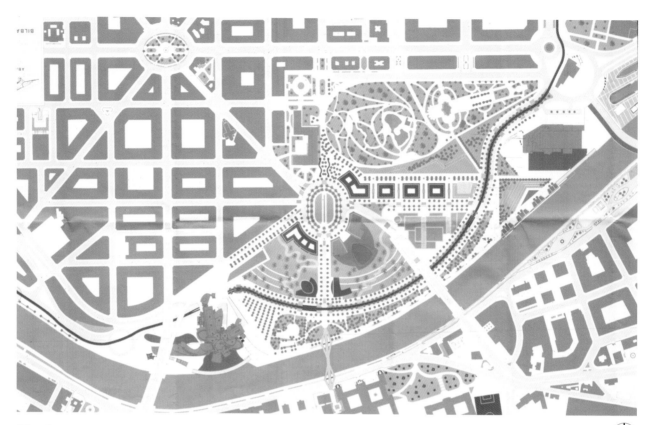

Site plan

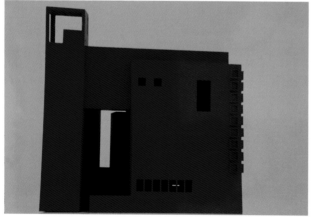
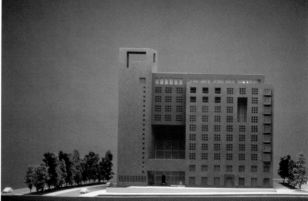

Models

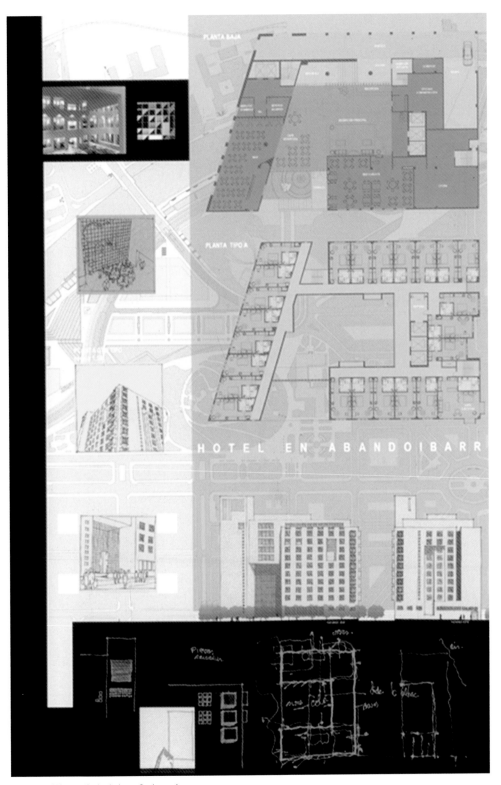

PLANTA BAJA

PLANTA TIPO A

HOTEL EN ABANDOIBARR

Composition of sketches & drawings

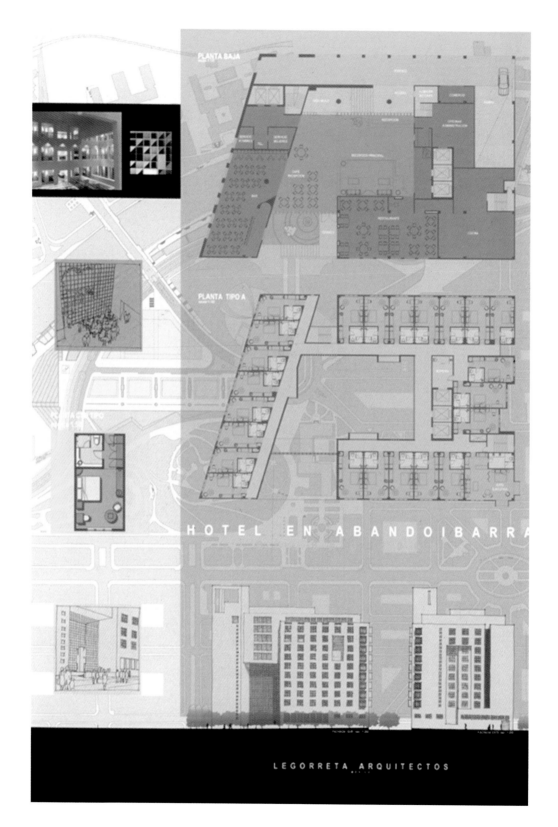

PLANTA BAJA

PLANTA TIPO A

HOTEL EN ABANDOIBARRA

LEGORRETA ARQUITECTOS

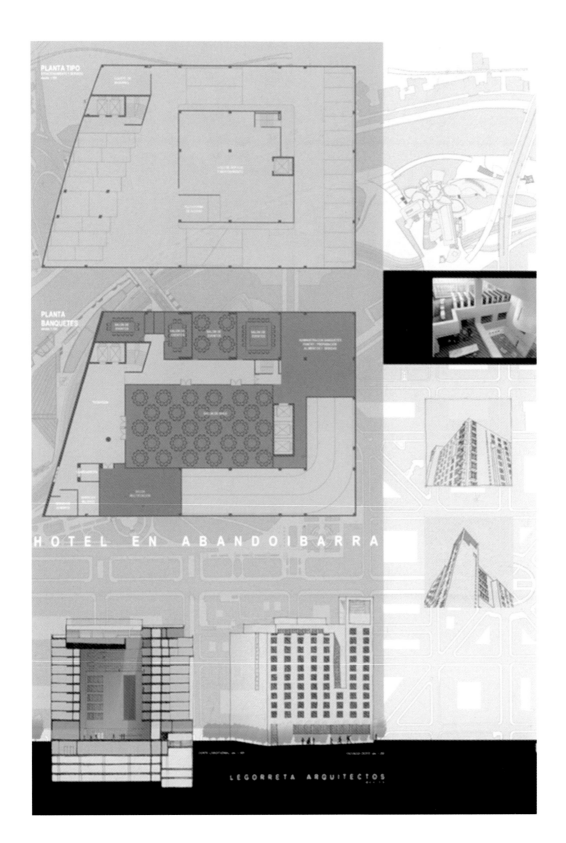

PLANTA TIPO

PLANTA
BANQUETES

HOTEL EN ABANDOIBARRA

LEGORRETA ARQUITECTOS

Mario Botta

Mario Botta was born in Mendrisio, Switzerland in 1943, and has been practicing architecture since the age of 15, when he started as an apprentice with Carloni & Camenisch in Lugano. He received his degree in architecture from the University Institute of Architecture in Venice in 1969. Working in collaboration with masters such as Le Corbusier and Louis I. Kahn, as well as his mentor, Carlo Scarpa, he inherited certain established traditions of the modern movement. In 1970 he established his own firm in Lugano. Since then his work has earned international renown, starting with a series of private houses in Switzerland, and he has gained prominence in the world of architecture. Characterized by an extraordinary use of natural light, which illuminates the interior and defines the exterior, his architecture explores zenithal light and the quest for large interior spaces.

Botta

■ **Mario Botta**

San Francisco Museum of Modern Ar San Francisco, CA, USA, 1995

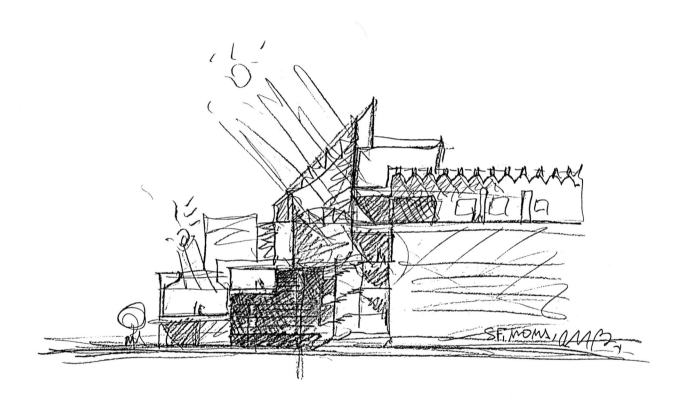

This museum is situated in an important urban enclave of San Francisco's Third Street, just south of Market Street, near the financial district and opposite the Yerba Buena Center. The project had three basic objectives: first, the use of natural zenithal light in most of the galleries, giving these spaces a special character in keeping with the weather and the time of day. Second, to ensure that the visitor can understand the interior layout as soon as he or she enters the building. And third, the expression of an architectural language that follows no trend or cultural fashion.

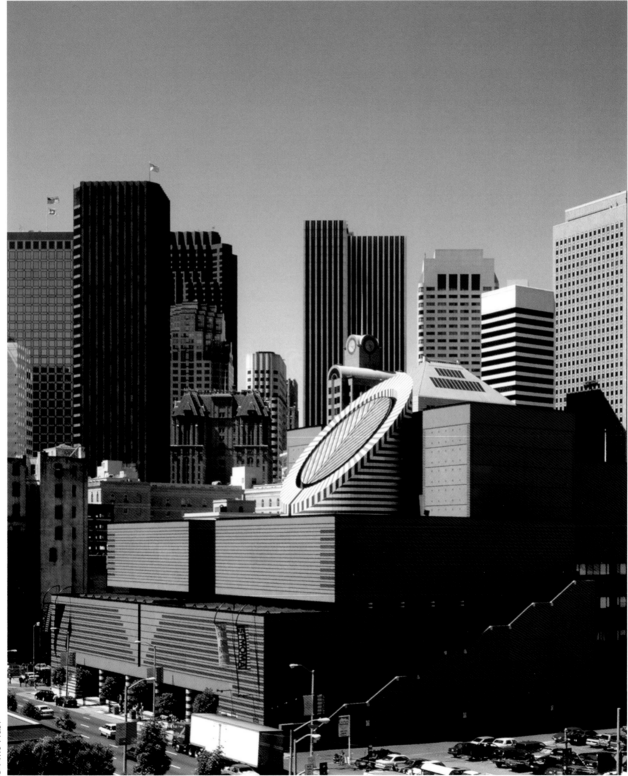

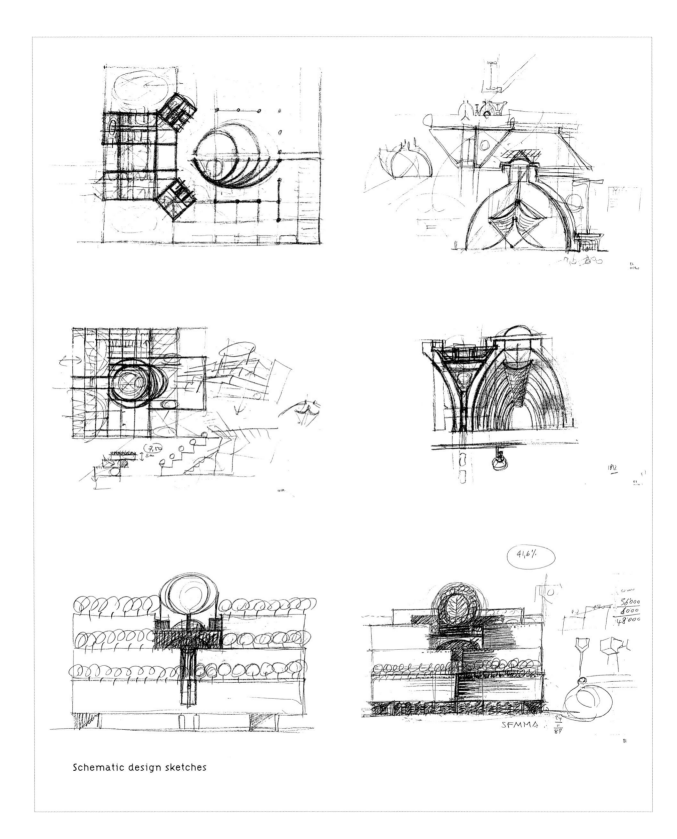

Schematic design sketches

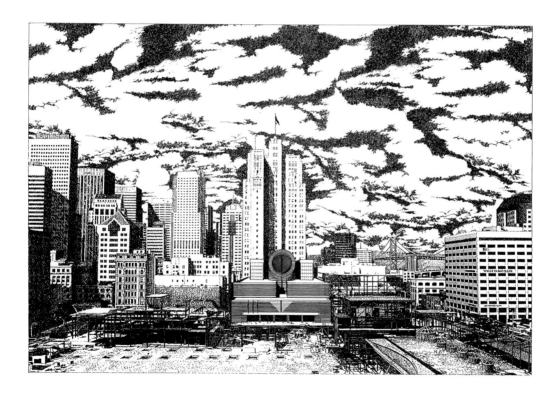

Design development perspective

Site plan

Ground floor plan

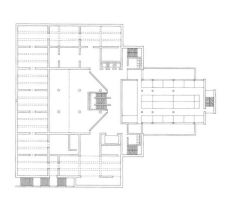

Second floor plan

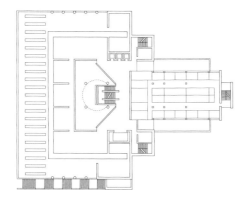

Third floor plan

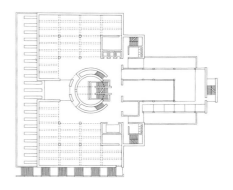

Fourth floor plan

0 5 10

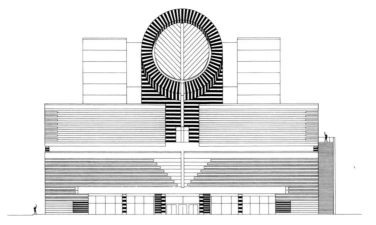

Elevation

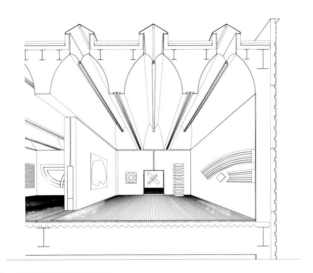

Sectional perspective

Perspective

Chapel of Santa Maria degli Angeli Ticino, Switzerland, 1996

The building detaches itself from the mountain, forming a new horizon like the starting point of an ideal viaduct. The entrance passageway begins at the natural slope of the mountain and offers two paths: one open air, leading to a belvedere that looks out at the panoramic view, the other interior, leading directly to the church entrance. Formed by amphitheater-like steps, the roof becomes a continuous passageway that looks toward the mountain and offers varied views of the landscape.

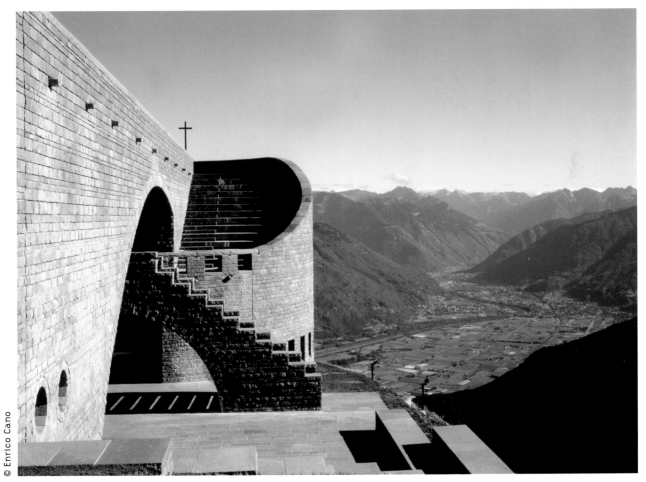

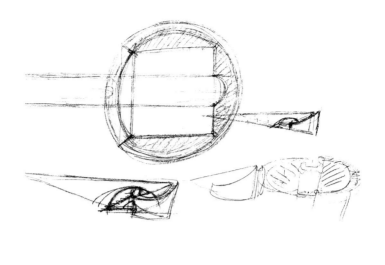

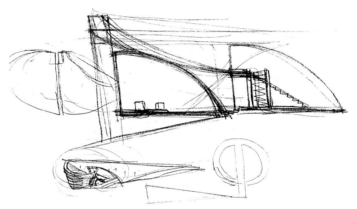

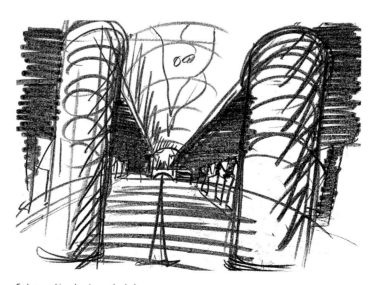

Schematic design sketches

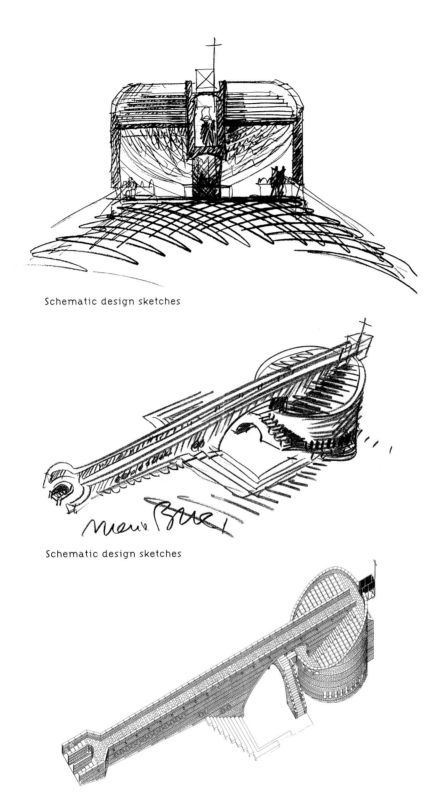

Schematic design sketches

Schematic design sketches

Design development model

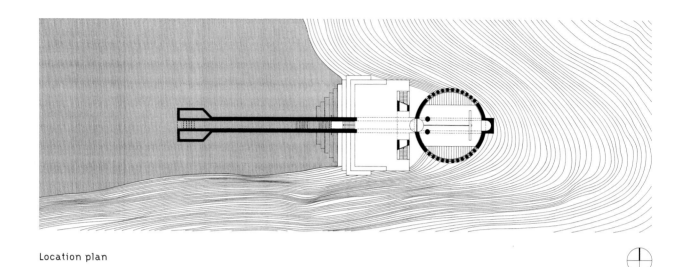

Location plan

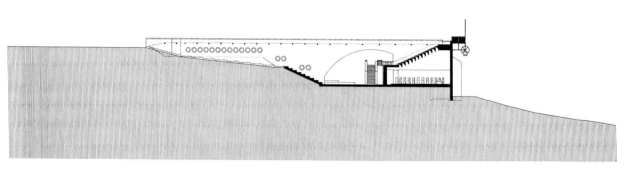

Longitudinal section

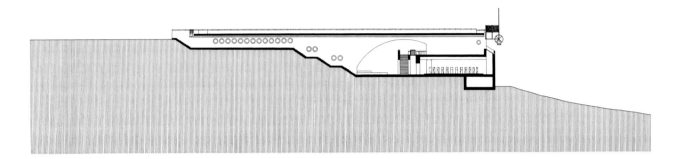

Longitudinal section

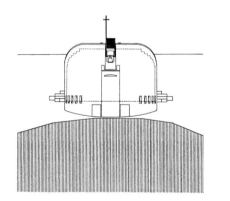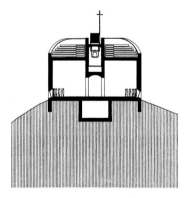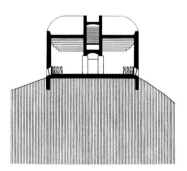

Cross sections

Cymbalista Synagogue Tel Aviv, Israel, 1998

This new building on the University of Tel Aviv campus was meant to be a place of prayer as well as a conference hall, where the religious and secular could come together. The most appropriate spot on the campus, an undeveloped corner, was chosen so the building would be a clear reference point within the university complex. Such a clear purpose and such favorable conditions, according to Botta himself, called for a simple, powerful plan: two towers joined by a vestibule on the first floor where the common-use areas are located.

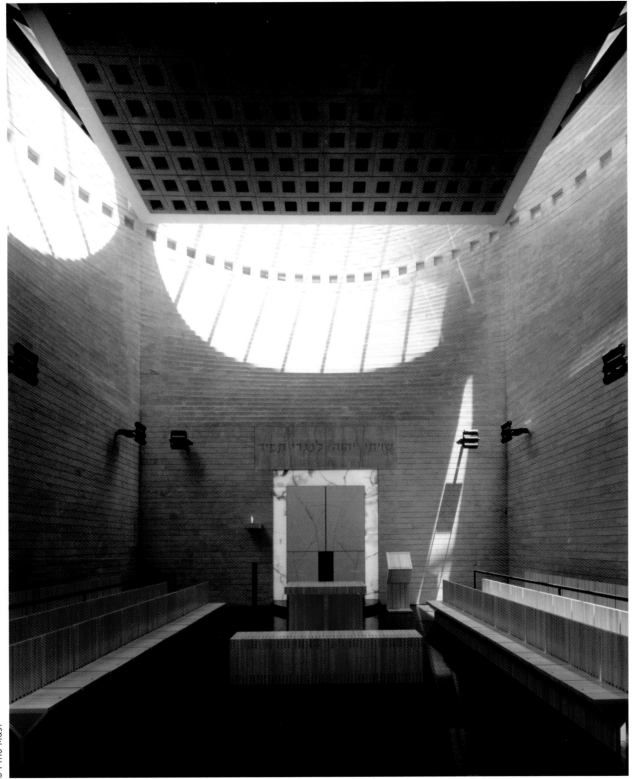

Schematic design sketches

Schematic design sketches

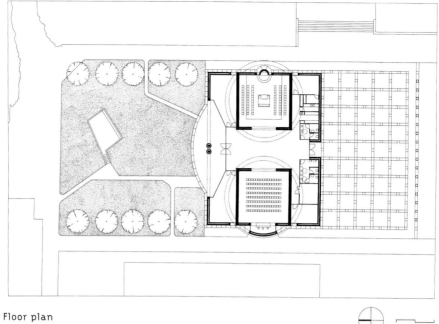

Floor plan

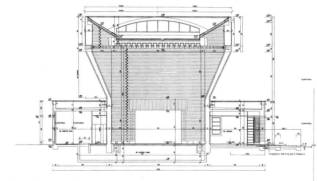

Construction section

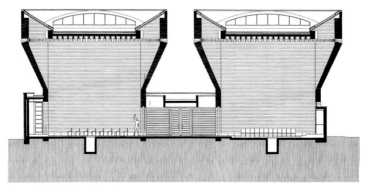

Longitudinal section

Axonometric drawing

Massimiliano Fuksas

Massimiliano Fuksas was born in Rome in 1944 and
earned his degree in architecture from La Sapienza
University in 1969. He established his firm in Rome in
1967, and subsequently opened offices in Paris (1989),
Vienna (1993), and, just recently, Frankfurt. He has been a
guest professor at many international universities, won
some of the most prestigious awards, such as the Grand
Prix d´Architecture Française, and been elected to
membership in the French Académie d´Architecture
and the Academia San Luca in Rome, and to honorary
membership in the American Institute of Architects.
Some of his current projects include the International
Trade Center in Pudong, Shanghai, the Congress Center
in Rome, and the Armani Megastore in Hong Kong.

Massimilia

☐ Twin Tower

☐ Niaux Cave

☐ Congress Center, Italy

Fuksas

◼ Massimiliano Fuksas

Twin Tower Vienna, Austria, 2001

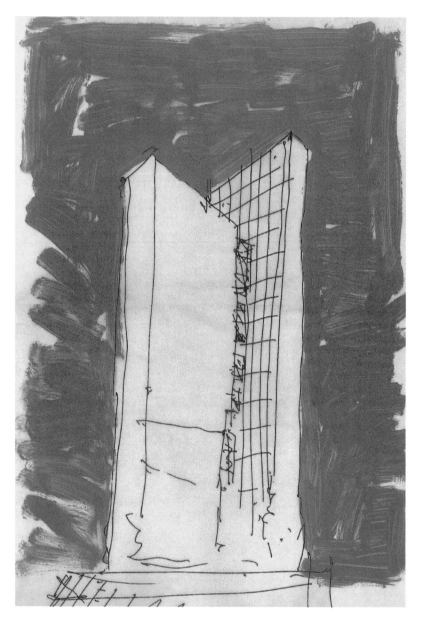

The objective of this million-and-a-half sq. ft. project was to enhance Vienna's skyline and add a distinctive building to the district in which it is found. The project is located in an urban fringe area, hence its three basic premises: development of the urban landscape, connection between urban density and green spaces (its most noteworthy feature is transparency), and the confluence of art and architecture.

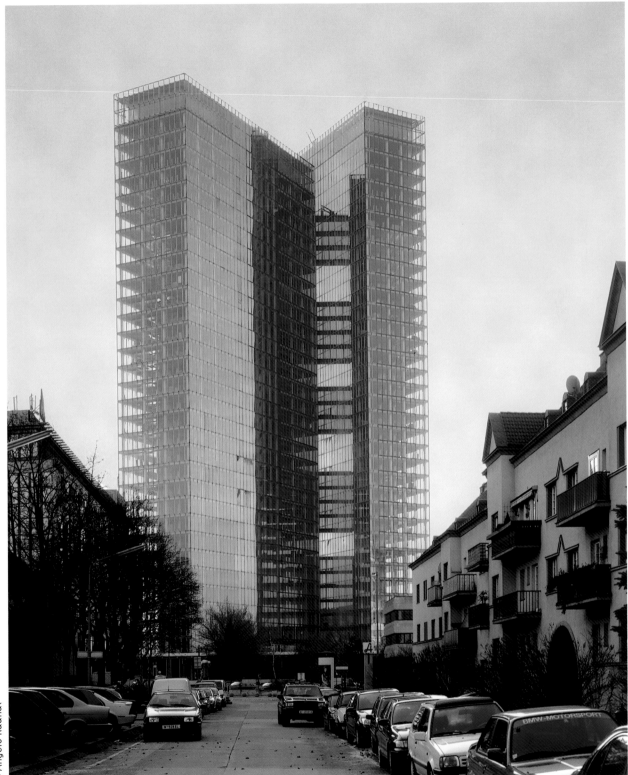

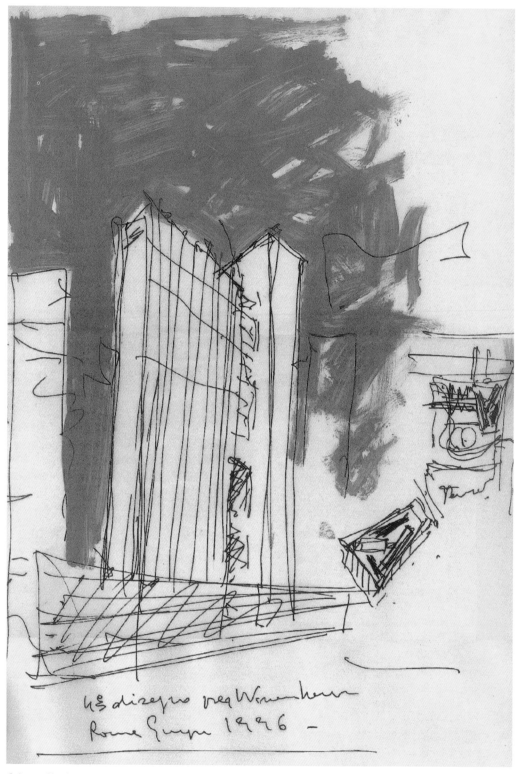

4.º disegno preliminare

Roma Giugno 1996 –

Schematic design sketches

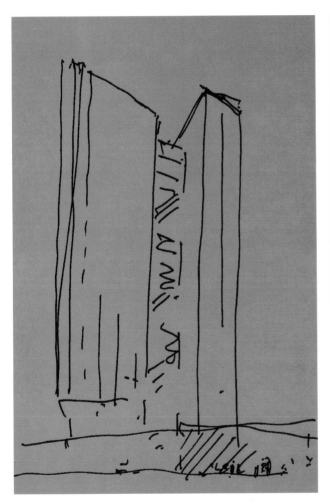

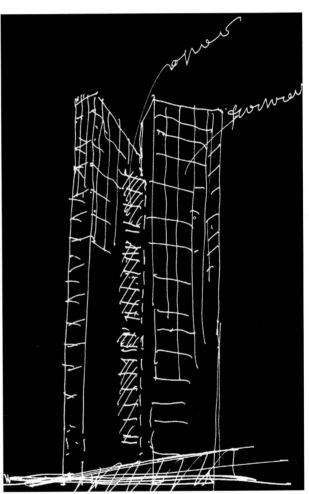

Schematic design sketches

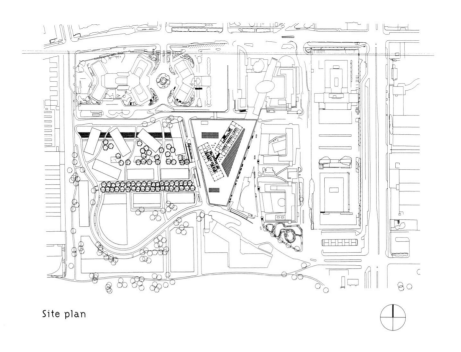

Site plan

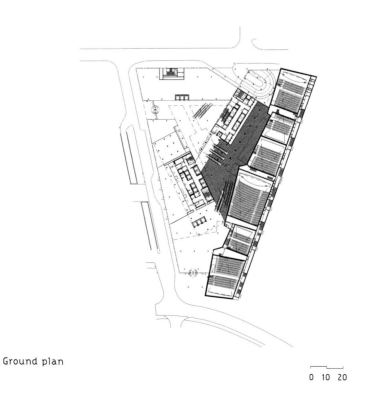

Ground plan

0 10 20

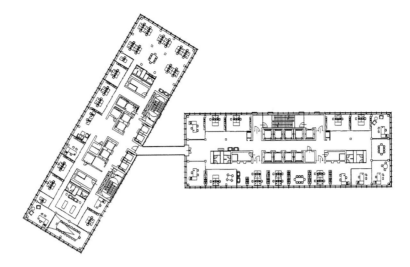

Type plan

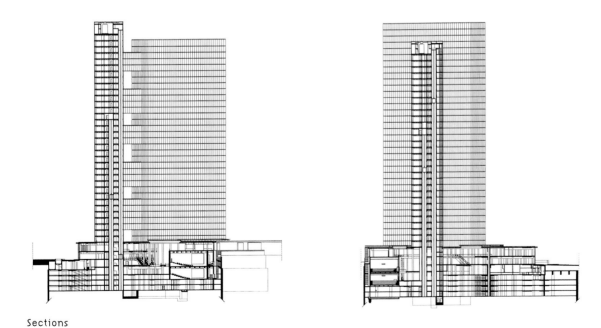

Sections

Massimiliano Fuksas

Niaux Cave Niaux, Ariège, France, 1993

7.7.88.
hai: cotani...

This project was born out of the need to create a meeting place for visitors and an access route between the parking area and the entrance to the grotto containing original Magdalenian era (11,000 B.C.) paintings. The objective was to represent a prehistoric animal emerging from a cave and opening its wings to receive visitors. The design tries to emulate an archeological dig. Hence, the building is constructed with Corten steel and the rusted look has been maintained. Out of respect for the environment, a path paved with wood leads across the ancient site to the reception area.

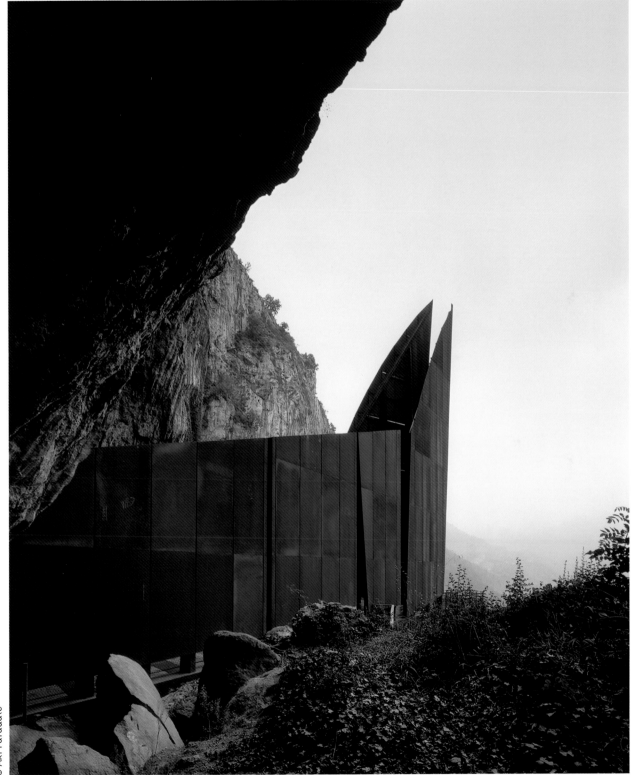

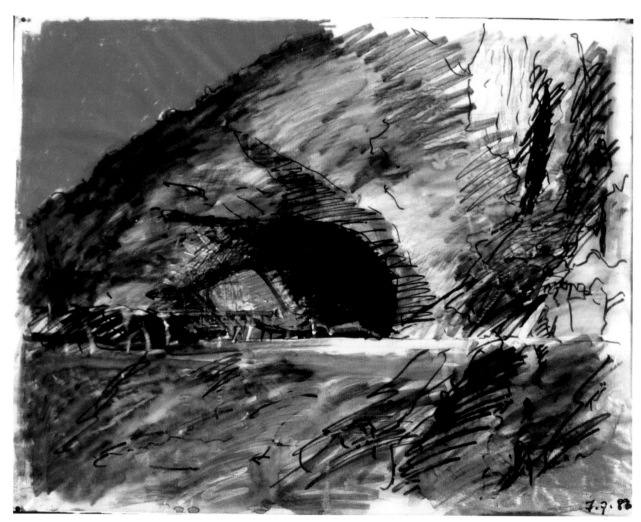

Schematic design study

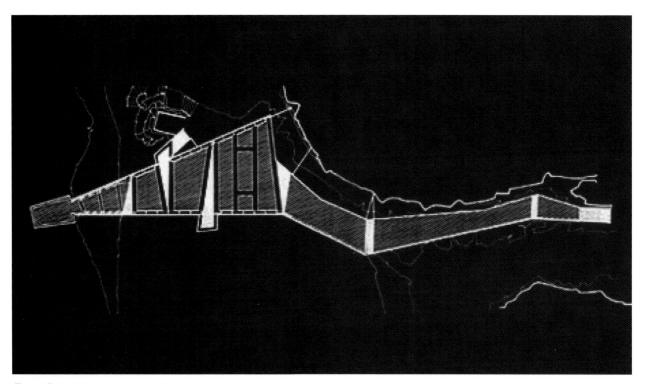

Floor plan

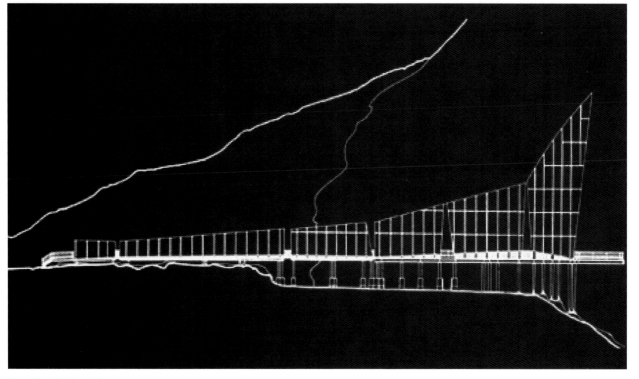

Longitudinal section

Massimiliano Fuksas

Congress Center Italy Rome, Italy, 2005

The concept of this project came to Massimiliano Fuksas after he saw some clouds being buffeted by strong winds. The massive, translucent building is 100 feet tall. On each side, a plaza opens up toward the city. Its simple lines are a tribute to the rationalist architecture of the 1930s that characterize the EUR and the nearby Conference Center designed by Adalberto Libera. Inside this shell, a giant steel and Teflon cloud suspended over a 107,600 sq. ft. area is designed to hold an auditorium and several meeting rooms

Schematic design sketches

Site plan

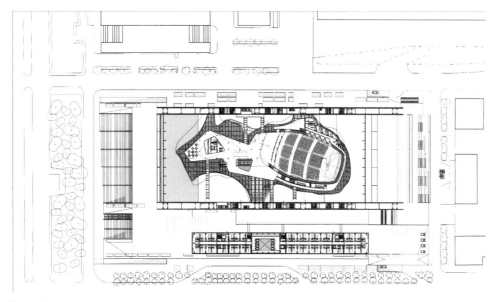

Floor plan

0 10 20

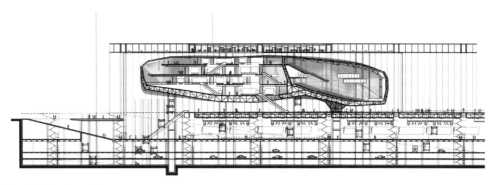

Longitudinal section

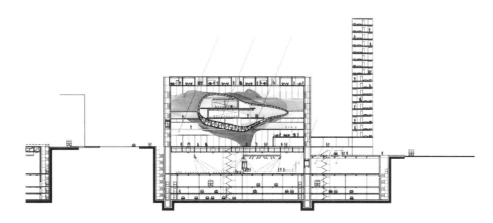

Cross section

Murphy/Jahn

Murphy/Jahn is an architectural firm that describes itself
as a place for seeking out and resolving the challenges
of the new millennium. Under the leadership of Helmut
Jahn, the firm has grown and evolved since its
beginnings more than 60 years ago. It operates under two
guiding principles: the search for the best creativity in
design, and corporate professionalism. The commitment
to maintaining this balance is fundamental to making
the architectural concepts a reality. Their approach to
design, from a rational and intuitive perspective, gives
each building its own philosophy and intellectual base.
The rational part works on the realities of the assignment,
while the intuitive part constructs the theoretical and
intellectual aspects. This dialogue makes it possible for
each project to take advantage of its best qualities and
make a visual and communicative statement.

☐ Sony Center

☐ Cologne-Bonn Airport

☐ Post Tower

Jahn

Sony Center Berlin, Germany, 2000

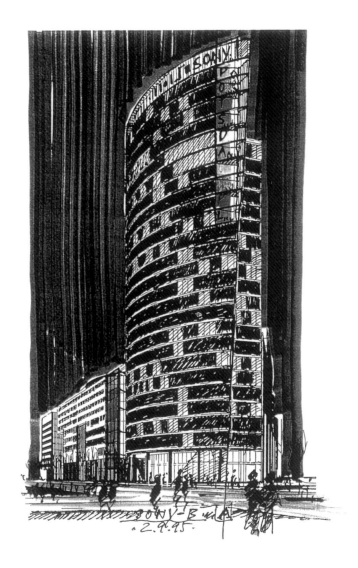

In the reconstruction of Berlin, the Sony Center is a new technological vision. More than just a building, it is a fundamental part of a new urban model, where the exterior is the real city and the interior is the virtual city. The volume and the composition of the building's facade relate to the city's streets and traditional spaces, while the interior contains a new type of covered urban forum that accommodates a variety of social and cultural activities, characteristic of our times. The passages and doors reinforce the transition between these two milieus.

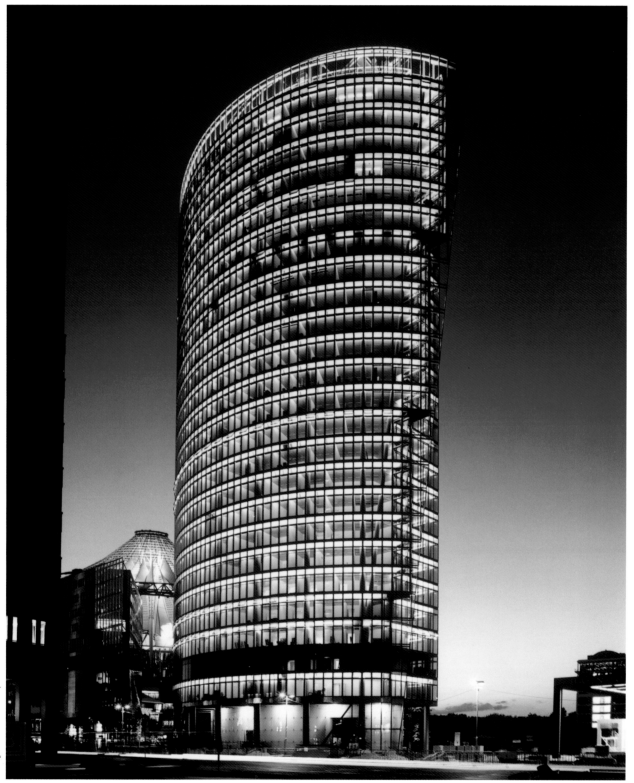

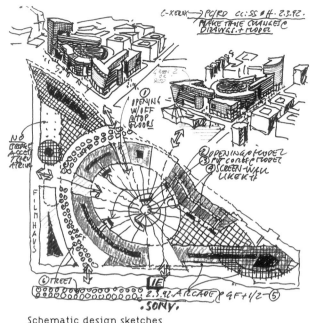

Schematic design sketches

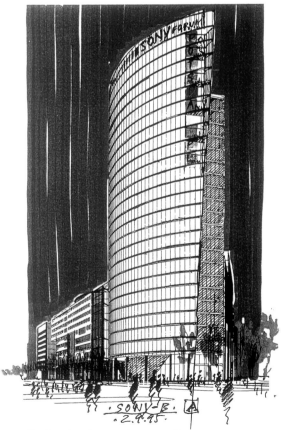

Design development perspective

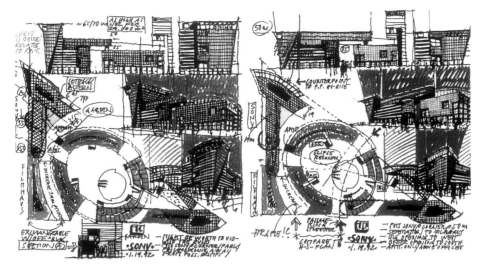

Schematic design sketches

Presentation

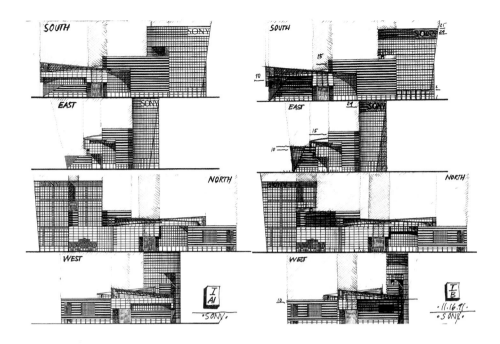

Facade study

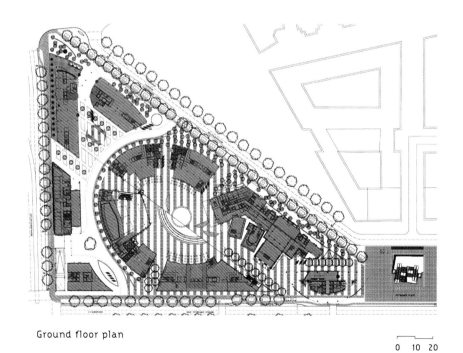

Ground floor plan

0 10 20

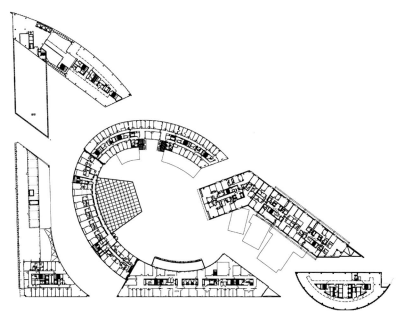

Floor plan

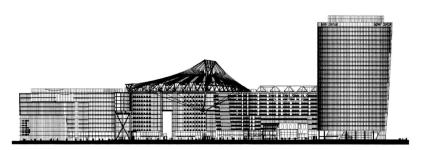

Elevation

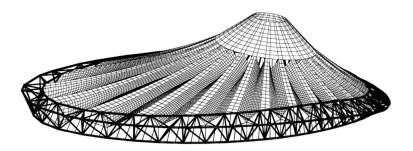

Detail of the inner cover

Cologne-Bonn Airport Cologne-Bonn, Germany, 2002

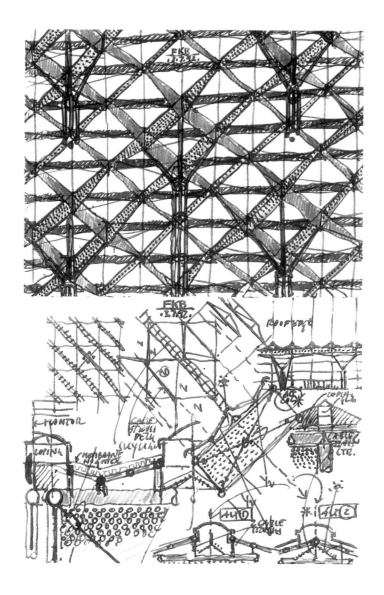

This complicated project consists of a second terminal that will expand the airport's capacity to 7.5 million passengers per year, two parking lots, a new two-level roadway serving the terminals, and an underground train station. Terminal 2 is a long volume extending from one of the arms of the existing U-shaped terminal. Unlike the original building, it has a light, transparent appearance, achieved with prefabricated steel components.

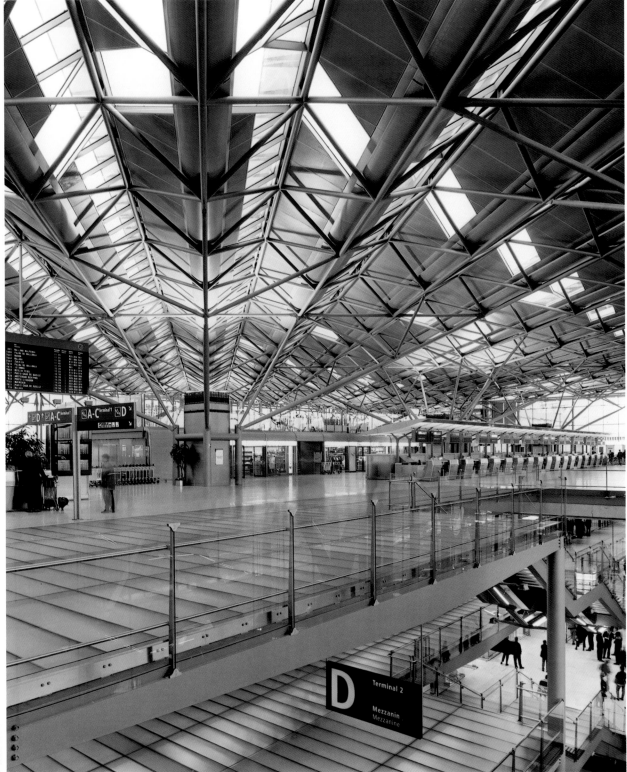

© H.G. Esch

D Terminal 2

Mezzanin
Mezzanine

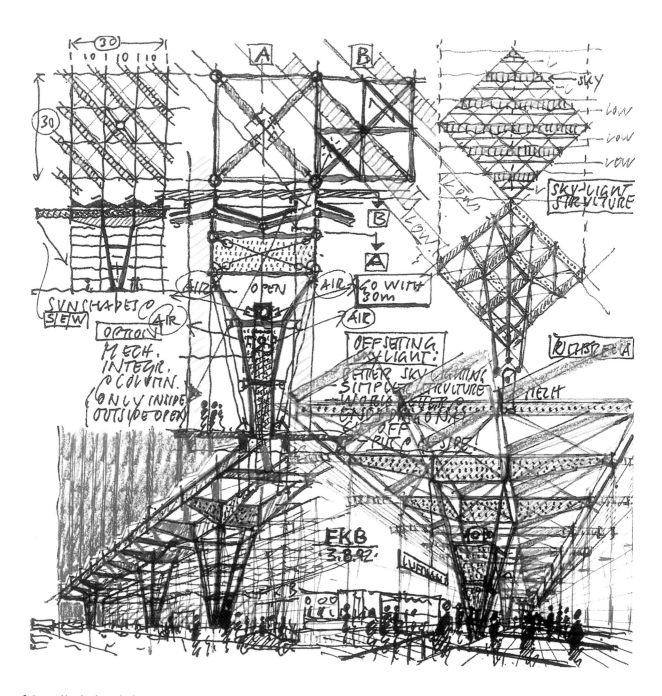

Schematic design study

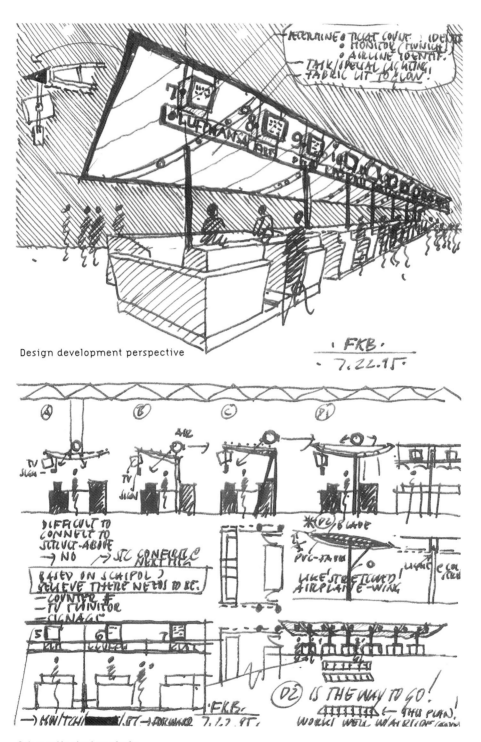

Design development perspective

Schematic design study

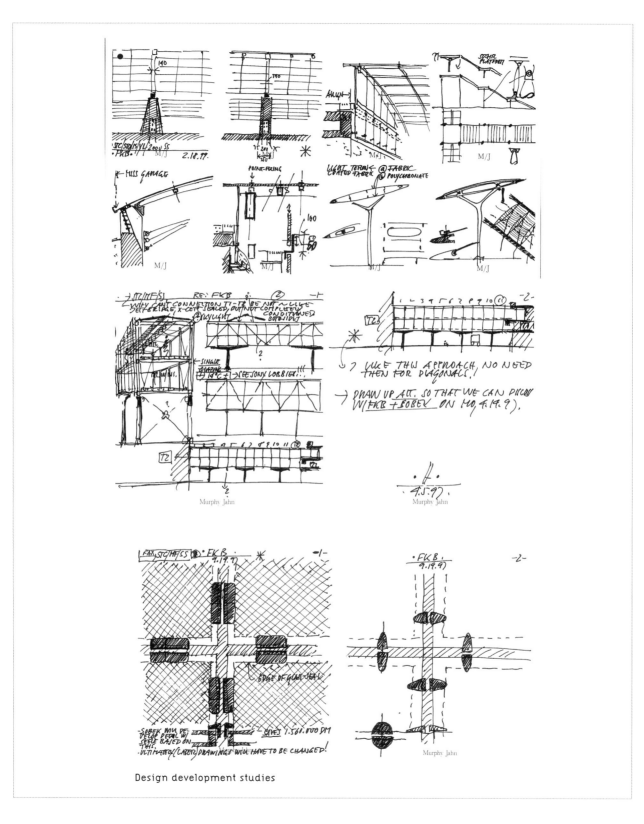

Design development studies

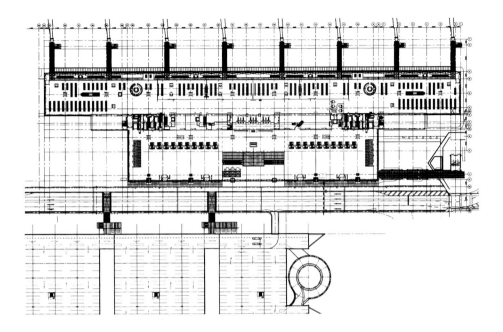

Floor plan

0 10 20

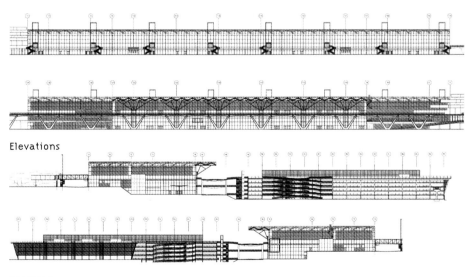

Elevations

Sections

■ Murphy/Jahn

Post Tower Bonn, Germany, 2003

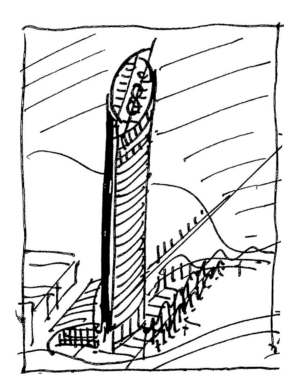

The design premise of this project, awarded through a competitive process, was to create a progressive corporate image for the company, now private but previously state-owned. Along with the Langer Eugen and Deutsche Welle towers the building is situated on the Rhine River and marks the transition from city to park. This factor influenced the shape of the building, which resembles two joined aerodynamic oval shells. The shape stimulates the dynamism of the public space that surrounds the building and leads to the river promenade. The interior composition, the construction systems, and the materials used ensure transparency, energy efficiency, and comfort.

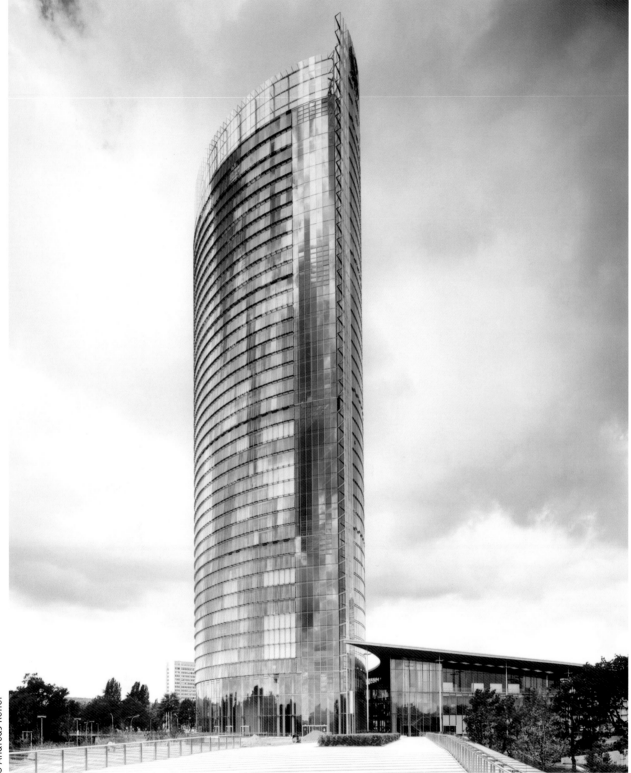

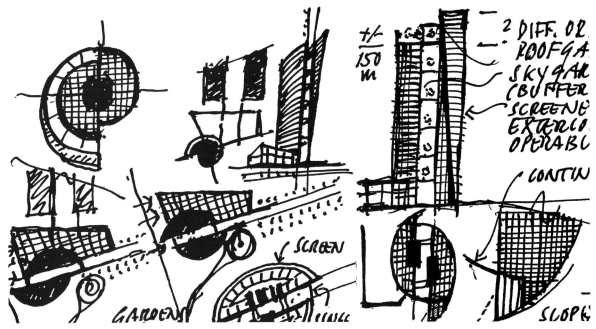

Schematic design study

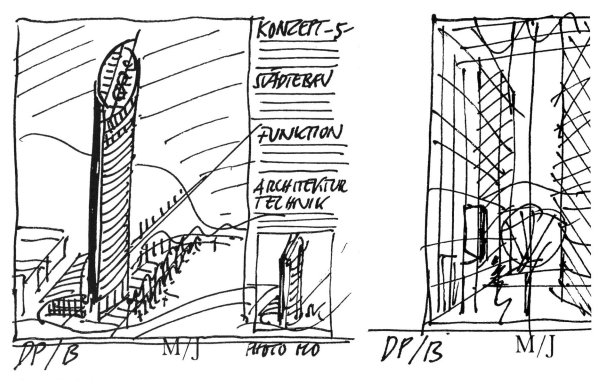

Schematic design study

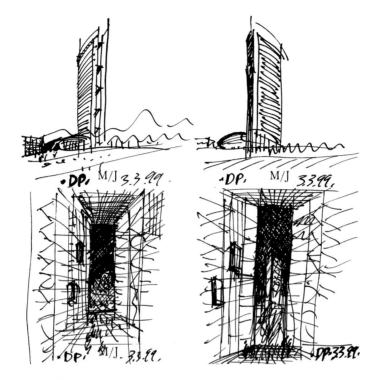

Schematic design study

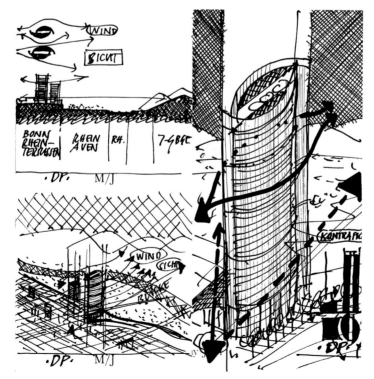

Schematic design study

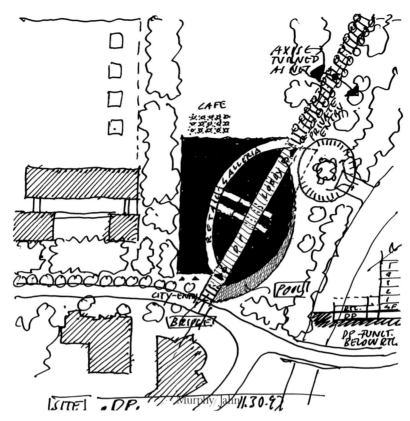

Design development study

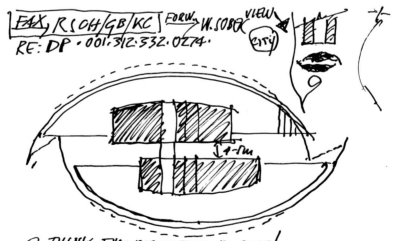

Design development study

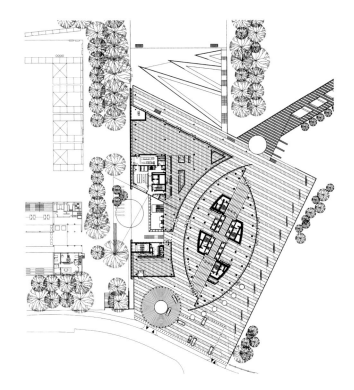

Ground floor plan

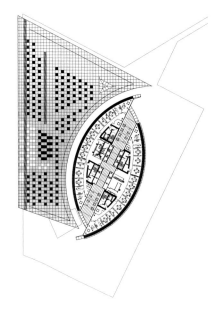

Detailed floor plan

0 5 10

Elevations

RCR Arquitectes

The principals of RCR Arquitectes are Rafael Aranda,
Carme Pigem, and Ramon Vilalta. Carme Pigem and
Ramon Vilalta studied at the School of Fine Arts of Olot. In
1987, along with Rafael Aranda, they received their
degrees in architecture at the Escuela Técnica Superior de
Arquitectura del Vallés in Barcelona, Spain. Since then
they have worked together in their office in Olot, in
northern Catalonia, on a wide variety of residential and
institutional projects. While their work is based primarily
in this region, they have received prestigious national
and international awards, and their buildings have
become an important part of the contemporary
Catalonian landscape.

Arquitectes

Les Cols Restaurant Olot, Spain, 2002

The restaurant is located in a stately three-story "masía," a typical rural Catalonian house. The project involved expanding the existing kitchen and finding a unique spatial character for the restaurant that would be in harmony with the owner's culinary art. Instead of the labyrinthine layout, with the restaurant spread out among the walled areas on the lower floor, the plan is open and T-shaped, creating a warm, tranquil, and understated ambience.

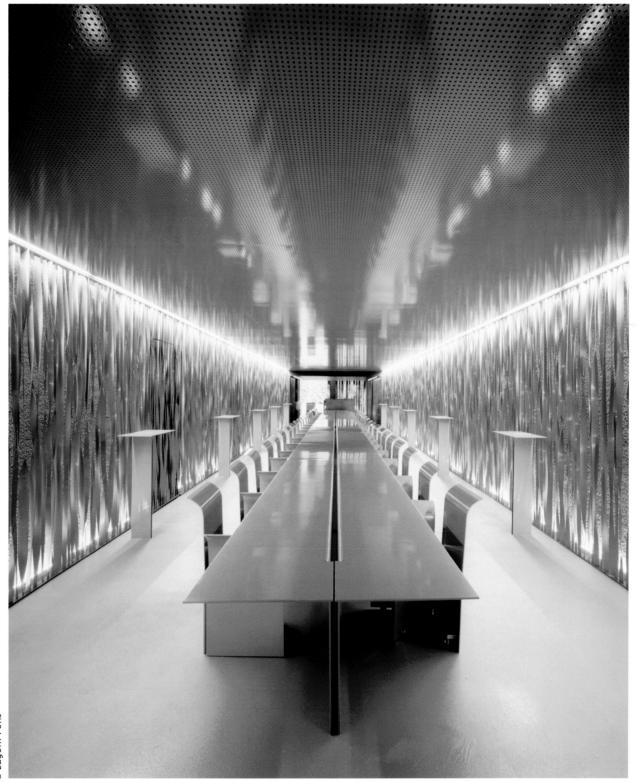

Schematic design studies

Schematic design studies

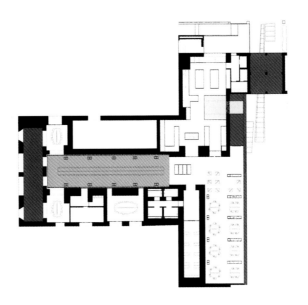

Floor plan

0 2 4

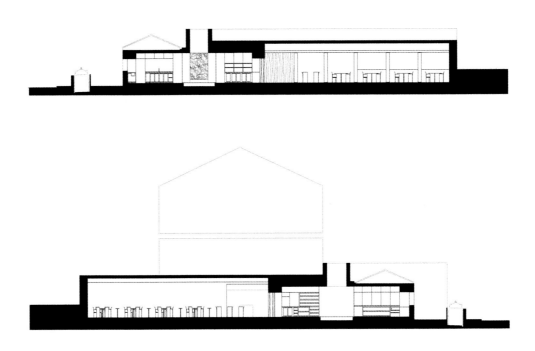

Sections

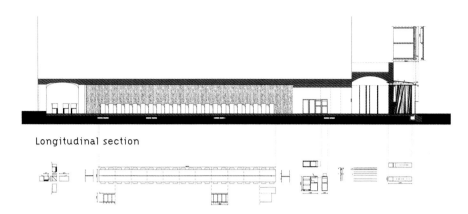

Longitudinal section

Furniture plan

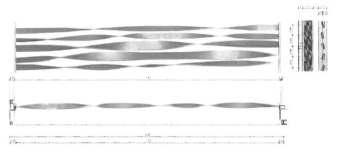

Color study

Detail

Tussols-Basil Track and Field Stadium Olot, Spain, 2001

This track and field venue, which sits in an exceptional natural setting, emphasizes the existing landscape and creates a close link between the athletic field and nature. The track was placed in a clearing of a white oak forest whose dominant presence is an integral part of the project's design. Maximum effort was made to avoid touching the trees, which lend different spatial qualities to this sports complex. The terraced slope becomes a grandstand for the public.

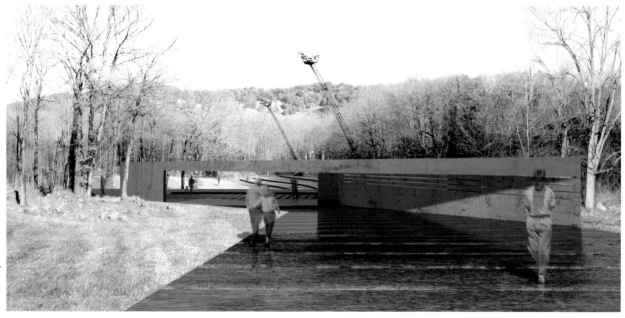

Design development studies

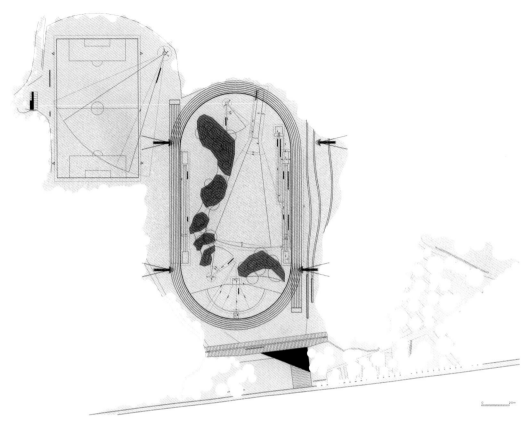

Site plan

0 10 20

Side section

Section

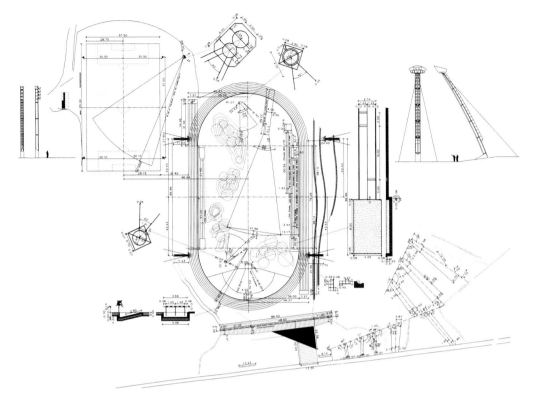

Site plan

Pavement study

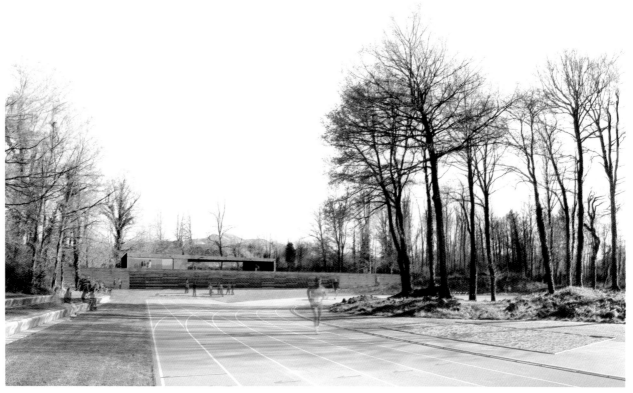

3-D model renderings

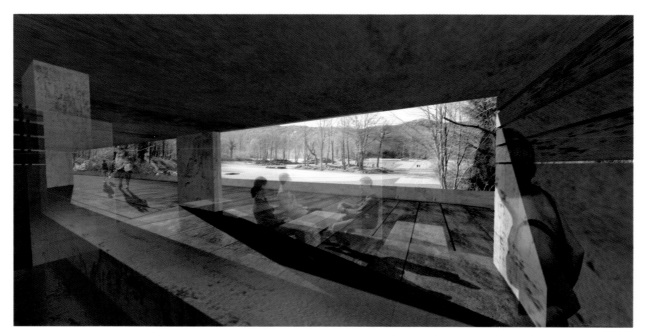

3-D model renderings

Pond and Exteriors at Vila de Trincheria Vall de Bianya, Spain, 2003

This project consists of landscaping and constructing a swimming pool for a rural house in northern Catalonia, Spain. The concept of a rural pond, traditionally used as a watering hole by animals, or a collection point for water, was a referent for the project. A white concrete base and the steel sheets that establish the perimeter define the pool and emphasize its sculptural and elegant character. In the winter, it does not look like an unused swimming pool, but rather like a rural pond.

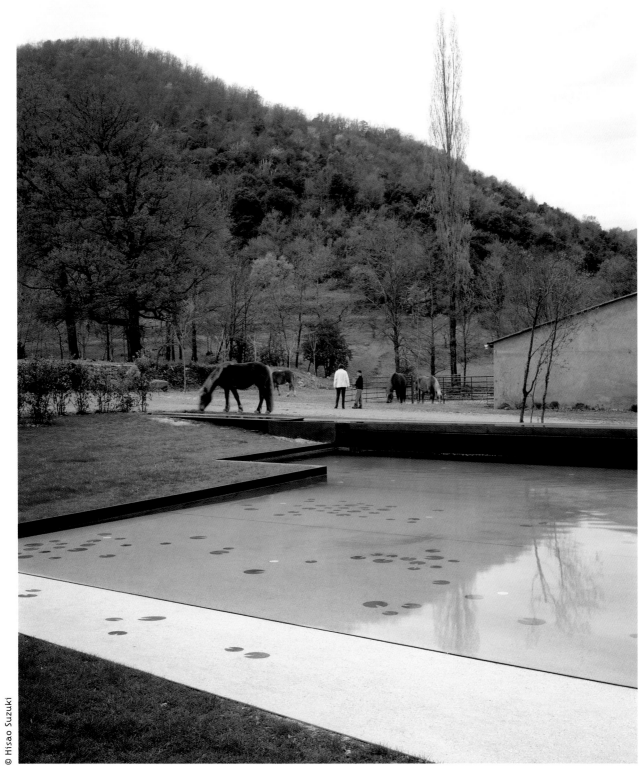

Schematic design studies

Schematic design studies

Site plan

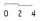

0 2 4

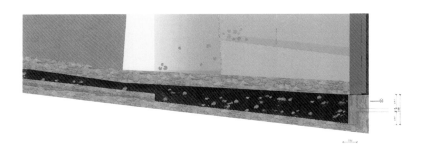

Sections

Site sections

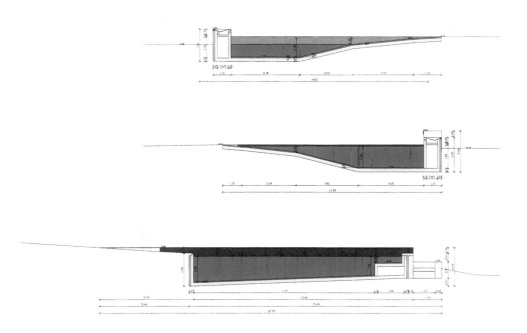

Building sections

Renzo Piano

Renzo Piano was born in Genoa in 1937 and studied
architecture at the Milan Polytechnic. While still a
student he worked with Franco Albini and visited his
father's worksites, gaining valuable experience. From
1965 to 1970 he completed his training with trips to Great
Britain and the United States, and in 1971 he opened a
studio with Richard Rogers, his associate on the Georges
Pompidou Center in Paris. Later he teamed up with
engineer Peter Rice and, in 1993, established the Renzo
Piano Building Workshop, where he designs widely-
praised buildings such as the Menil Collection, the Kansai
International Airport, and the remodeling of Potsdamer
Platz. His work has received the most prestigious awards,
such as the Pritzker Prize (1998) and the International
Union of Architects (IUA) Gold Medal (2002).

☐ Georges Pompidou Center

☐ Kansai International Airport

☐ Jean-Marie Tjibaou Cultural Center

Piano

Georges Pompidou Center Paris, France, 1977

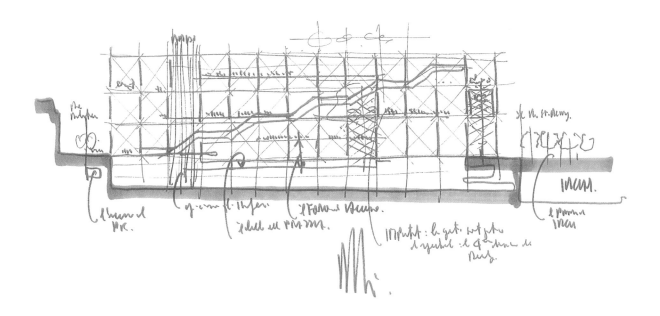

The Georges Pompidou Center is a symbol of modern architecture in the heart of Paris, occupying more than 1,076,400 square feet and devoted to the figurative arts, music, industrial design, and literature. The building clearly reflects the program laid out in the competition, which called for the integration of culture into the setting and the creation of a vast plaza and a very active urban and cultural entity. Having exceeded visitors' expectations for 20 years, the center has reopened its doors after its recent renovation and continues to stand for the excellence of contemporary art and culture in the French capital.

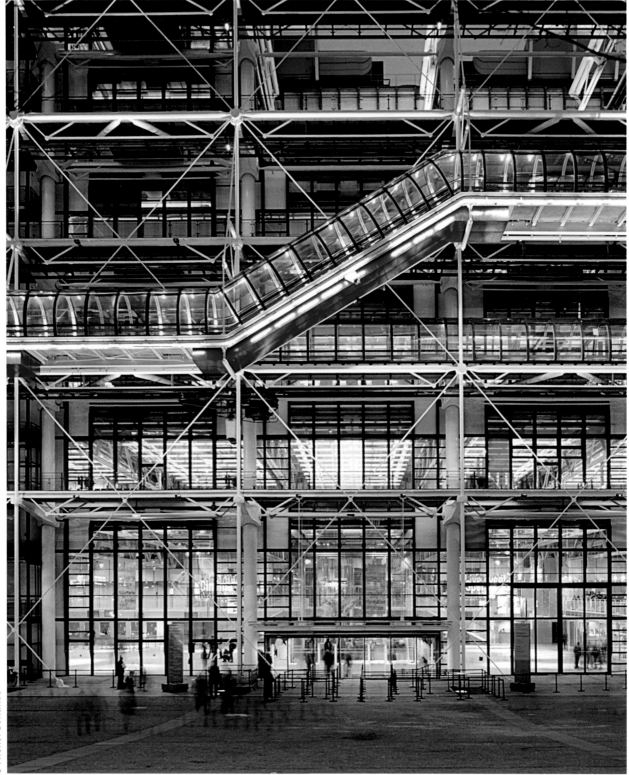

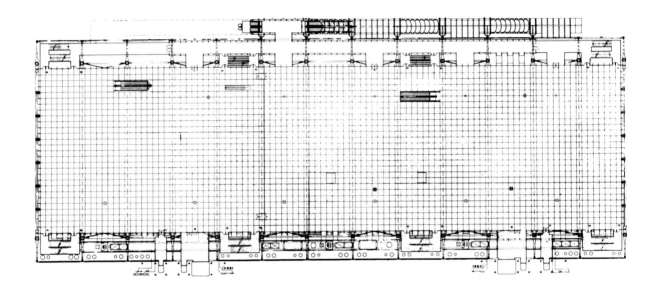

Floor plan

0 5 10

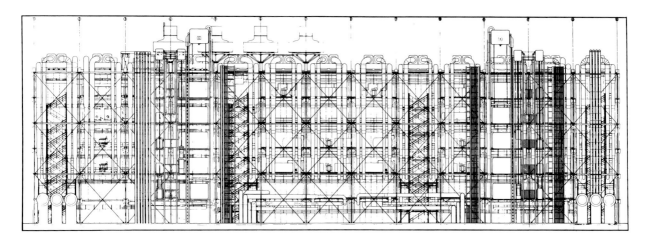

Elevation

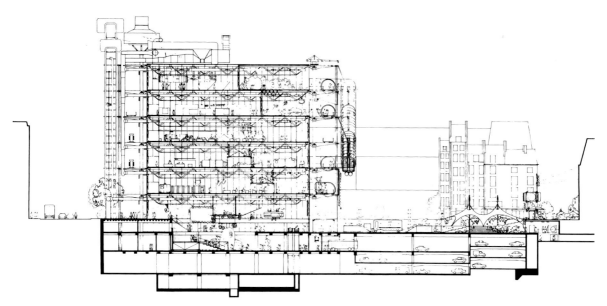

Section

Kansai International Airport Osaka, Japan, 1994

Building the Kansai International Airport entailed enormous effort, since it is located on a 3-mile-long artificial island and serves the cities of Osaka, Kobe, and Kyoto. The terminal had to operate like a precision instrument, withstand earthquakes, accommodate more than 100,000 passengers a day, and be completed in 38 months. The roof, whose shape was inspired by the internal flows of air, consists of 82,000 identical stainless steel panels.

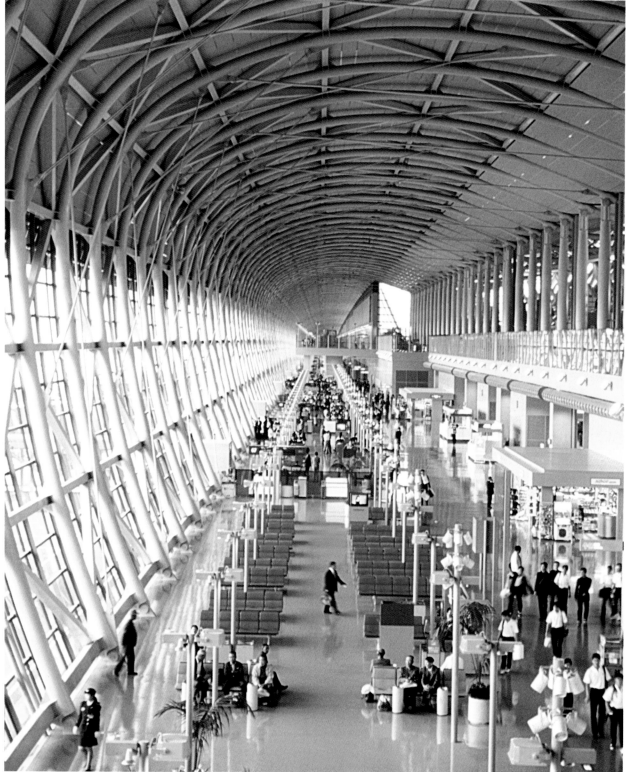

Schematic design study

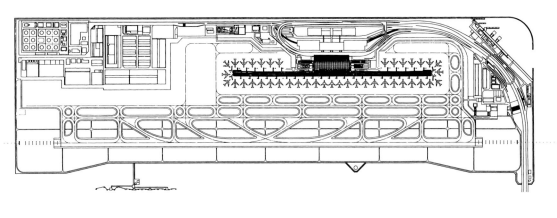

Floor plan

0 50 100

Elevation

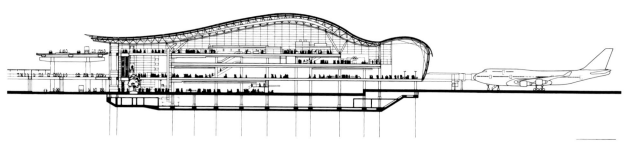

Cross section

Elevation

Renzo Piano

Jean-Marie Tjibaou Cultural Center Nouméa, New Caledonia, 1998

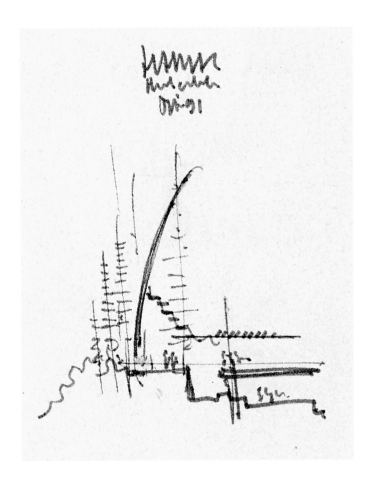

The government of New Caledonia commissioned the construction of a cultural center in memory of assassinated Kanak leader Jean-Marie Tjibaou. One of the project's basic objectives was to combine the functional program with the idea of the structure as a symbol of Kanak civilization that avoided becoming a quaint imitation of the local architecture. The huts have a double shell and wooden ribs and beams covered by a skin of iroko wood, reminiscent of the interwoven fibers of the local vegetation and structures.

404 Sketch • Plan • Build

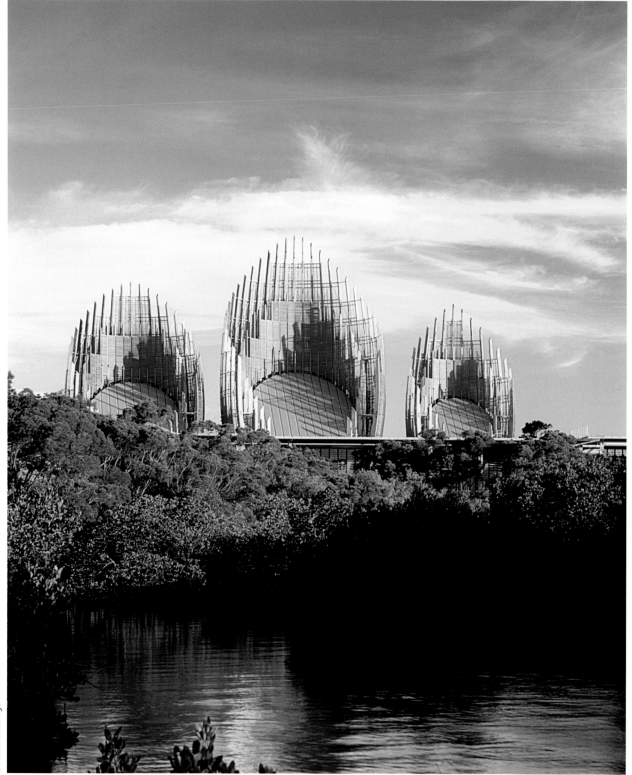

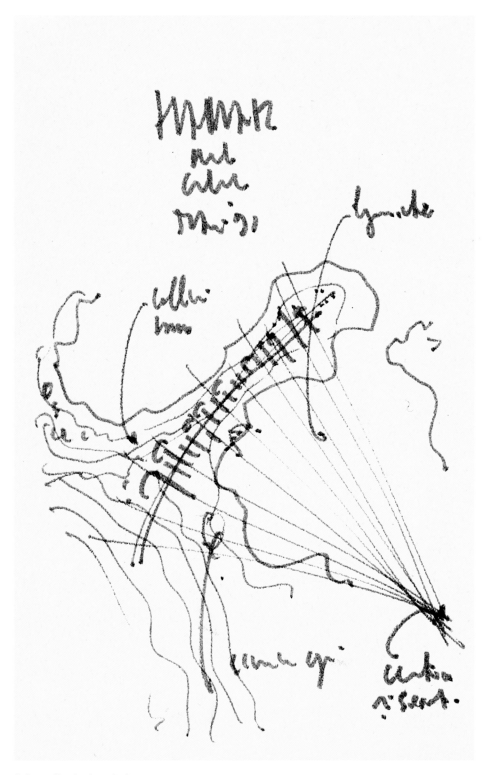

Schematic design study

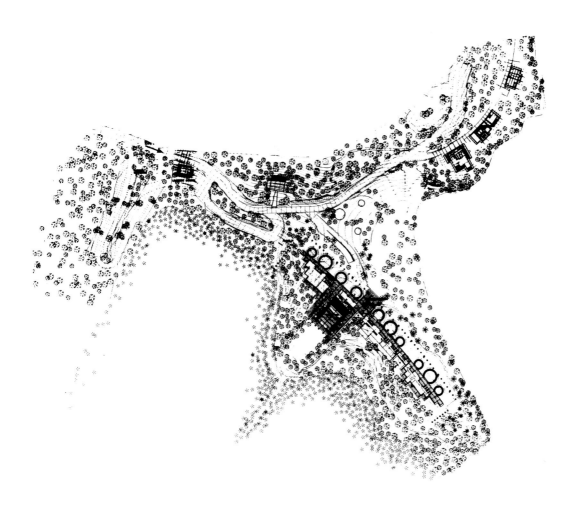

Site plan

Construction details

General elevation

Elevation

Sauerbruch Hutton Architects

Mathias Sauerbruch and Louisa Hutton established their architectural firm in London in the late 1980s. A second office was opened in Berlin in 1993, with Juan Lucas Young and Jens Ludloff joining in 1999. At present they have a group of more than 40 people working for the firm. Through various competitions and studies, Sauerbruch Hutton have exhaustively researched the development of the post-industrial city, with special interest in sustainable construction. With their urban projects in Berlin, they have begun to redefine the contemporary dominant notions of ecological awareness in construction. Concern about the economical use of resources is combined with a search for the spaces' own idiosyncrasies. State-of-the-art technology and the use of passive energy mechanisms coexist with the use of compositions rich in color, materials, and textures.

☐ Federal Agency for the Environment

☐ Pharmacological Research Laboratories

☐ Hennigsdorf Town Hall

Architects

Federal Agency for the Environment Dessau, Germany, 2005

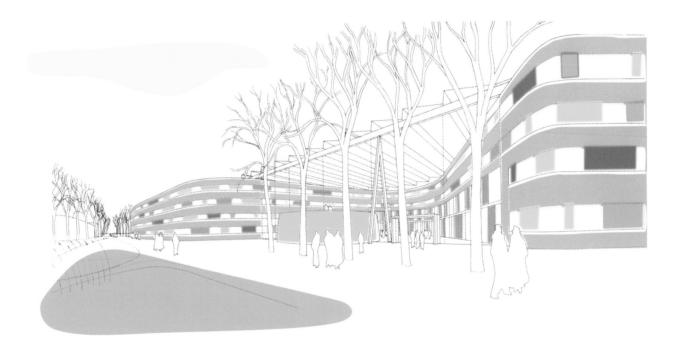

The Offices for the Agency for the Environment could be a case study for sustainable con-
struction. The location, in Dessau's former "gas quarter," has been selected to demonstrate
the possibilities and problems of a brownfield site. Contaminated land will be treated, and
the buildings of the old Wörlitzer railway station and part of a former gas appliance factory
will be integrated into the complex. The new building has been designed so that a large
portion of the original site will remain accessible to the public—creating a new public park
for the city.

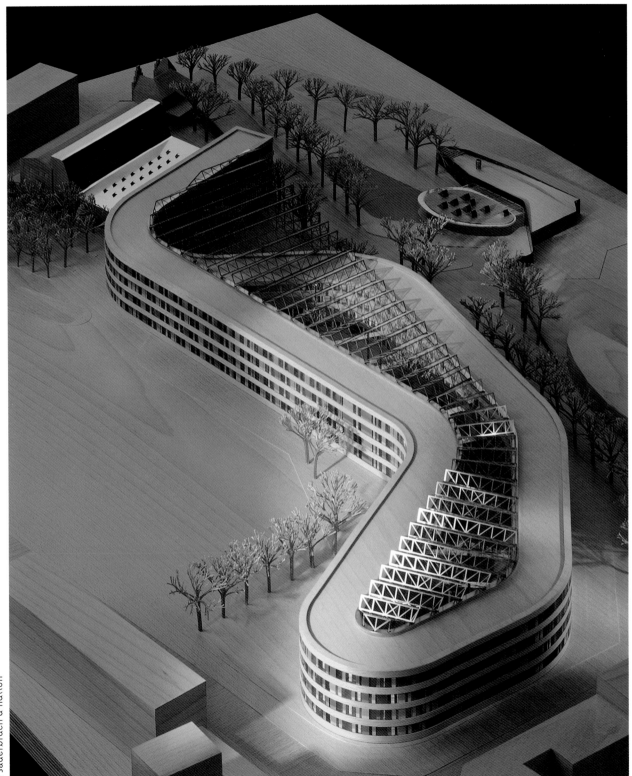

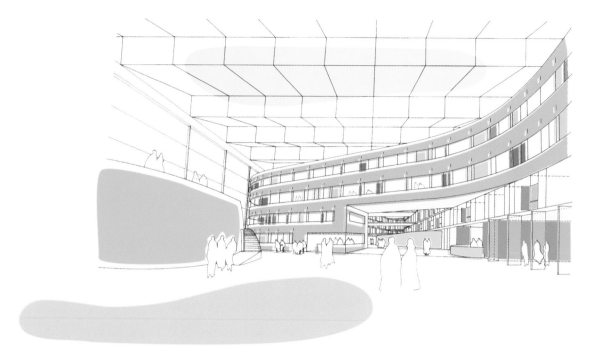

3-D model rendering for study

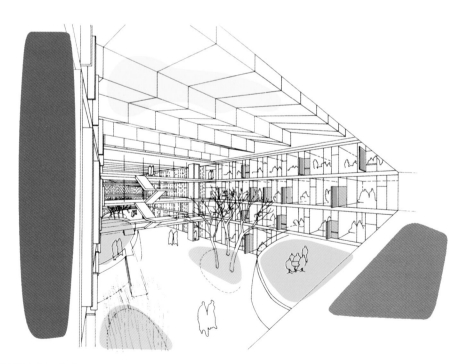

3-D model rendering for study

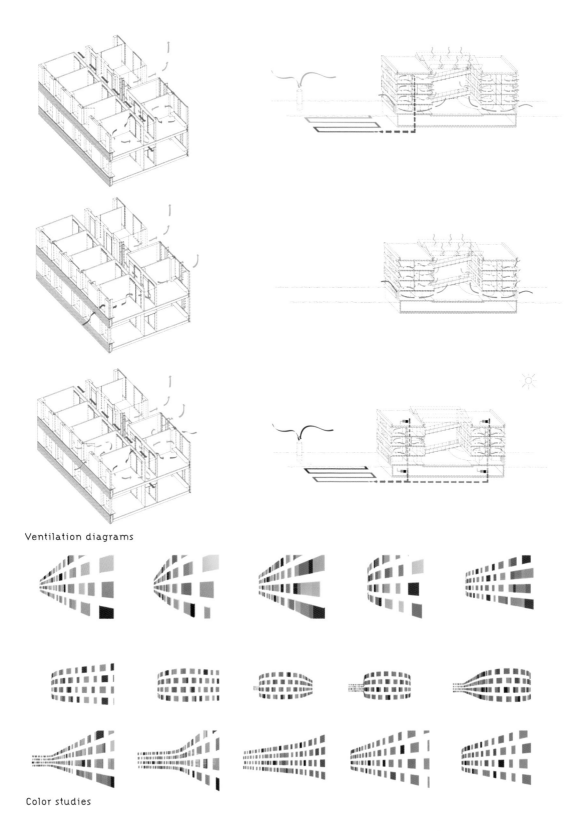

Ventilation diagrams

Color studies

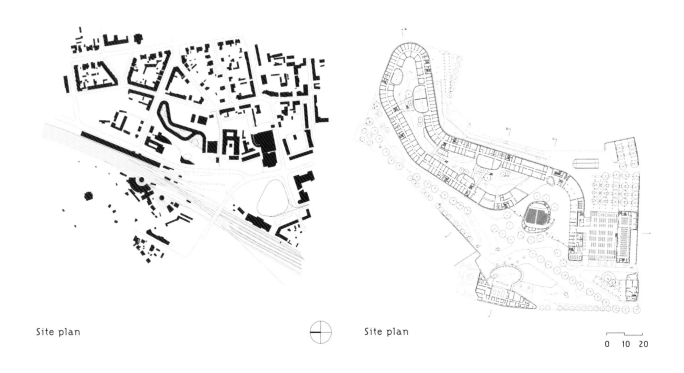

Site plan

Site plan

0 10 20

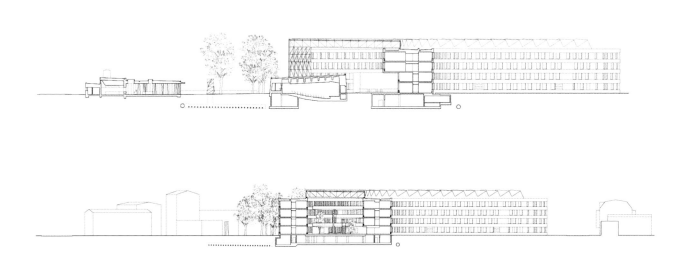

Cross sections

Longitudinal section

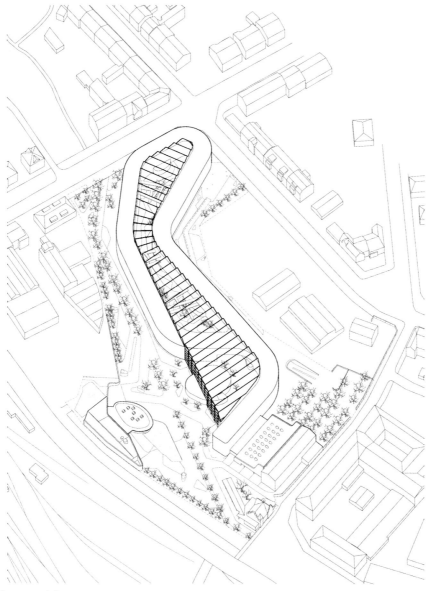

Axonometric

Pharmacological Research Laboratories Biberach, Germany, 2002

This project is a component of a research campus located in Biberach, Germany, and accommodates both offices and laboratories. It consists of a seven-story building with a spacious first-floor foyer which facilitates its connection to the adjacent building and the rest of the campus. The building is divided into two parts according to function: an office area in the west and laboratories in the east. A long atrium, which gets natural light from above, divides and connects the two parts.

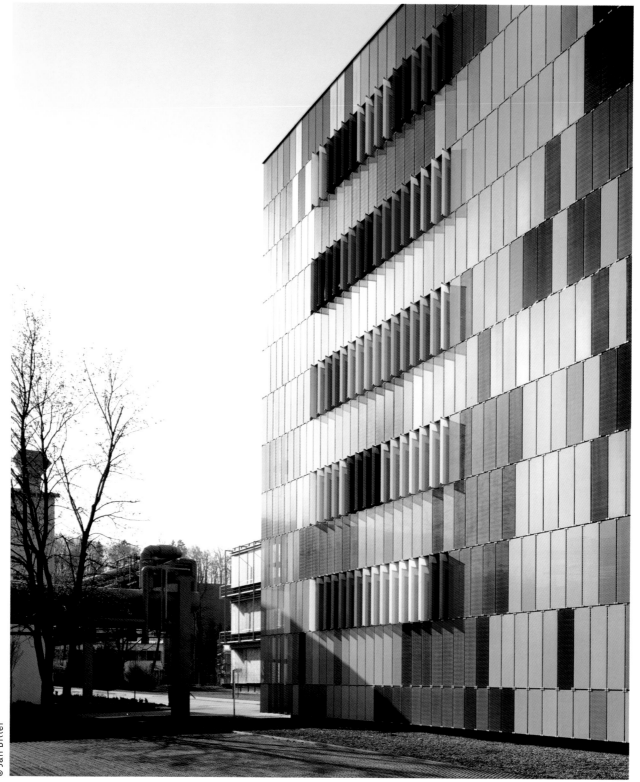

© Jan Bitter

Site plan

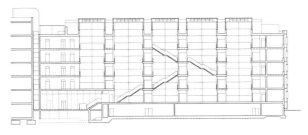

Longitudinal section

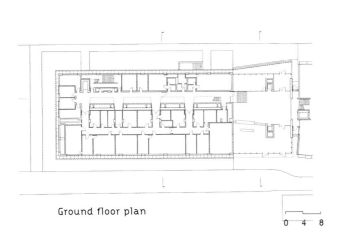

Ground floor plan

0 4 8

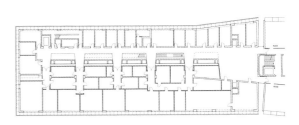

Second floor plan

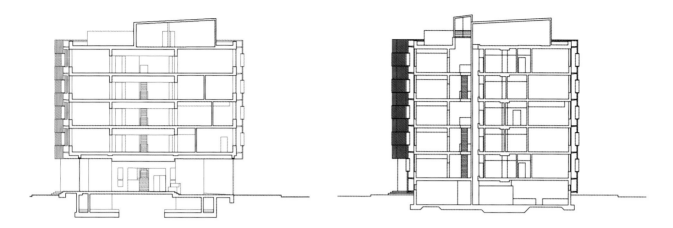

Cross sections

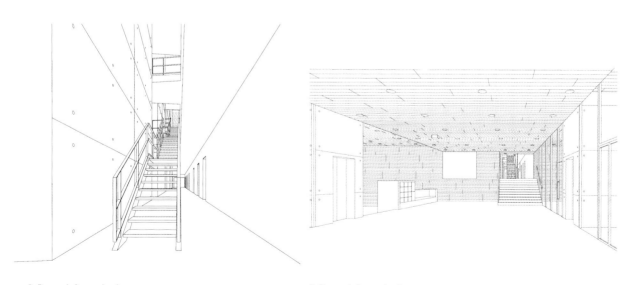

3-D model rendering

3-D model rendering

Hennigsdorf Town Hall Hennigsdorf, Germany, 2003

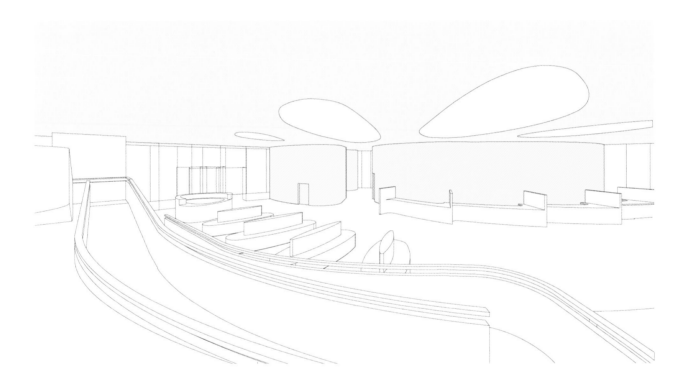

Hennigsdor's town hall building had to come to terms with the different influences of this urban enclave. It functions as a link between a small park on the edge of this historic city and the new urban center that has sprung up across the railroad tracks. The building and its height mediate between the facades of the houses on the main street and the neighboring five-story residential buildings. Soft geometry and visual permeability in the ground floor emphasize its integration with the public space that surrounds it.

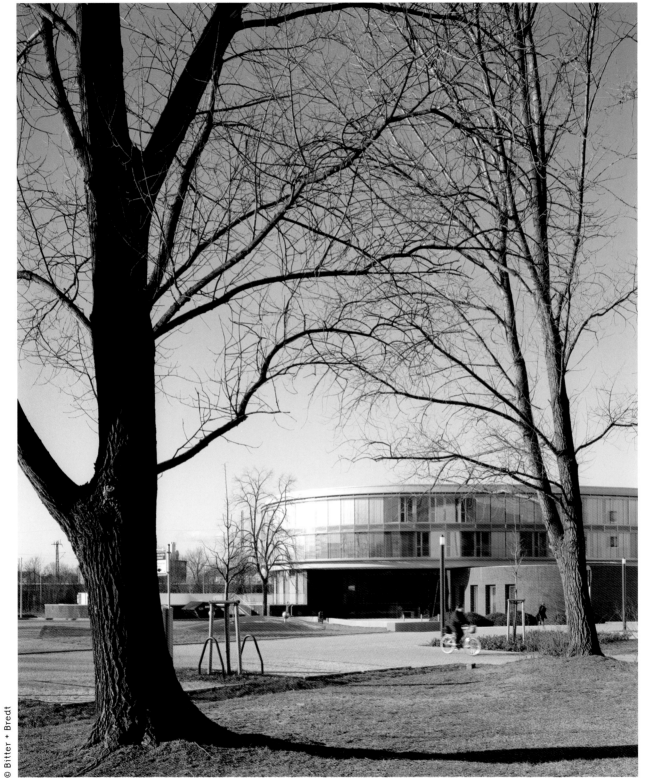

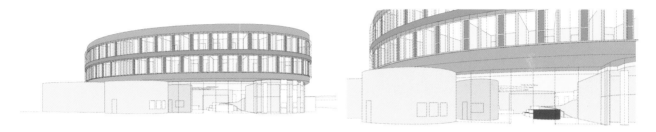

3-D model rendering study

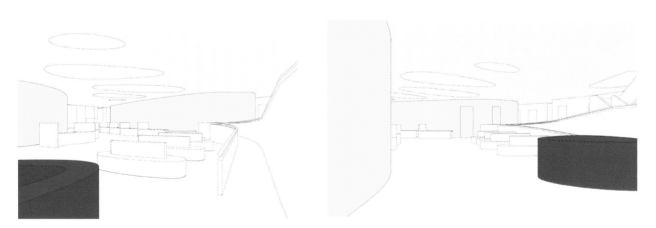

3-D model rendering study

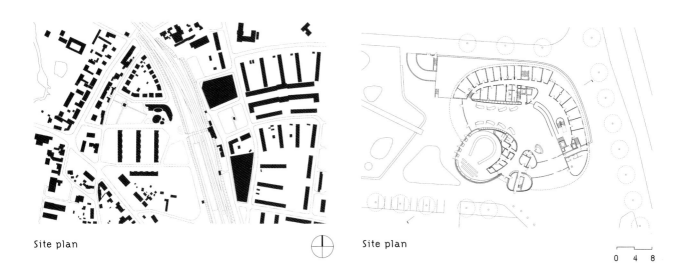

Site plan

Site plan

0 4 8

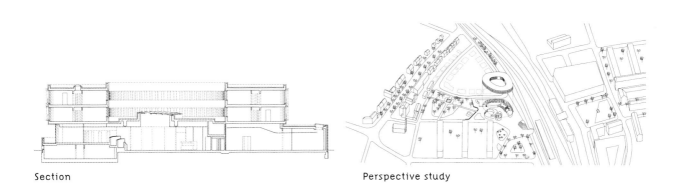

Section

Perspective study

Tadao Ando

Tadao Ando was born in Osaka, Japan in 1941 and, unlike most contemporary architects, had no formal education but taught himself by reading and traveling throughout the world. This strategy, which requires a great deal of discipline, laid the foundation for his productive knowledge and sensitivity. In addition to being an impeccable builder, he is also a prolific theorist who champions combining innovative language and techniques with traditional aesthetic and spatial principles. He feels deep admiration for nature and advocates a respectful integration of buildings with their surroundings. He has earned many awards during his career, including the Pritzker Prize (1995).

☐ Church of the Light

☐ Chikatsu-Asuka Historical Museum

☐ Museum of Modern Art, Fort Worth

Ando

Church of the Light Osaka, Japan, 1989

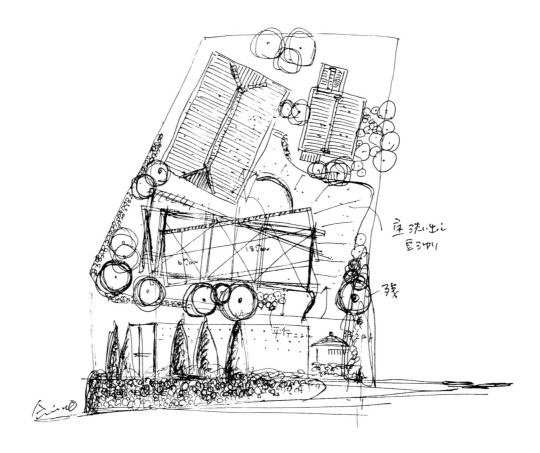

The church sits in a quiet residential suburb of Osaka and consists of a rectangular unit with a self-bearing wall cutting through it at a 15-degree angle, separating the entrance from the rest of the chapel. Light penetrates the profound darkness of this box through a cross cut into the altar wall. The floor and pews are made from unfinished planks of wood, which are low-cost and in keeping with the character of the space. The linear pattern of the planks and the beams of light that pass through the cross speak, in a pure language, to the relationship between man and nature.

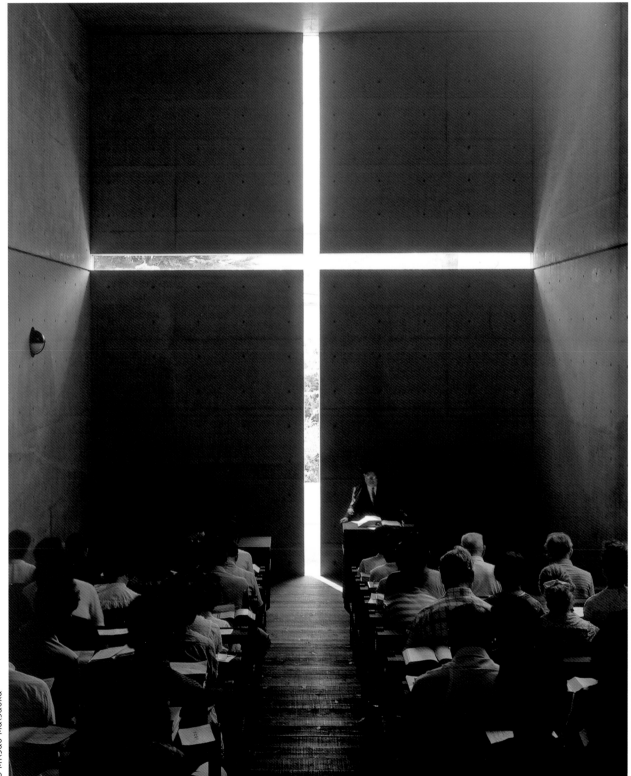

© Mitsuo Matsuoka

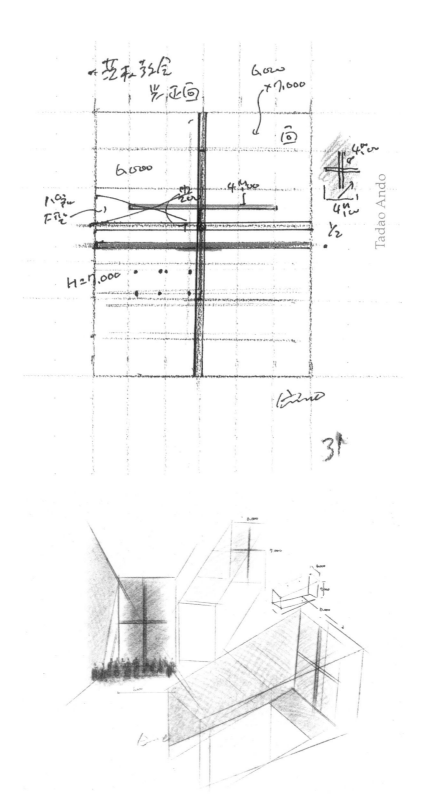

Schematic design study

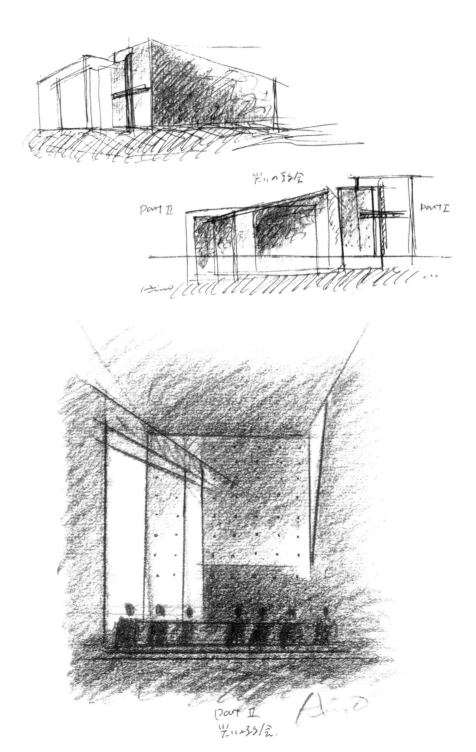

光の教会

part Ⅳ ————— part Ⅰ

光の教会

part Ⅱ.
光の教会.

Ando

Schematic design study

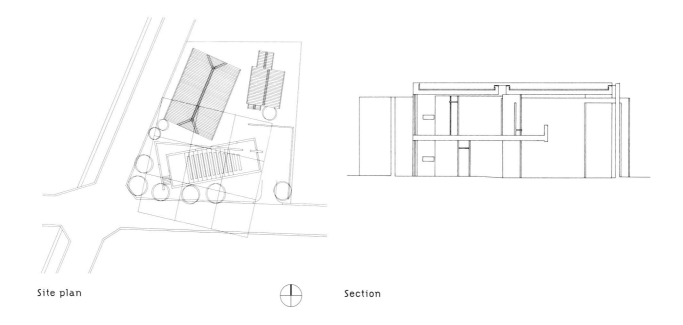

Site plan

Section

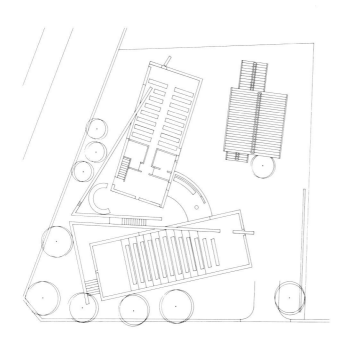

Ground floor plan

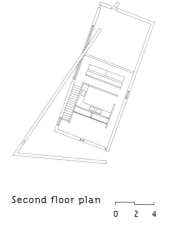

Second floor plan

0 2 4

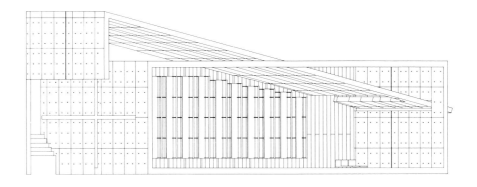

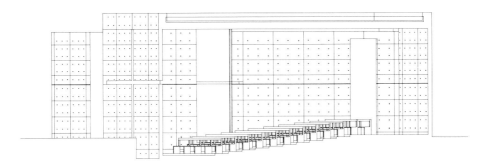

Sections

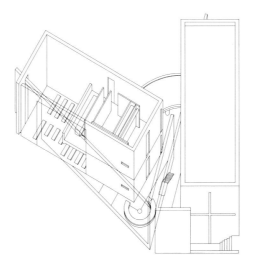

Axonometric drawing

Chikatsu-Asuka Historical Museum Osaka, Japan, 1994

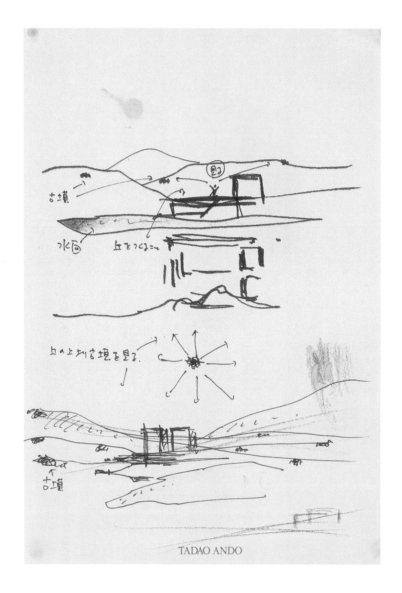

TADAO ANDO

The Chikatsu-Asuka area is the cradle of the kofun period, an early stage of Japanese history. This region is home to one of the largest burial sites in the country, with more than two hundred tombs, four of which are imperial. The museum, dedicated to the dissemination of information about and the study of kofun culture, was placed close to but higher than the excavations, as if it were on a natural hill. The tombs gradually come into view for the visitor as he climbs the vast stairway, until, at the highest point, he can enjoy a breathtaking panorama.

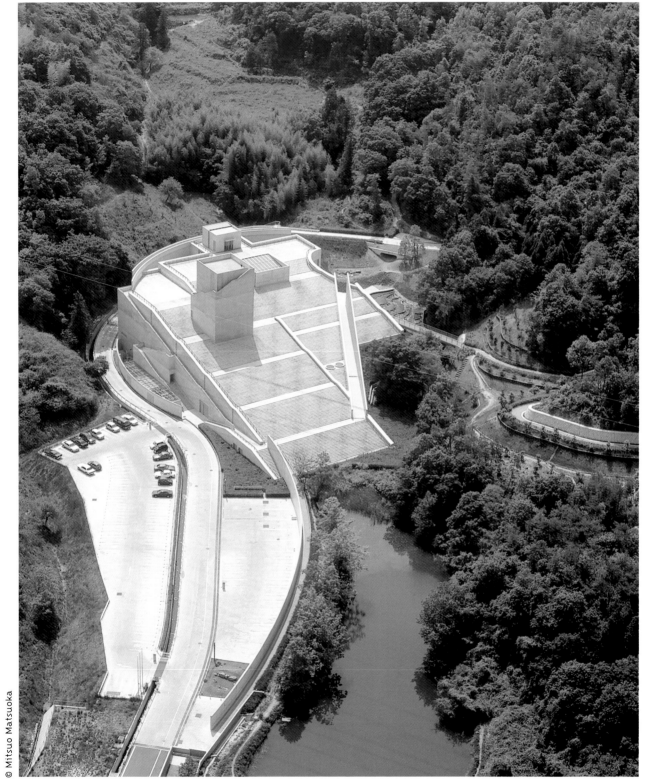

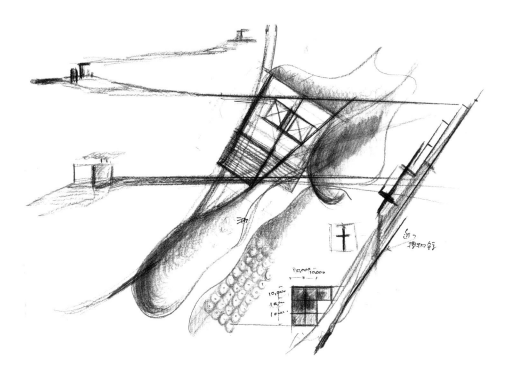

Schematic design sketches

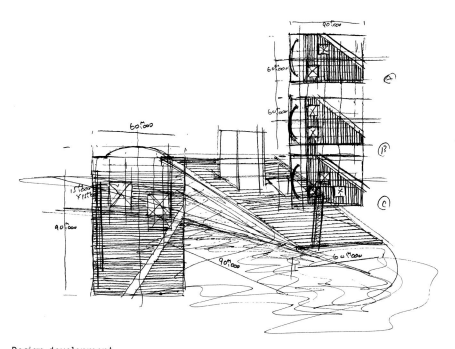

Design development

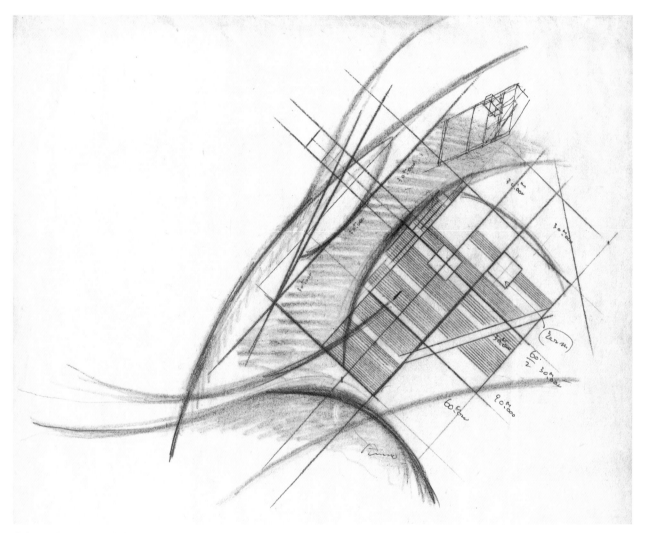

Schematic design sketches

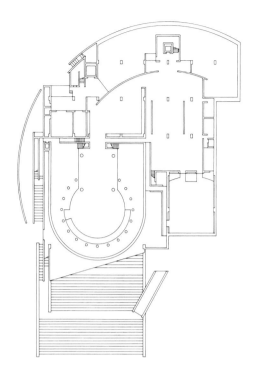

Ground floor plan

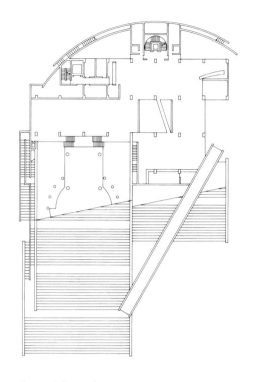

Second floor plan

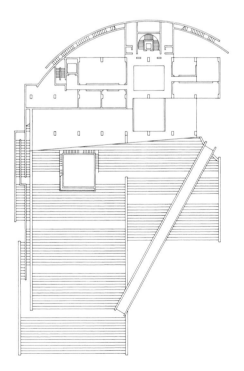

Third floor plan

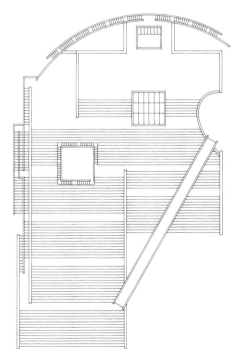

Roof plan

0 2 4

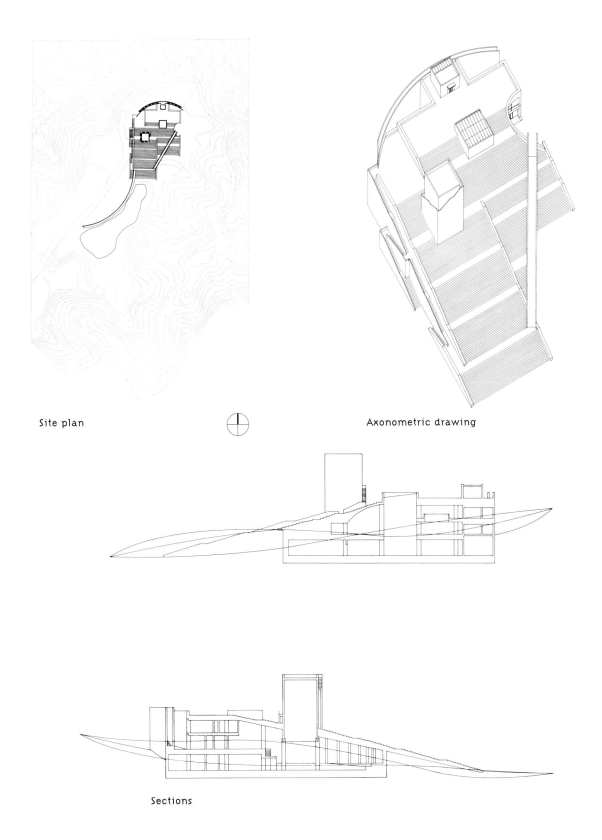

Site plan

Axonometric drawing

Sections

Museum of Modern Art, Fort Worth Fort Worth, TX, USA, 2002

This project is located on the outskirts of Fort Worth, in the midst of a vast park and oppo-
site one of the master works of twentieth -century architecture: the Kimbell Art Museum by
Louis Kahn. Naturally, the greatest design challenge was to establish a good relationship
between the new building and the Kimbell, while finding the optimal placement on such a
large plot. The strategy was to create a project in which the boundaries between interior and
exterior dissolve and where all the spaces are suitable for exhibiting works of art.

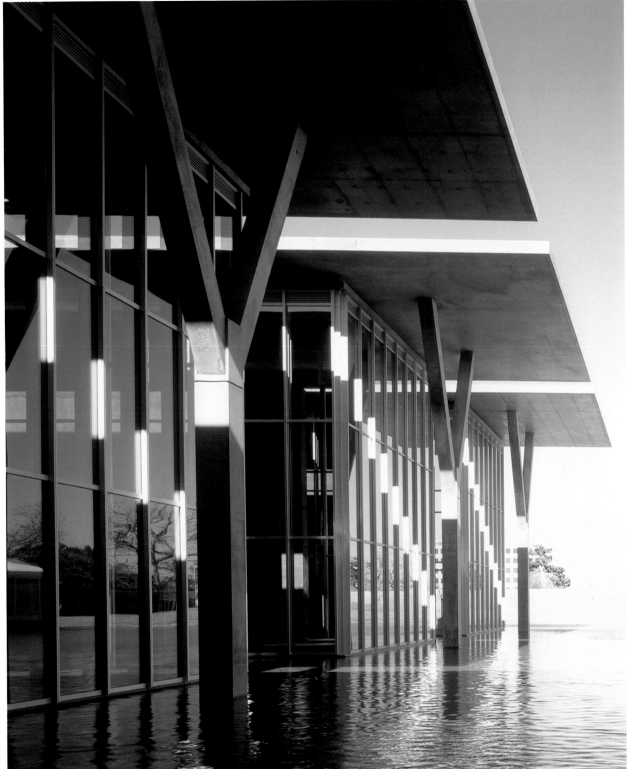

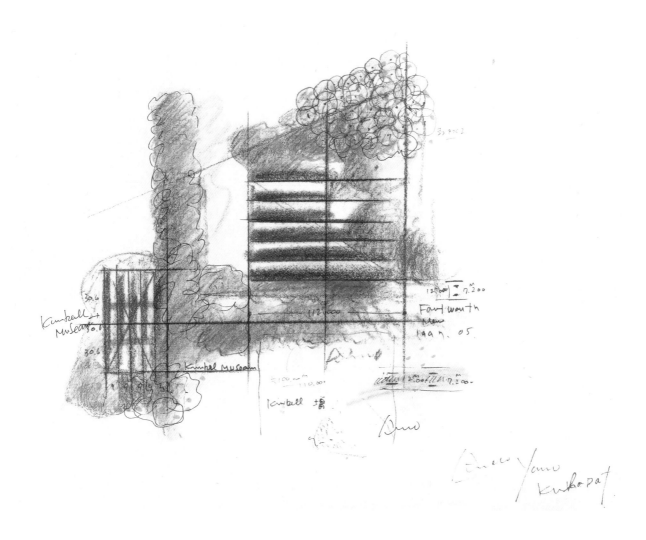

Design development sketch

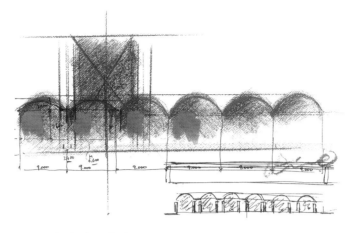

Schematic design study

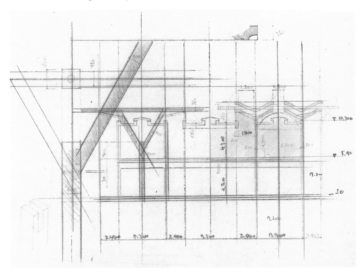

Design development drawing

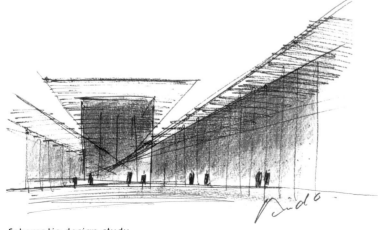

Schematic design study

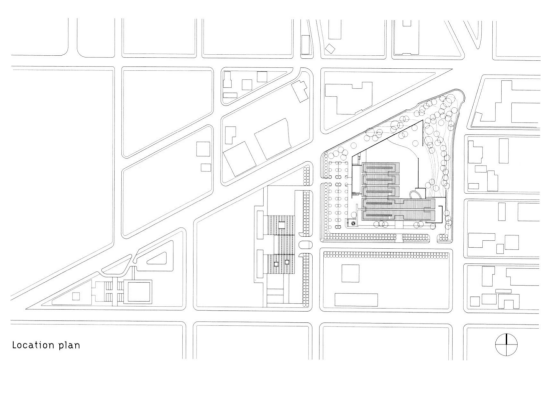

Location plan

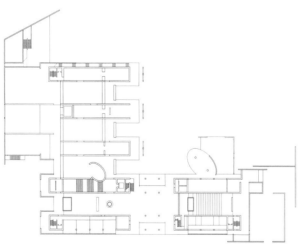

Ground floor plan

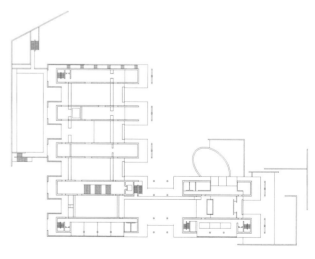

Second floor plan

0 10 20

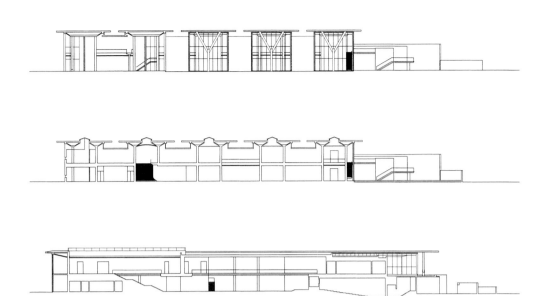

Sections

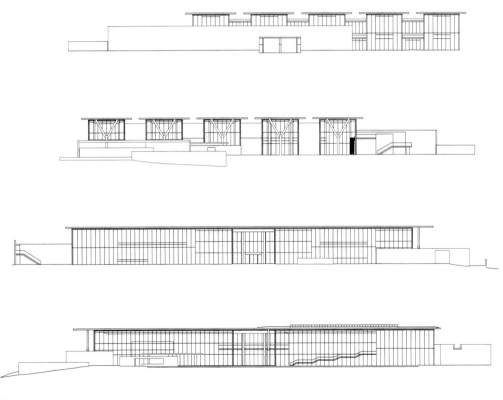

Elevations

Theo Hotz

Theo Hotz, a Swiss architect born in 1928, is well known for his large industrial and institutional buildings, which he has been constructing since 1949. Early in his career he was associated with Fedor Altherr and Max Kollbrunner. The bulk of his work has been performed in Switzerland, and he only gained international recognition in 1988 when the American Institute of Architects (AIA) presented him with the R.S. Reynolds Memorial Award. He has been recognized on several occasions for his spectacular glass structures, such as the addition to the Basel Trade Fair Complex and the Swiss Post Office and Telecom Building. He has been an honorary member of the Association of German Architects (BDA) since 1997 and of the Royal Institute of British Architects (RIBA) since 2000. While Hotz has focused mainly on Switzerland throughout his career, his work with the likes of Norman Foster, Richard Rogers, and Renzo Piano is evidence of his strong international ties.

☐ ABB Konnex Engineering Building

☐ Zum Löwenplatz Commercial Building

☐ Bäckerstrasse Apartment Building

Hotz

ABB Konnex Engineering Building Baden, Switzerland, 1995

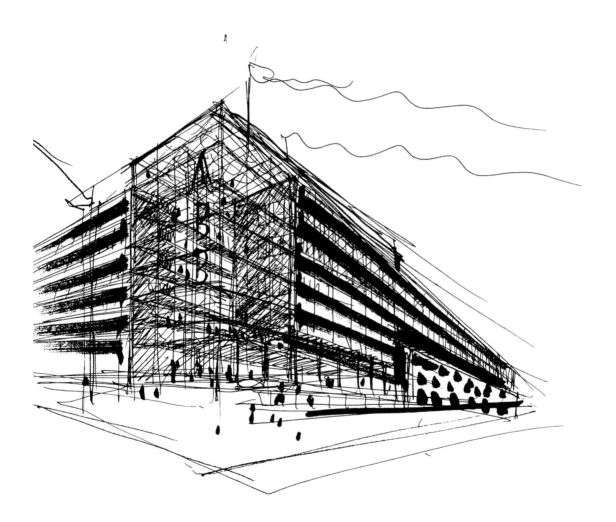

This project is part of a general renewal plan for the vast BBC industrial zone in the north of Baden. It is hoped that this abandoned part of the city will become home to the services sector. The huge glass volume that dominates the composition responds to the desire to create an updated image for the firm and ensure energy efficiency. The concrete platform on which the building rests absorbs solar radiation during the day and provides heating at night.

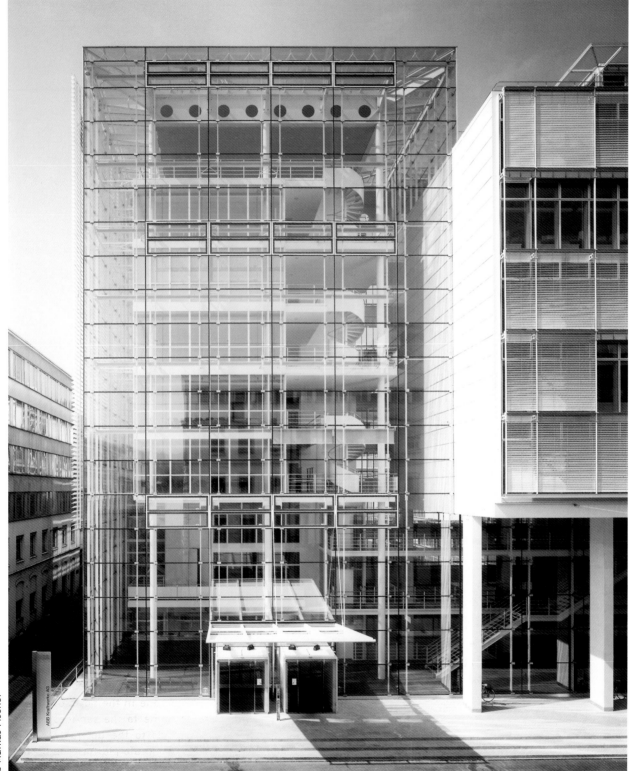

Schematic design sketches

Variante plune Halle
md Kesselhaus

Schematic design sketches

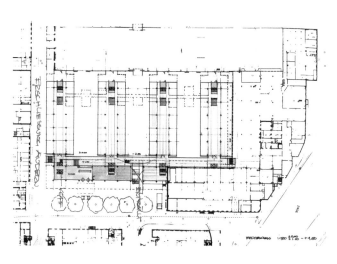

Construction documentation

Schemes of implantation

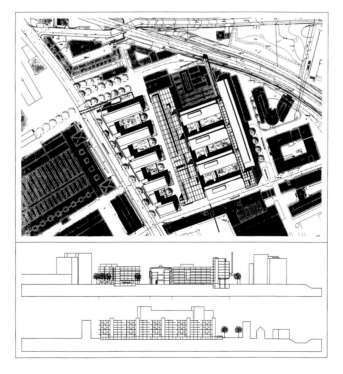

Site plan, section, and elevation

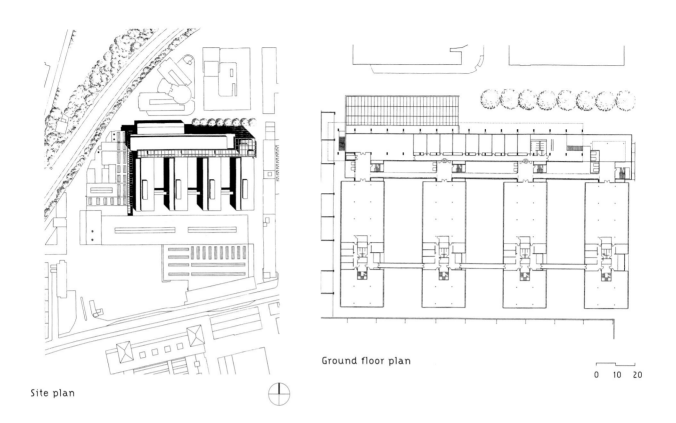

Site plan

Ground floor plan

0 10 20

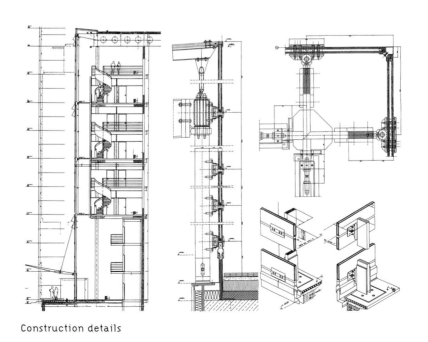

Construction details

Sections

Elevation

Zum Löwenplatz Commercial Building Zürich, Switzerland, 1992

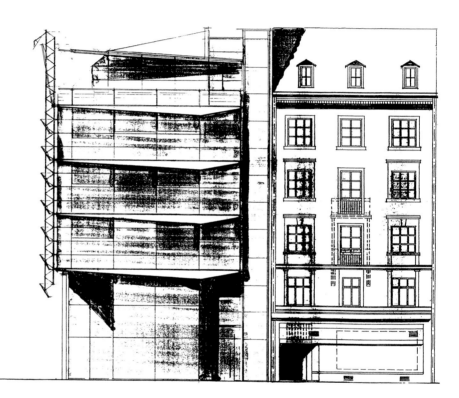

The design for this commercial unit had to take into consideration the circumstances of a traditional urban enclave in downtown Zürich, Switzerland. The building had to respond to the strategic location within the city at the foot of Löwenplatz street, the second busiest commercial street in Zürich, after the Bahnhofstrasse. It also had to honor the alignment of buildings on this street, which is part of the train station radial plan, put in place in 1862 and still in effect.

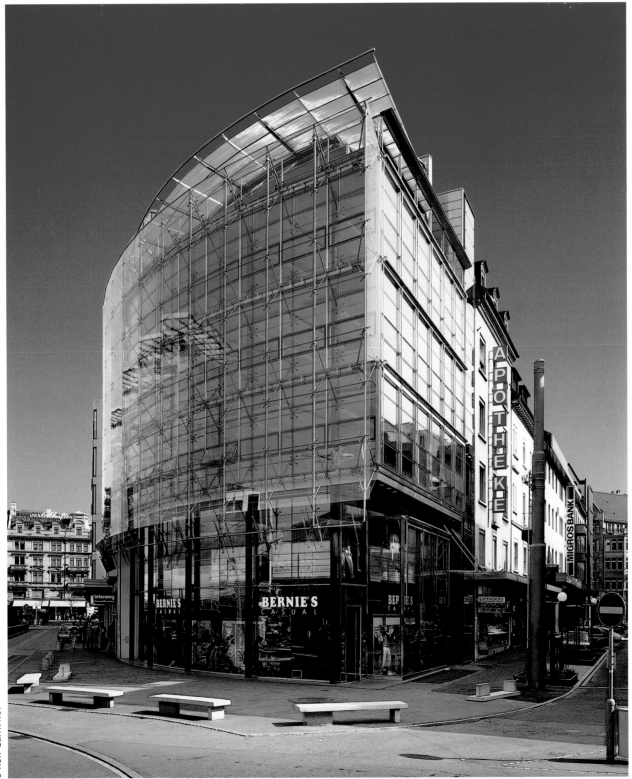

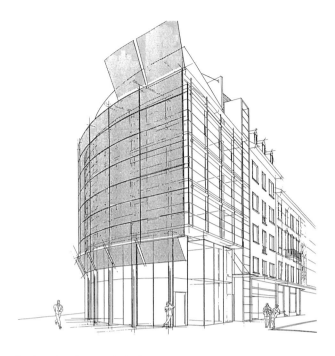

Design development study

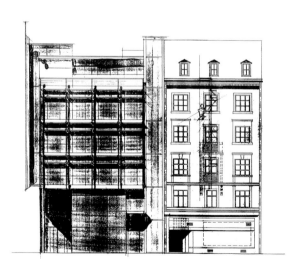

Elevation

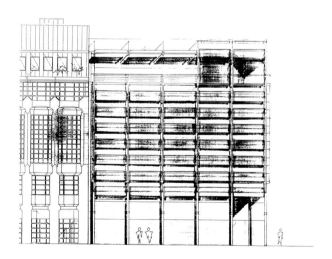

Elevation

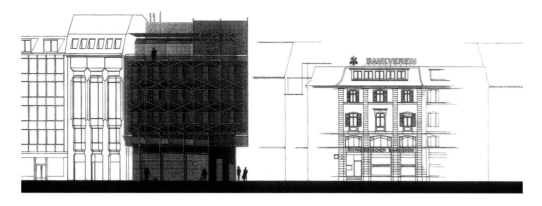

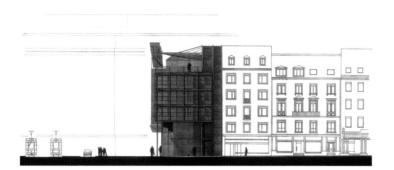

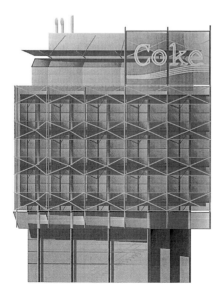

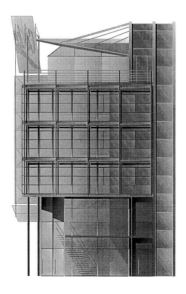

Facade studies

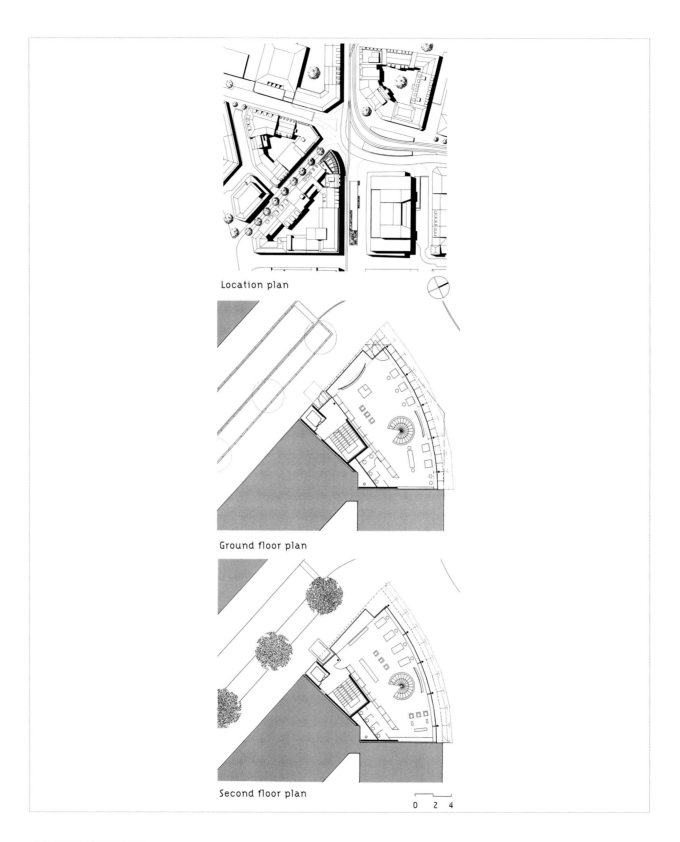

Location plan

Ground floor plan

Second floor plan

0 2 4

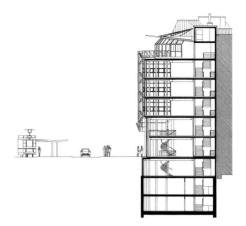

Section

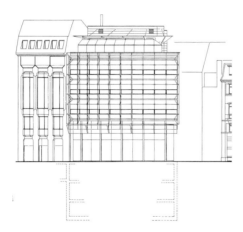

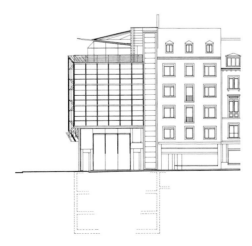

Elevations

Bäckerstrasse Apartment Building Zürich-Aussersihl, Switzerland, 2000

Although it could very well pass for an office building from the outside, this is an energy-efficient residential complex that fits subtly into the urban profile surrounding it. The continuous rhythm of the adjacent facades is maintained by the bands of exposed concrete that mark each floor, while a changing rhythm is created by the openings, double heights, and green balconies that open on the Facade. Double glazing provides an insulating chamber that keeps the interior temperature constant and saves on air conditioning.

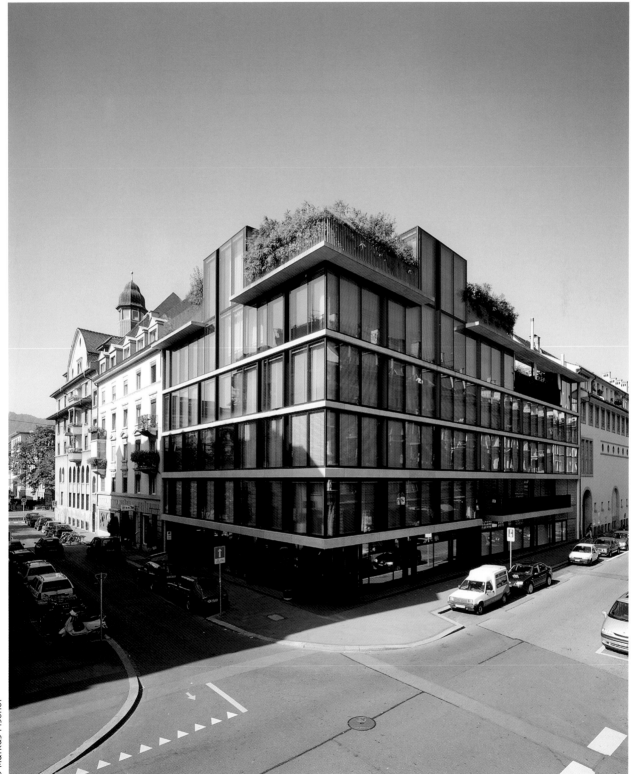

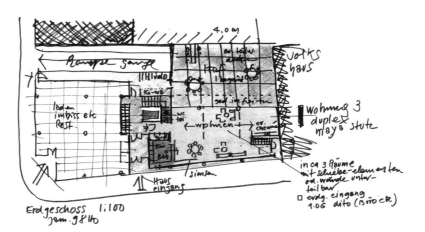

Schematic design sketches

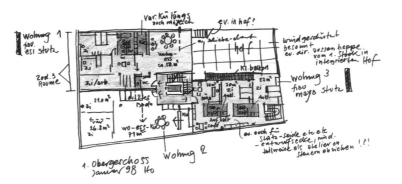

Schematic design sketches

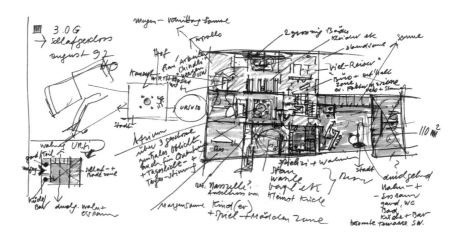

Schematic design sketches

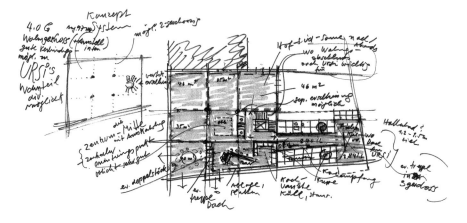

Schematic design sketches

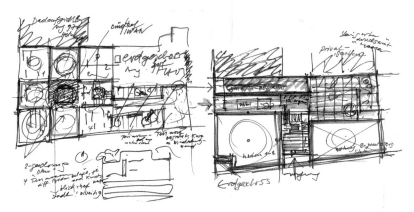

Schematic design sketches

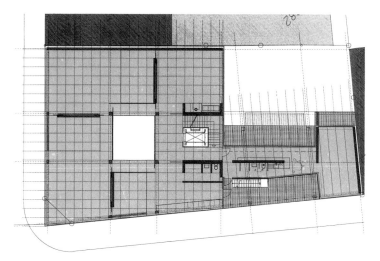

Construction documentation

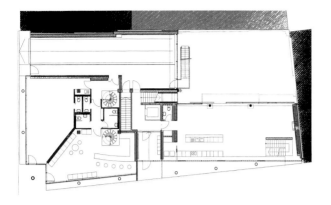

Ground floor plan

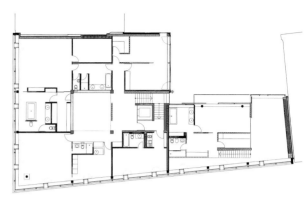

Fourth floor plan

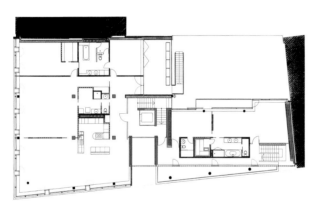

Second floor plan

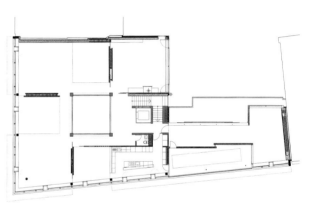

Fifth floor plan

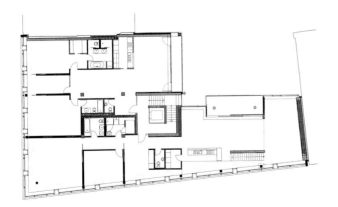

Third floor plan

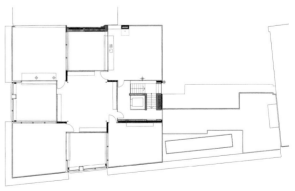

Sixth floor plan

0 2 4

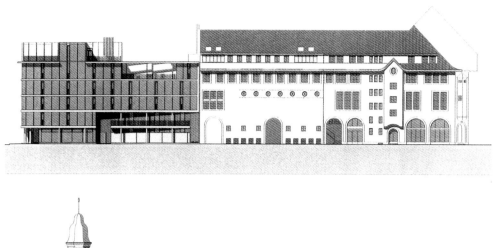

Elevations

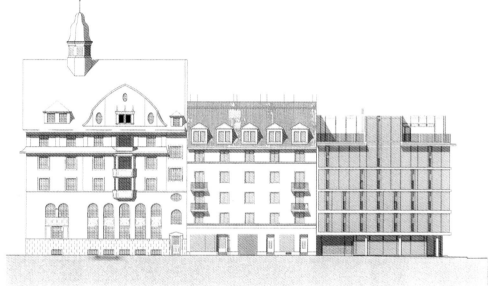

Sections

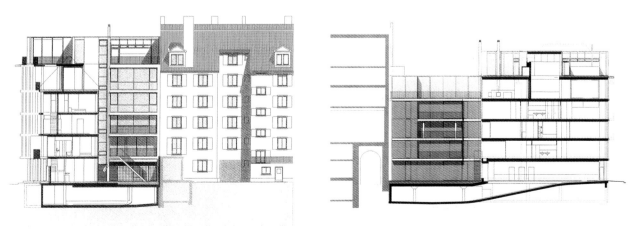

UN Studio

In 1988, Ben van Berkel and Caroline Bos set up the
architectural firm known as UN Studio, based in
Amsterdam, the Netherlands. Van Berkel studied
architecture at the Rietveld Academy in Amsterdam and
the Architectural Association of London, while Bos studied
Art History at Birkbeck College of the University of London.
UN Studio gave them the opportunity to exchange
theoretical projects for the practice of architecture.
Caroline Bos is an analyst for the firm, which observes,
studies, and describes the various programmatic
questions and communicates them directly to the
different parties involved in each project. They are
essentially a network of specialists in the fields of
architecture, urban development, and infrastructure.

Studio

La Defense Office Building Almere, the Netherlands, 2004

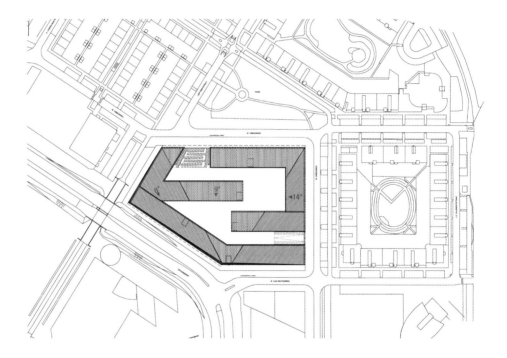

In its urban context, the La Defense office building appears as a modest volume that reflects its immediate surroundings in its metallic facade. The exterior skin that surrounds the building is an expression of urban consciousness and the degree of closeness of the units. The project's most genuine and original qualities can be appreciated from the inner courtyard, which is the focal point of the composition. The facades adjacent to the courtyard are made of glass panels with integrated multicolored foil sheets. Depending on the time of day and the angle of the light, the facades change from yellow to blue, red to purple, or green to black.

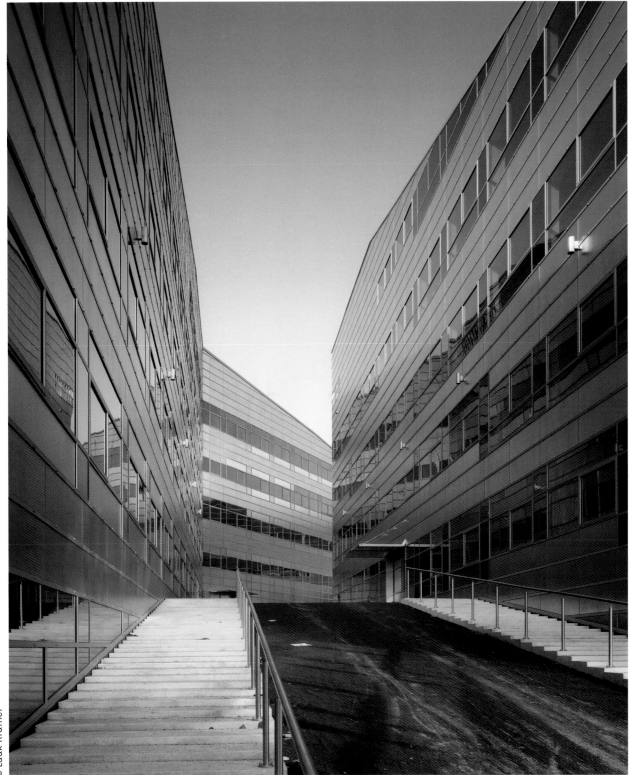

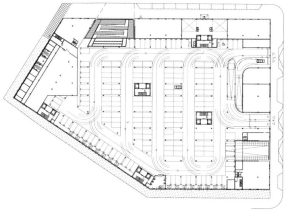

Basement plan

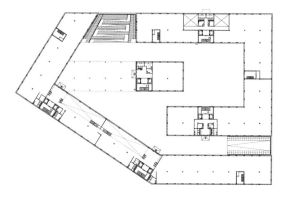

Ground floor plan

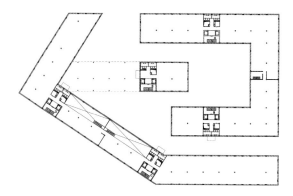

Second floor plan

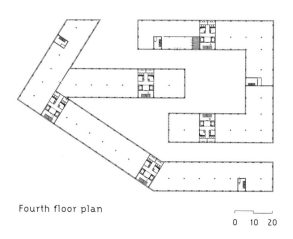

Fourth floor plan

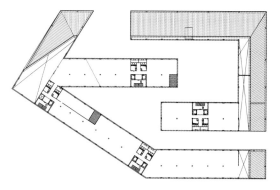

Third floor plan

0 10 20

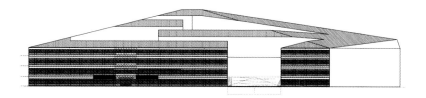

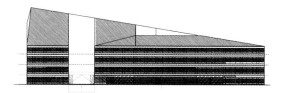

Elevations

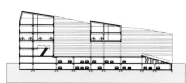

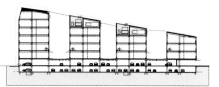

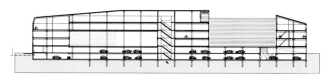

Sections

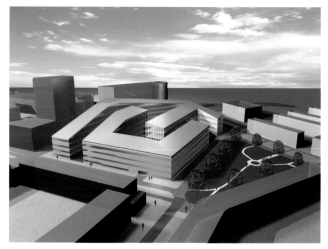

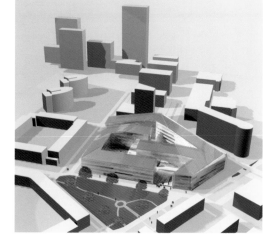

Renderings

Living Tomorrow Pavilion Amsterdam, the Netherlands, 2003

The Living Tomorrow Pavilion is located in southeastern Amsterdam on a small plot that had to accommodate a wide range of activities. It contains a hall for exhibits and demonstrations on the house and office of the future. Other requirements were spaces for events, an auditorium, a future business department, and lounges. The building's curved shape derives from the concept that the vertical and horizontal create a fluid, continuous composition.

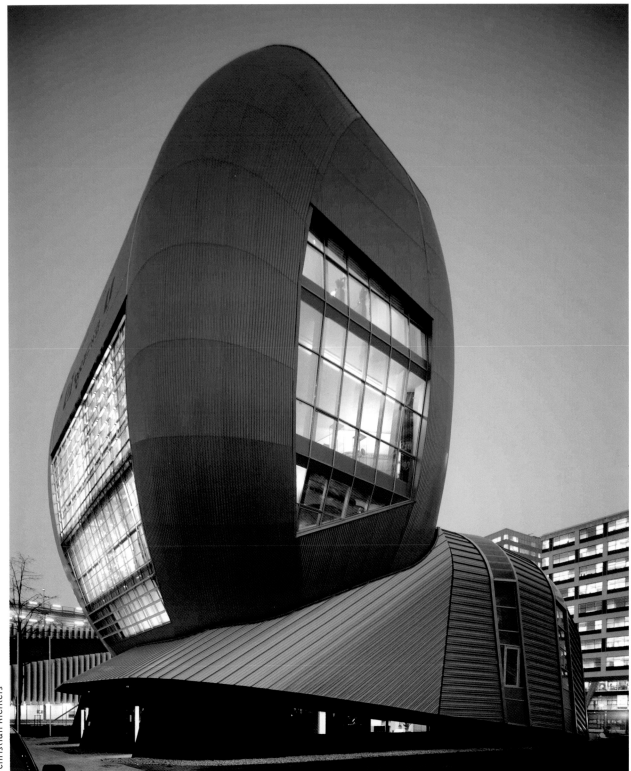

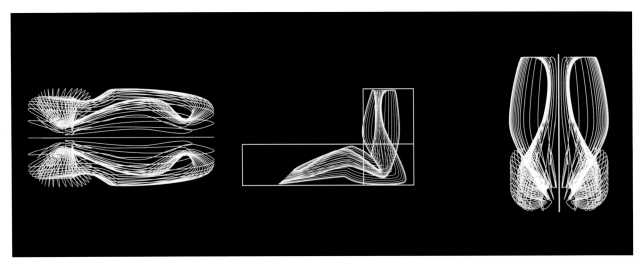

Schemes

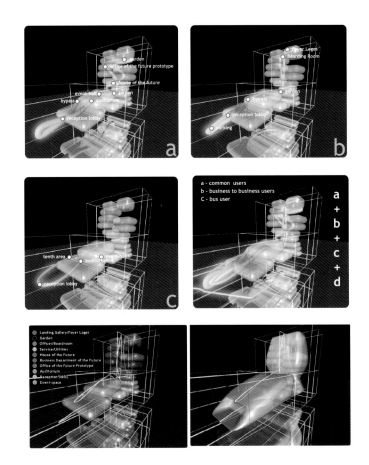

Diagrams of operation

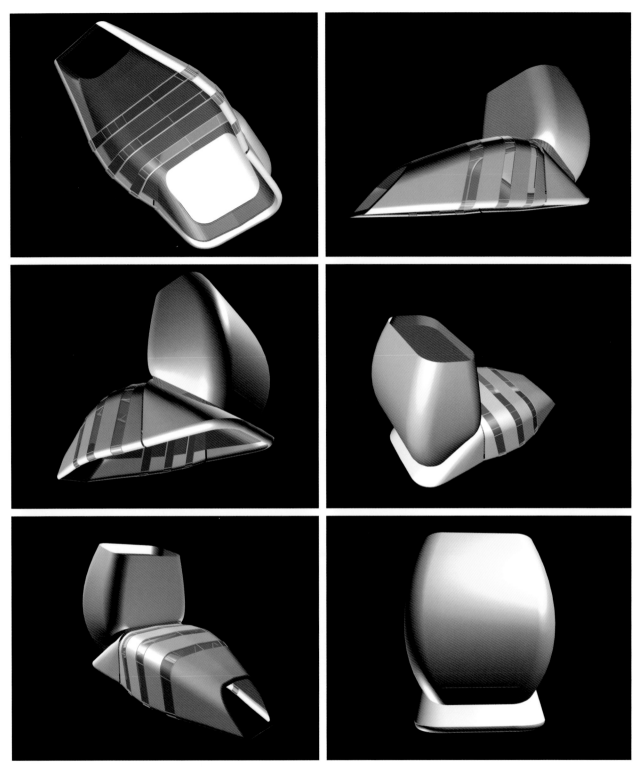

Schematic design sketches

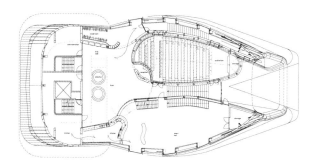

First floor plan

0 2 4

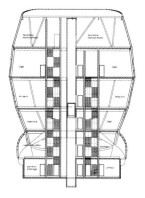
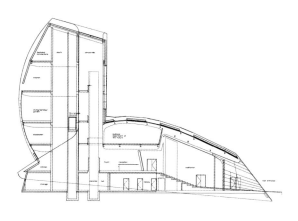

Sections

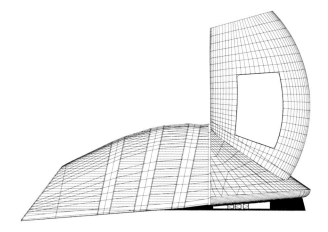

Elevations

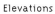

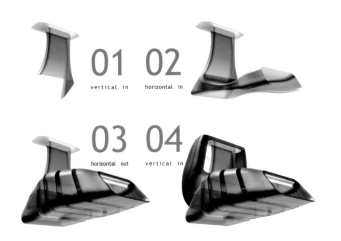

01
vertical in

02
horizontal in

03
horizontal out

04
vertical in

3-D model rendering

3-D model rendering

Vincent van Duysen

Vincent van Duysen earned his degree in architecture
from Saint-Lucas Hogeschool voor Wetenschap & Kunst in
Ghent, Belgium. From 1986 to 1987 he collaborated with
stylist Cinzia Ruggeri and worked with Aldo Cibic of
Sottsass Associati. He opened his own firm, specializing
in architecture, in Antwerp in 1990. His many works
include private buildings, stores, and offices,
characterized by a limited use of formal elements. As he
himself says: "The interiors and architecture of Vincent
Van Duysen Architects are characterized by a mix of
simplicity and sensuality and a preference for primary
forms and compact volumes. Our style can be described
with a long line of adjectives: flat, simple, clear, but also
pure, elementary, essential, minimal, and silent, quiet,
relaxed. Design is the outcome of a process of refinement
in which the raw material, a mixture composed of
suggestions, awareness, and reminiscence, is gradually
purified and ordered until it reaches a final point of
equilibrium and geometric stability."

Vincent
Van

☐ **Office Building in Waregem**

☐ **DC House**

☐ **VDD House**

Duysen

Vincent van Duysen

Office Building in Waregem Waregem, Belgium, 2000

This project created a new landscape in an industrial context, using and extending the structure of an old Belgian textile company building. The industrial flavor was maintained in the overall appearance through the neutral use of the materials and the modular design. But the monolithic character created by the three large lightboxes and their routing on the site gives the building a presence of its own. The boxes, inspired by the additions to the roofs of industrial buildings, create a strong image from the exterior and a special effect in the interior, which is flooded with natural light.

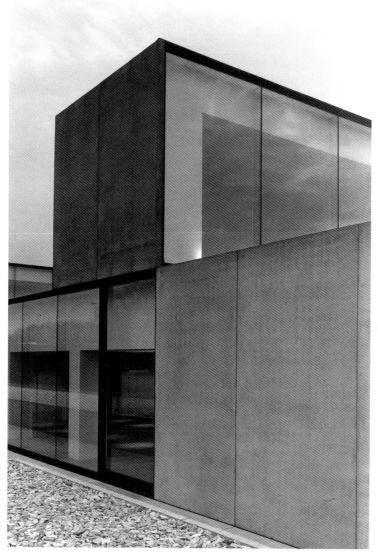

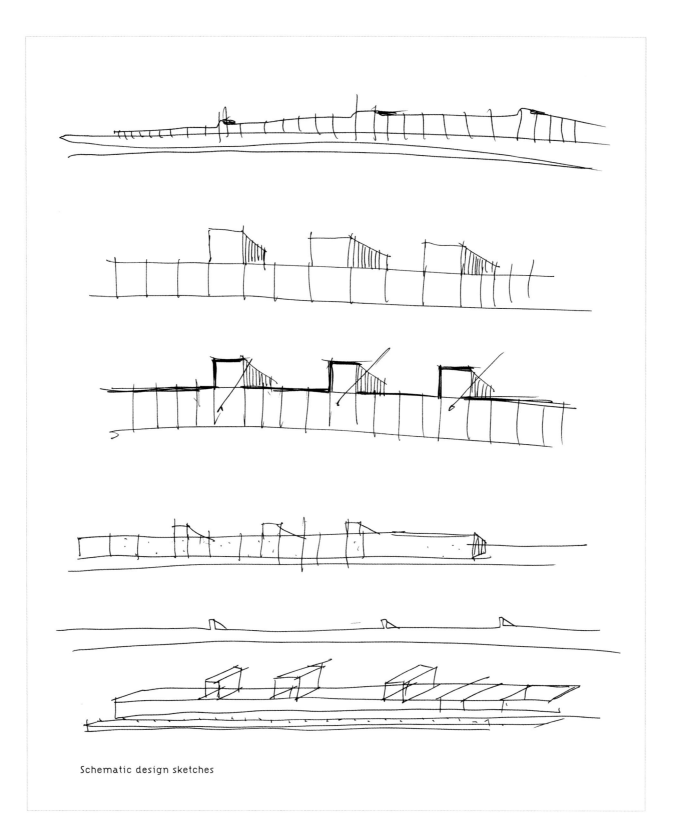

Schematic design sketches

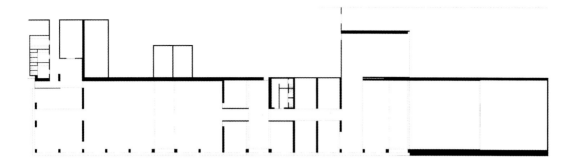

Floor plan

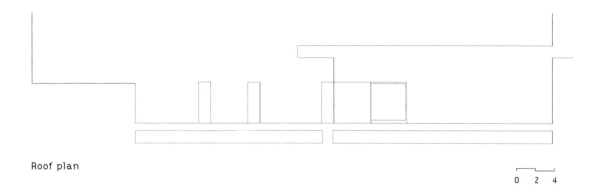

Roof plan

0 2 4

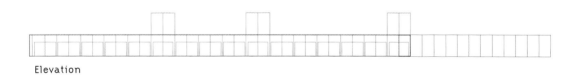

Elevation

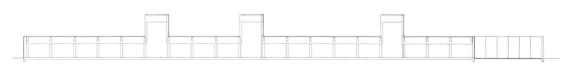

Section

DC House Waasmunster, Belgium, 2001

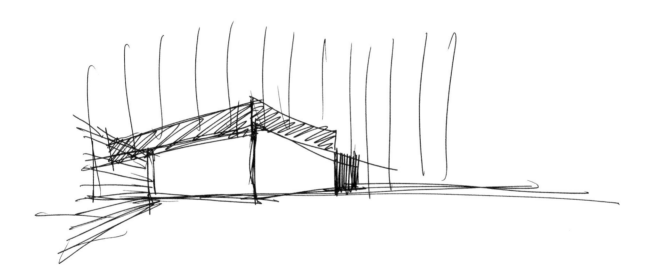

This house sits in a residential area surrounded by vegetation and classic homes. In the summer the area is popular with pedestrians. So the designers tried to create a building where one could be out of the line of sight of passersby when both inside and outside. From outside, the house looks like a modern, peaceful fortress, accentuated by warm tones. The perimeter wall of the garden wraps around the practically transparent ground floor, where most daily activity takes place.

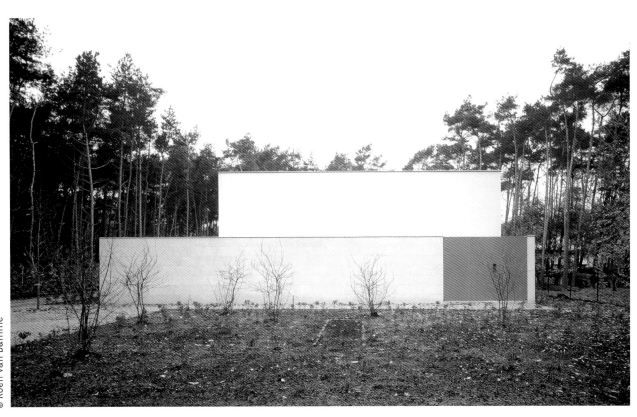

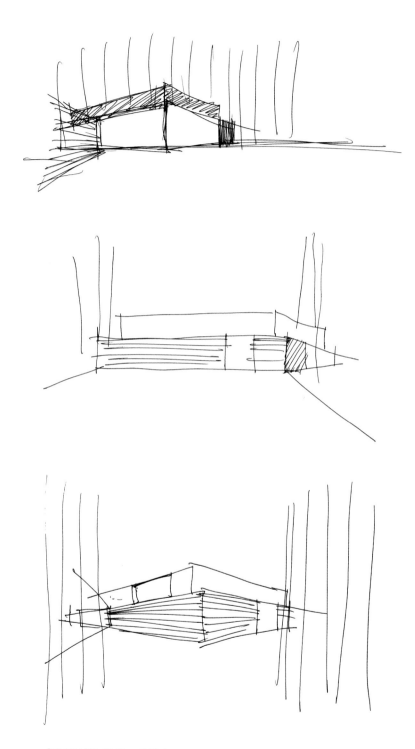

Schematic design sketches

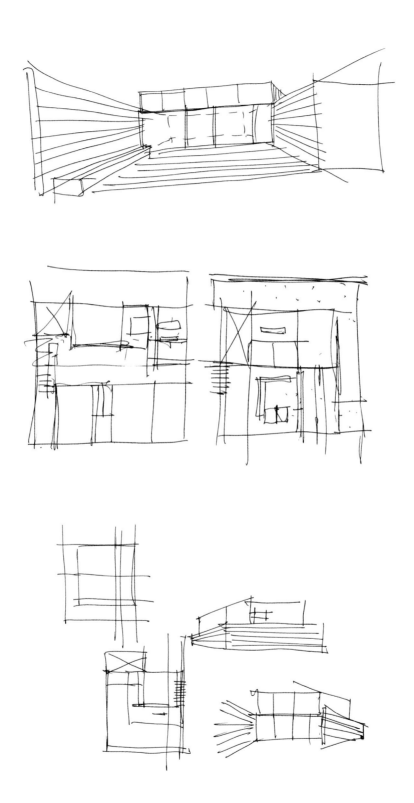

Site plan

Ground floor plan

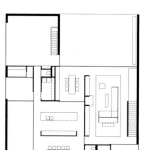

Second floor plan

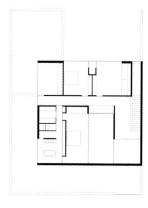

0 2 4

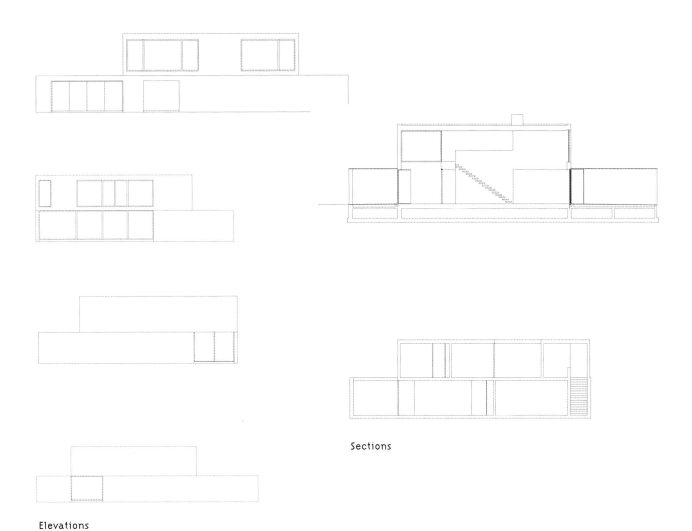

Sections

Elevations

VDD House Dendermonde, Belgium, 2003

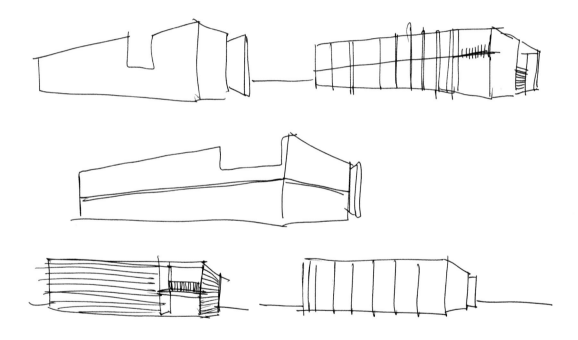

There were two main determinants on the site of this house: a river and a tidy strand of trees. The house faces the garden and is parallel to the river. The southern facade, which is open to the garden, has a strong rhythm of solid columns inspired by the trees and the way they are planted. The northern part of the house is organized around a courtyard, creating a buffer with the street and a source of natural light in the central area of the home.

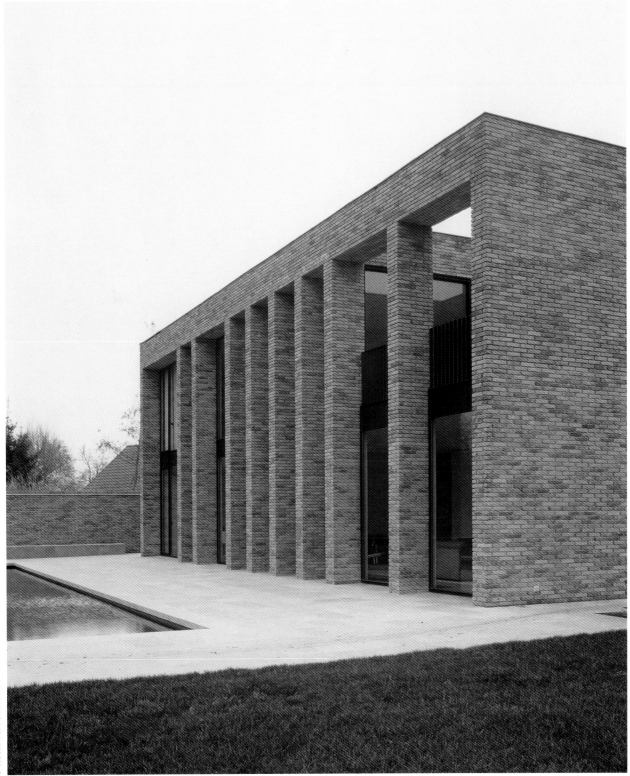

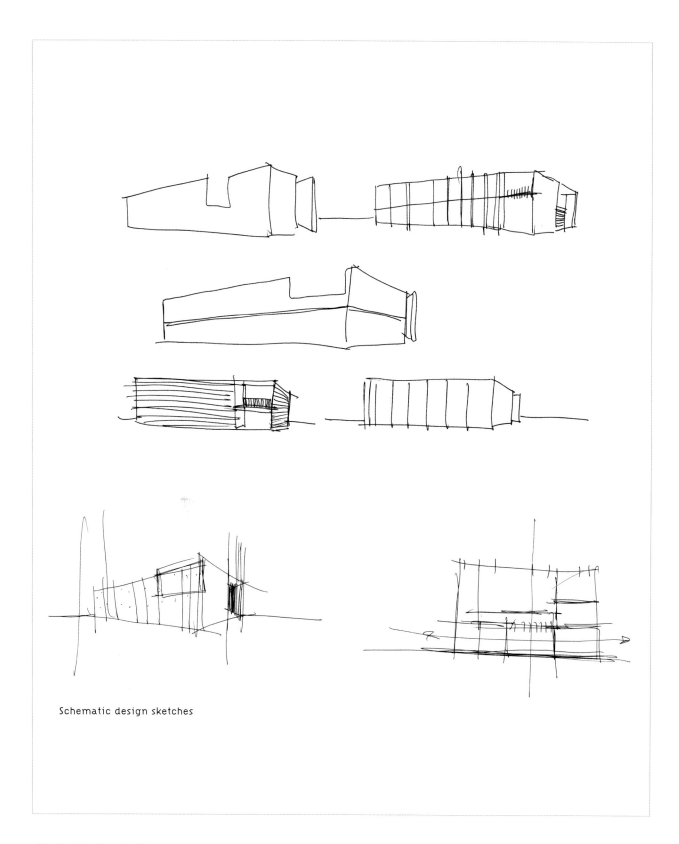

Schematic design sketches

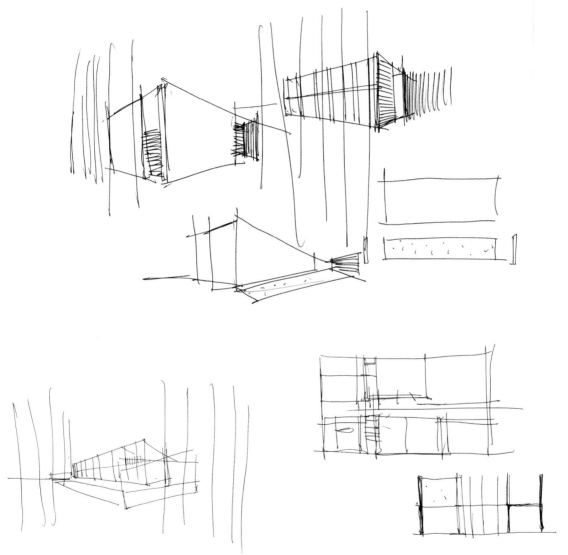

Schematic design sketches

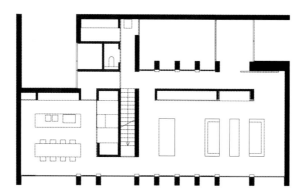

Ground floor plan

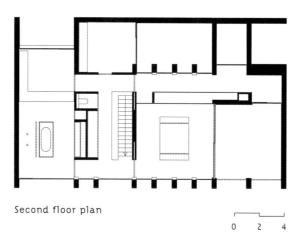

Second floor plan

0 2 4

Sections

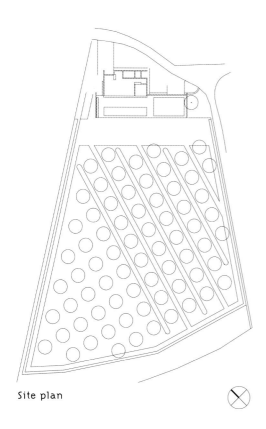

Site plan

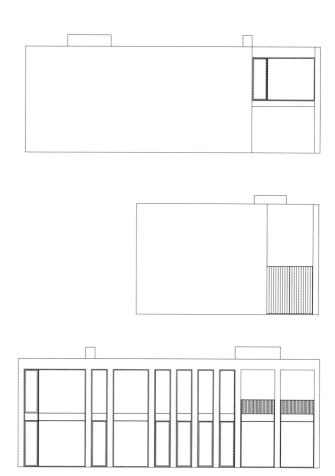

Elevations